EILEEN GRAY AND THE DESIGN OF SAPPHIC MODERNITY

The first book-length feminist analysis of Eileen Gray's work, *Eileen Gray and the Design of Sapphic Modernity: Staying In* argues that Gray's unusual architecture and design – as well as its history of abuse and neglect – emerged from her involvement with cultures of sapphic modernism. Bringing together a range of theoretical and historical sources, from architecture and design, communication and media, to gender and sexuality studies, Jasmine Rault shows that Gray shared with many of her female contemporaries a commitment to designing spaces for sexually dissident modernity.

This volume examines Gray's early lacquer work and Romaine Brooks' earliest nude paintings; Gray's first built house, E.1027, in relation to Radclyffe Hall and her novel *The Well of Loneliness*; and Gray's private house, Tempe à Pailla, with Djuna Barnes' *Nightwood*. While both female sexual dissidence and modernist architecture were reduced to rigid identities through mass media, women such as Gray, Brooks, Hall and Barnes resisted the clarity of such identities with opaque, non-communicative aesthetics. Rault demonstrates that by defying the modern imperative to publicity, clarity and identity, Gray helped design a sapphic modernity that cultivated the dynamism of uncertain bodies and unfixed pleasures, which depended on staying in rather than coming out.

Jasmine Rault is Assistant Professor in the Women's Studies Program, Department of Communication Studies and Multimedia at McMaster University, Canada.

Eileen Gray and the Design of Sapphic Modernity

Staying In

Jasmine Rault

LONDON AND NEW YORK

First published 2011 by Ashgate Publishing

Published 2016 by Routledge
2 Park Square, Milton Park, Abingdon, Oxon OX14 4RN
711 Third Avenue, New York, NY 10017, USA

Routledge is an imprint of the Taylor & Francis Group, an informa business

Copyright © 2011 Jasmine Rault

Jasmine Rault has asserted her right under the Copyright, Designs and Patents Act, 1988, to be identified as the author of this work.

All rights reserved. No part of this book may be reprinted or reproduced or utilised in any form or by any electronic, mechanical, or other means, now known or hereafter invented, including photocopying and recording, or in any information storage or retrieval system, without permission in writing from the publishers.

Notice:
Product or corporate names may be trademarks or registered trademarks, and are used only for identification and explanation without intent to infringe.

British Library Cataloguing in Publication Data
Rault, Jasmine.
 Eileen Gray and the design of sapphic modernity : staying in.
 1. Gray, Eileen, 1878–1976 – Criticism and interpretation. 2. Gray, Eileen, 1878–1976 – Friends and associates. 3. Women architects – Ireland. 4. Women architects – France. 5. Women designers – Ireland. 6. Women designers – France. 7. Modernism (Aesthetics) 8. Modern movement (Architecture) 9. Architecture, Domestic – France – History – 20th century. 10. Lesbian culture – History – 20th century.
 I. Title
 704'.086643–dc22

Library of Congress Cataloging-in-Publication Data
Rault, Jasmine.
 Eileen Gray and the design of Sapphic modernity : staying in / Jasmine Rault.
 p. cm.
 Includes bibliographical references and index.
 ISBN 978-0-7546-6961-6 (hardcover : alk. paper)
 1. Gray, Eileen, 1878–1976 – Criticism and interpretation. 2. Modernism (Aesthetics) – History – 20th century. 3. Homosexuality and art. I. Gray, Eileen, 1878–1976. II. Title.

N6797.G688R38 2011
745.4092–dc22

2010035844

ISBN 9780754669616 (hbk)

Contents

Illustrations	vii
Acknowledgements	ix

	Introduction	1
	Redressing critical oversights	6
	"Pioneer lady" in context	11
	Re-viewing Gray's work	17
1	Decadent perversions and healthy bodies in modern architecture	27
	Looking back: reading Gray in the 1920s	30
	Decadent interiorities and moral panic: a history of aesthetic health	33
	Building health	39
	Building (for) other bodies	43
	Gray in context: sapphic decadence	49
	Conclusions	54
2	Screening sexuality: Eileen Gray and Romaine Brooks	61
	Domesticity, femininity and sexuality	67
	"Smouldering sensuality": interior decoration and Brooks' first nudes	72
	Screening sexuality: Gray's first lacquer works	78
	Domesticating the "specular" lesbian	84
3	Accommodating ambiguity: Eileen Gray and Radclyffe Hall	93
	E.1027: the privilege of privacy	96
	E.1027 as "critical commentary"	103
	Other accommodations: E.1027 and *The Well*	105
	Fashion, vision, architecture	108

	Other fashions, visions, architectures	112
	Conclusions	117
4	Not communicating with Eileen Gray and Djuna Barnes	125
	Retreat from communications	128
	Architecture and communications	133
	Nightwood and Tempe à Pailla: some conclusions	147

Conclusion: staying in 161

Bibliography *169*
Index *181*

Illustrations

All photographs of Gray's architecture at E.1027 and Tempe à Pailla were taken by Gray, unless otherwise noted.

Introduction

I.1 E.1027, view from the sea, 1928. Reproduced with the kind permission of the National Museum of Ireland.

I.2 E.1027, living room with Le Corbusier mural (1938), 2004.

I.3 Gray, photograph by Berenice Abbott, 1926. Reproduced with the kind permission of the National Museum of Ireland.

I.4 "Boudoir de Monte Carlo," XIV Salon des Artistes Décorateurs: showing white block screens, beside sofa with black and white frame, piled with silk and fur blankets, on white, black and grey wool rug, lit by parchment lamps, all designed by Gray, 1923. Reproduced with the kind permission of the National Museum of Ireland.

1 Decadent perversions and healthy bodies in modern architecture

1.1 E.1027, main living room, nautical map with "L'invitation au voyage" stencil visible on the right, 1929. Reproduced with the kind permission of the National Museum of Ireland.

2 Screening sexuality: Eileen Gray and Romaine Brooks

2.1 Romaine Brooks, *The Screen* (or *The Red Jacket*), 1910. Courtesy of the Smithsonian American Art Museum.

2.2a Eileen Gray, *Le destin*, 1913.

2.2b Eileen Gray, *Le destin*, 1913.

2.3 Aubrey Beardsley, *The Peacock Skirt*, 1893.

2.4 Eileen Gray, *Le magicien de la nuit*, 1912.

3 Accommodating ambiguity: Eileen Gray and Radclyffe Hall

3.1 E.1027, alcove divan headboard with electrical outlets and built-in pivoting bedside table. Reproduced with the kind permission of the National Museum of Ireland.

3.2 E.1027, entryway partition, with partial views through to living room. Reproduced with the kind permission of the National Museum of Ireland.

3.3 E.1027, main and lower floor plan. Reproduced with the kind permission of the National Museum of Ireland.

3.4 Eileen Gray, photograph by Berenice Abbott, 1926. Reproduced with the kind permission of the National Museum of Ireland.

4 Not communicating with Eileen Gray and Djuna Barnes

4.1 Tempe à Pailla, seen from the road, 1934. Reproduced with the kind permission of the National Museum of Ireland.

4.2 Tempe à Pailla, view from footpath, with bicycle. Reproduced with the kind permission of the National Museum of Ireland.

4.3 Tempe à Pailla, view of the east-facing front façade. Reproduced with the kind permission of the National Museum of Ireland.

4.4 Tempe à Pailla, door to the main entrance. Reproduced with the kind permission of the National Museum of Ireland.

4.5 Tempe à Pailla, terrace towards study/living room windows. Reproduced with the kind permission of the National Museum of Ireland.

4.6 Tempe à Pailla, rounded storage screen in main entrance, dining room (foreground) and study/living room (background). Reproduced with the kind permission of the National Museum of Ireland.

4.7 Tempe à Pailla floor plan. Reproduced with the kind permission of the National Museum of Ireland.

4.8 Tempe à Pailla, view from living room to terrace, with fireplace, chimney and extended shelf. Reproduced with the kind permission of the National Museum of Ireland.

4.9 Tempe à Pailla, study. Reproduced with the kind permission of the National Museum of Ireland.

4.10 Tempe à Pailla, living room. Reproduced with the kind permission of the National Museum of Ireland.

4.11 Tempe à Pailla, view from living room to terrace (Herbst, *25 années UAM*). Reproduced with the kind permission of the National Museum of Ireland.

Acknowledgements

This book has been a long time coming. It started as a short essay for an excellent graduate course taught by Aron Vinegar, who turned me on to thinking about modernist architectures of bodies and subjects. This essay became the topic of my dissertation, which, along with the support and challenge of my supervisors, Will Straw and Christine Ross, sustained me through my Ph.D. This dissertation, morphed, twisted and undead, became the shape of a book project that haunted me through my post-doctoral work on everything other than this book. It has finally, at the tail end of my post-doctoral fellowship and throughout the first dizzying year of my first academic position, become something like the book on Eileen Gray that I was hoping to write, and perhaps more like the beginning of the book on (transnational) modernities, cultural production and the (affective) politics of anti-normative sexuality that I'd like to write next.

I have had so much help throughout these years. Without the direction and critical engagement provided by Christine Ross and the advice, perspective and good times provided by Will Straw, this book would never have been completed – or would not have been worth reading. Their guidance through the fields of art history and communication studies made this highly interdisciplinary project make sense (to me). They've taught me how to do academic work that I can live with and perhaps most importantly how to live with academic work. I really can not thank either of them enough.

I am also extremely grateful to Bridget Elliott, first for her own inspiring work on Gray and early twentieth-century women artists, writers and interior designers, but also for her support, encouragement, engagement and advice, which buoyed me through my post-doctoral research and thrilled me with the possibilities for future research on sapphic modernities.

For her thoughtful suggestions, understanding and patience, I thank Meredith Norwich. For their critical engagement, valuable time and generous feedback at various stages of the long research and writing process, I would also like to sincerely thank Lisa Henderson, Carrie Rentschler, Bronwen Wilson,

Cynthia Hammond, Jenny Burman, Joseph Rosen, Susana Vargas, Ilya Parkins and T.L. Cowan.

I would also like to thank Michael Kenny, Sandra McElroy and Jennifer Goff for guiding me through the Eileen Gray archive at the Collins Barracks, National Museum of Ireland, Dublin; Eva White for her assistance with the Gray collections at the Victoria and Albert Museum archives; Marie-Laure Jousset at the Centre Pompidou for her invaluable advice, direction and stunning hospitality while in Paris; Gilles Peyroulet at Galerie Gilles Peyroulet & Cie in Paris for sharing his time, recollections of and enthusiasm for Eileen Gray; and Renaud Barrès for guiding me through E.1027 and sharing his expertise on the house, its interior design and its complex history. For his meticulous help in scanning and preparing images, I would like to thank Ihor Holubizky.

A note on image copyright: I've made all reasonable efforts to contact the copyright holders, but if anyone objects to the inclusion of any image, do contact me with questions.

For their foundational and stimulating work on Eileen Gray, upon which much of this project is based, as well as their informal feedback on my project at crucial stages of the research, I would also like to thank Peter Adam, Caroline Constant, Beatriz Colomina, Philippe Garner and Penny Sparke.

I would also like to acknowledge the financial support from the Fonds québécois de la recherche sur la société et la culture, the Social Sciences and Humanities Research Council of Canada, the James Lougheed Award of Distinction from the Alberta Scholarship Foundation, the Canadian Center for Architecture and the McGill Center for Research and Teaching on Women, without which I would not have finished, let alone started, this long and pricey project. This research has also been very importantly encouraged by Canadian Governor General's Gold Medal Award, McGill Alumni Association Graduate Award and McGill's K.B. Jenckes Award – which made me recognize, at the end of my Ph.D., that this work might be interesting to people outside my committee or immediate circle of friends and family.

For taking me smoothly through every administrative step of this Ph.D. process, I sincerely thank Karin Bourgeois, Maureen Coote and Susana Machado of the Art History and Communication Studies Department at McGill University.

For his periodic translations and decipherings of Gray's idiosyncratic handwritten French, consistently strong allongé and many months of reliably chipper early-morning conversation I thank Laurent at Café Esperanza (now Cagibi). And for the dreamy perseverance and distinctive personality to translate her idealistic labors into such a comfortable community café, the support for my transforming one smoky corner of it into my office for a year and the morning updates which put my stresses in perspective, I thank a.d.

Also: Kiva and Mauro and Massimo (Casa and Sala), Tom and Thea and Nora, Dave, Dan, Mory, Lienne, Lulu, Danielle, Steph, Steve, Evie, Saskia, Aissa,

Rebecca, Olive, Joseph, Jenny and Ruby-Max for withstanding my insanities, feeding me, drinking with me, housing me, entertaining me, giving me hope and teaching me what friendship means I will never know how to properly thank you.

My family, Marina, Jeff, Owen, Dylan, Ali, Sue, Anne, Gale and Ron for inspiration, for faith, for hope, for love, I am awed and forever in debt.

For so many years of surprising and teaching me, I am and will always be grateful to Susana Vargas.

Finally, I'd like to thank my grand piano and partner in crime, T.L., for putting all the pieces together.

Introduction

This book examines the intersections between histories of communication, European architectural modernity and sapphic modernity to understand the role that mediations of domestic space played in the creation, circulation and contestation of sexuality during the early part of the twentieth century. Sapphic modernity studies have shown that the historical and conceptual achievement of a static and stubbornly persistent lesbian identity resulted from the wide circulation of photographs of Radclyffe Hall in the mass media coverage of the 1928 obscenity trials of her novel *The Well of Loneliness* (1928).[1] Architectural historians have shown that the apparently unified identity of modernist architecture resulted from a similar mass media reduction of several building styles and aesthetics into one highly circulated advertising image.[2] Indeed, communication technologies have played central and similar roles in the creation of both a lasting modernist architectural canon and a pathologized mannish lesbian identity. It is with this centrality in mind that I analyse the private architectural and design works of Eileen Gray in relation to other sapphic modernist configurations of domestic space during the early part of the twentieth century. In the chapters that follow, I focus specifically on the points of overlap between Gray's work and Romaine Brooks' early paintings (1910–13), Radclyffe Hall's novel and highly publicized trials and finally Djuna Barnes' dense and non-communicative novel *Nightwood* (1937). I argue that a distinctive resistance to communication technologies, as well as to the publicity, clarity and immediate communicability that they promised at the time, was characteristic of non-heterosexual women's visual, literary and architectural renderings of private space. Sapphic modernist designs on domestic space introduce us to a cultural history of female sexual dissidence that resisted the lesbian identity produced by modern media of communication.

The ongoing story of Gray's first built house provides a compelling introduction to Gray's unusual work and its long history of neglect and abuse,

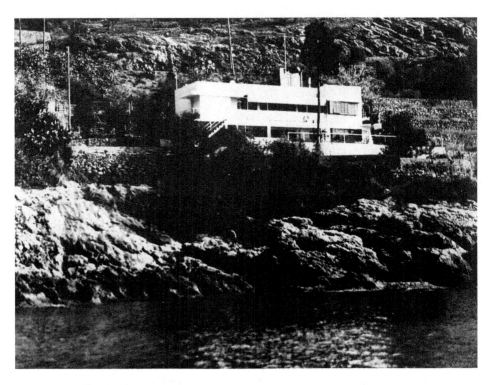

I.1 E.1027, view from the sea, 1928. Reproduced with the kind permission of the National Museum of Ireland.

as well as its recent rediscovery and the increasing amount of critical interest it has been receiving. In 1928, after nearly 20 years of working on interior design in Paris and about four years informally studying architecture, at the age of 50 Gray completed her first intricately designed house, E.1027, on an isolated ocean-front plot of land in the south of France (Figure I.1). By 1938, Le Corbusier, perhaps the most influential figure in European modernist architecture, had painted a total of eight murals on the walls of E.1027. Gray's biographer writes of the murals as an act of sexual violence: "It was a rape. A fellow architect, a man she admired, had without her consent defaced her design."[3] Le Corbusier's uncanny interest in her house led him, in 1952, to build himself a small hut on E.1027's property line, directly overlooking her space. He would eventually come to occupy the site, living out his last eight years there before drowning in the waters off its shore. Beatriz Colomina first told this story in 1993, when she suggested that Le Corbusier's peculiar "war" on Gray's architecture was related to both her gender and her non-heterosexuality.[4] This one short article, republished at least three more times,[5] has been extremely influential in the fields of feminist architectural and interior design history, and has prompted my own years of research on Gray

and what relation her work may have had with female sexual dissidence in the early part of the twentieth century.

This book was first motivated by the question of what there was in Gray's architecture and design that provoked Le Corbusier's obsessive, invasive and sexualized violence. Did Gray build some threatening non-heterosexuality into E.1027? How would a house communicate sexuality? And what would it mean to communicate female sexual dissidence at a time before the word "lesbian" had accrued a stable referent, when female masculinities and same-sex desire were not yet read as indications of identity? That is, how could architecture and design communicate something that was not really communicable? In order to answer these questions, I focus on Gray's work in the context of not only the cultures and discourses of European architectural and design modernity with which she critically engaged, but also the cultures and discourses of sapphic modernity from which these criticisms emerged and the technologies and strategies of communication by which they were articulated.

Up to the most recent publication of Colomina's article, in 1996, she could write that "Gray's name does not figure, even as a footnote, in most histories of modern architecture, including the most recent and ostensibly critical ones,"[6] and E.1027 was still deteriorating through years of neglect and vandalism. Her contributions to modern architecture and design were quite literally buried beneath the famous male architects of her time.[7] However, the status of Gray and her work has changed considerably. By 2001, E.1027 had been declared a *monument historique*, with efforts towards its restoration being supported by the French government as well as by a coalition of architectural historians, art historians and museum curators calling themselves "Friends of E.1027" (and counting Colomina herself among its influential advocates). By 2003, Lynne Walker could write that "Eileen Gray's status has never been higher ... she has achieved canonical status in architectural history."[8] As Walker points out, several reassessments of Gray's work have been published since 1968, and her work has been the subject of numerous exhibitions, catalogues and articles and two important books from Caroline Constant.[9] The story of domestic violence at E.1027 "is a now well-known dominance gesture," and Walker speculates that Gray may by now be *the* feminist "heroine."[10] But despite this recent resurgence of interest in her work, until 2007 E.1027 was still crumbling, and restoration efforts stalled over the question of what to do with Le Corbusier's murals, which have remained eerily precise and intact (Figure I.2). As of 2008, work was finally underway to restore the house to its original 1928 condition, with the exception of the murals, which will be preserved (and the restorations are scheduled to be completed by 2011).

In spite of the notoriety of this story, and the extent of feminist investment in it, *Eileen Gray and the Design of Sapphic Modernity* is the first book to explore the insight it might give us into the gendered and sexual implications of

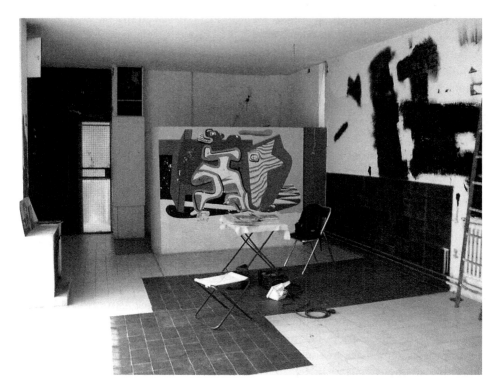

I.2 E.1027, living room with Le Corbusier mural (1938), 2004.

Gray's work, modern architecture or early twentieth-century configurations of domestic space more generally. Le Corbusier's violence at E.1027 has functioned, Colomina argues, to efface not only Gray's name and work but also her sexuality from the history of modern architecture,[11] and continuing to ignore, dismiss or obscure her non-heterosexuality risks perpetuating this initial act of violence. This book, thus, sets out to account for Gray's contributions to the European cultural history of sapphic modernity – constituted by a loose network of women, including Brooks, Hall and Barnes, whose creative works and communities cultivated the intimate connection between sexual dissidence and modernity itself. A growing field of research in the field of sapphic modernity has shown that for women, before the media advent and wide circulation of a stable and criminal lesbian identity, becoming non-heterosexual was synonymous with becoming modern.[12] The idea of an alternate modernist movement and culture, organized primarily around early twentieth-century women writers, centred primarily on Gray's Left Bank neighborhood in Paris and bound essentially by "all forms of lesbian experience," was first theorized as "Sapphic modernism" by Shari Benstock.[13] In the past 20 years, the theory has been challenged, expanded

and revised perhaps most influentially by Doan as sapphic modernity – a framework through which to account for a variety of women's experiences and expressions of modernity and same-sex desire. As Doan explains,

> Mellifluence aside, "Sapphic" efficaciously denotes same-sex desire between women and, at the same time, because it is less familiar to us today, reminds us that the "lesbian," as a reified cultural concept or stereotype, was, prior to the 1928 obscenity trials, as yet unformed in English culture beyond an intellectual elite.[14]

While Doan concentrates specifically on England, in the more recently published *Sapphic Modernities,* historians of modernism use this theoretical framework to explore a range of topics, from smoking to driving to portraiture to spirituality, in different contexts across England, France and Australia.[15] While none of the authors included focuses on Gray or early twentieth-century architecture, Bridget Elliott's essay on the art deco interior designs of two couples, Phyllis Barron and Dorothy Larcher, and Evelyn Wyld and Eyre de Lanux (with whom Wyld collaborated after working with Gray), points to exciting possibilities for scholarship on Gray.[16] Elliott acknowledges that "despite the fact that one couple remained life-long partners, these women designers do not seem to have self-identified as lesbian, Sapphic or even primarily women-oriented in ways we would recognize now."[17] Rather than grafting a contemporary sexual or social identity back on to these designers, or their works, Elliott allows their unfamiliarity, their "liminality and ambiguity [to] sugges[t] that the boundaries between lesbian, bisexual and straight have been more fluid than our current use of these terms implies."[18] By negotiating the double challenge of both accounting for the significance of these couples' dissident sexualities and *not* reducing their differences to accommodate our recognizable categories of identity, Elliott suggests an extremely useful model for studying Gray's work.

While the scholarship on sapphic modernity has carefully traced the role that new media and communication technologies played in reducing various female masculinities and dissident sexualities into one pathological lesbian identity, it has been less attentive to the strategies that women devised to resist this reduction. Moreover, while media studies of architecture have shown that modernist architecture was fashioned out of and into new technologies of communication,[19] the gendered and sexualized implications of this insistence on clarity, transparency, openness, exposure and publicity have not yet been explored. While Gray's resistance to communication has been dehistoricized and attributed to her unaccountably private, shy and fussy character,[20] I argue that by resituating Gray and her work within the history of sapphic modernity, and examining the importance of opacity, privacy and incommunicability in sapphic modernist configurations of domestic space, we can see this resistance as a critical intervention into the coherence and creation of lesbian identity.

Redressing critical oversights

Intimate relations among these women were usually unacknowledged, in accordance with the mores of the time, just as Gray remained discreet about her relationship during the early 1920s with the famous singer Marisa Damia (pseudonym of Marie-Louise Damien) Gray's sense of propriety and natural shyness led her to carry out her personal life with extreme discretion.

Caroline Constant[21]

Gray was born in Enniscorthy, Ireland, in 1878 and studied at the Slade School of Art in London (1901), and at the École Colarossi and Académie Julian in Paris between 1902 and 1905. She moved permanently to Paris in 1906 and launched her successful design career with lacquer furnishings in the 1910s. By the 1920s, her work had expanded into wool rug, lighting and furniture design and interior decoration, which she promoted through Jean Désert, the shop that she started and ran with her friend Evelyn Wyld, from 1922 to 1930. Gray began studying architecture in the mid-1920s, under the tutelage of Jean Badovici, an architect and editor of the avant-garde journal *L'architecture vivante* (1923–33), and produced three built houses in the south of France (E.1027, 1928; Tempe à Pailla, 1932–34; Lou Perou, 1954–61), along with plans for several unbuilt houses, lightweight shelters and multi-dwelling cultural and vacation centres between 1933 and 1961. The most thorough critical considerations of Gray's life and works have been published by Caroline Constant, who argues that "Gray's architectural production derived from critical engagement with contemporary approaches to the modern dwelling."[22] Constant explores the differences in Gray's work and her investment in intimacy, sensuality and domestic interiors, which constituted her critical and alternate "non-heroic modernism."[23] While Constant is clearly interested in rehabilitating critical interest in the differences constituted by Gray's emphasis on sensuality, arguing that we can "see Gray's architecture not simply as an 'other' approach to the Modern Movement, but as an extensive commentary on the Movement itself,"[24] she is less interested in exploring what these differences might be in service of, and even less so in their significance to changing conceptions of gender and sexuality at the time.

Sylvia Lavin published a rejoinder to Colomina's influential article, arguing that it allows scholars to begin the task of thinking differently about these "differences" in Gray's work.[25] Lavin explains that while Colomina's focus remains on Le Corbusier, the article offers "the opportunity to disentangle Gray from Le Corbusier, for the most active agent in the history of E.1027 has been Le Corbusier himself, and his authority ... remains in some way dominant."[26] That is, Colomina's article provides us with the conceptual tools not only for thinking of the differences between Gray's and Le Corbusier's work, but for thinking of Gray as an active agent working in some way outside the tangle of canonical modernist architectural history where Le Corbusier's authority

remains dominant. As Walker explains, "[a]nalysing Eileen Gray's work in the narrow architectural context of the modern movement and seeing her as an 'exceptional pioneer' is problematic and counter-productive."[27] Following Lavin, Walker suggests that we "find a positive, more productive reading of 'Eileen Gray', the historical subject, in what Griselda Pollock identified as 'a gap ... that space of possibility': between gendered cultural prescriptions of femininity and difference which is outside 'dominant masculine meanings embodied' in modernist history."[28] Walker's article gestures to considerations of gender and sexuality as routes towards these more productive readings of Gray as a historical subject, artist, architect and designer, noting that "[i]n most recently published works on Eileen Gray, her lesbianism and bisexuality have been recognised, but little analysed."[29] The reasons for this critical lacunae are manifold, ranging from the lack of sources to "prove" her non-heterosexuality or straightforward evidence to demonstrate that gender and sexuality were central factors in the production and reception of her work, to family, friends and historians who withhold, dismiss or overlook Gray's non-heterosexuality in deference to "mores of the time," or what they may consider respect for Gray's own "extreme discretion" about "her personal life."[30] The absence of critical attention to historical significance of sexuality in Gray's life and work results in ongoing efforts to establish Gray's rightful place in a heteronormative canonical history, dominated by men's names and accomplishments, whose exclusivity remains unquestioned.

The challenges faced by those of us interested in analysing, and not simply mentioning, Gray's sexuality are, the Lesbian History Group reminds us, typical:

In [our] case ... the problem of sources is magnified a thousand-fold. First, there is relatively little explicit information about lesbian lives in the past, though probably much more than we know about at the moment. Second, much important material has been suppressed as irrelevant, or its significance overlooked by scholars pursuing a different theory. Material may have been omitted as "private" or likely to embarrass the family or alienate the reader. Much of the evidence we do have has been distorted by historians who wilfully or through ignorance have turned lesbian lives into "normal" heterosexual ones. Women can be ignored, but lesbians must be expunged.

Lesbians do not leave records of their lives. Those who do may not include any details which would identify them as unmistakably lesbians.[31]

In the case of Gray, this problem of sources has been exacerbated by the fact that she published only one written explanation and description of her work[32] and that many of her notes, architectural and design plans, and personal papers were destroyed (after World War II by retreating German forces, and by herself shortly before her death). Moreover, while some of her remaining archive was acquired by museums in the 1970s and 1980s,[33] much of her archive was privately held by her biographer, Peter Adam, until it was acquired by the National Museum of Ireland in 2003.[34] Limited access

to the already small amount of archival information on Gray's personal and professional life and thoughts has no doubt contributed to the difficulty that scholars face in attempting, as Walker urges, "to try to explain the role that sexuality played in her creative life."[35]

To this already considerable set of obstructions to feminist historical studies of sexuality in Gray's work – limited sources, critical oversight and the heteronormative authority of modern architectural history – we need to add the trouble of terminology, the easy distortions and obfuscations of historical specificity effected by our use of loose and retrospectively applied terms like "gay," "lesbian" or "bisexual" when talking about women who pursued intimate same-sex relationships in the early part of the twentieth century. That is, Gray's sexuality, despite her reputed intimate relationships with women or with the architect Jean Badovici, would not have looked like anything we recognize as lesbian, bisexual or heterosexual. While Colomina suggests that Le Corbusier's violence was related in some way to the fact that Gray was "openly gay,"[36] and Walker suggests that we need to analyse her lesbianism or bisexuality, alternate, non-heterosexual, anti-normative or dissident female sexualities in the 1920s had not yet accrued into such stable cultural or social identities. I have been using this clumsy terminology, then – referring to sexual dissidence or non-heterosexuality rather than lesbians – out of respect for the uncertain terminology and categories of identity at the time. During the early part of the twentieth century there was no fixed vocabulary or clear definition for female same-sex desires, relationships or identities. As Laura Doan explains, "[i]n the 1920s lesbianism was not a 'fact' marked on the body, nor was it commonly understood as a particular object choice or sexual practice between women, nor was it (as yet) a modern identity or subjectivity."[37] The absence of a stable language or identity for female sexual dissidence may have contributed to the tendency in Gray scholarship to leave the significance of sexuality unacknowledged or unanalysed. And indeed, reading contemporary sexual identity back onto Gray risks effacing the range of historically and culturally specific meanings and aesthetic practices associated with and cultivated by women like Gray who lived outside the bounds of conventional heterosexuality in the early decades of the last century. However, overlooking the significance of Gray's non-heterosexuality risks obfuscating the broader social and cultural implications of her critical project and perpetuating the violence of Le Corbusier's gesture at E.1027.

What seems to have further complicated analyses of the related significance of gender and sexuality in Gray's work is her oft-cited late-life resistance to burgeoning feminist interests in the gender specificity of her architecture. In a letter that Gray wrote to Sheila de Bretteville on exhibiting Gray's work at the 1973 Women's Building in Los Angeles, Gray explains,

I quite agree, up to now women had no legal recognition ... but I am
sorry that the building in L.A. is called the Women's building. For what

reason? It seems to mean that women are an inferior species. Otherwise, why is this building not for everyone? Surely criticism must only be based on merit, and merit implies knowledge: the perception of new angles, perhaps, but not emphasizing the difference between individuals.[38]

Adam cites this letter as evidence that feminists were "trying to win her for the woman's cause" but concludes that "[Gray's] common sense prevented her from agreeing to any such scheme."[39] While Constant concedes that Gray's "work and thought process have many parallels with recent feminist criticism" she immediately closes those potential lines of enquiry, citing this letter and maintaining that Gray "rejected [such] terms of exclusion."[40] Constant and Adam have both used this letter effectively to bracket off and dismiss feminist interests in the significance of gender or sexuality to Gray's work.

Most recently, however, this letter has been re-used by Bridget Elliott to provide a framework for the first and only published article that attempts "to explain the role that sexuality played in [Gray's] creative life."[41] Elliott cites the letter at the outset of the article, speculating that Gray's resistance to feminist concerns would likely have been shared by "many women artists of her day."[42] But instead of using the letter to dismiss analyses of gender and sexuality, Elliott proposes a shift to "writing about Gray's work in the context of recent revisionist accounts of modernism by feminist critics and historians ... [which] will enable her work to be viewed from the new angles that she welcomed, without relegating it to the sort of feminine ghetto that she feared."[43] In a major departure from the existing literature on Gray, Elliott explains that "[i]nstead of differentiating Gray's work from that of her male counterparts in the field of architecture, I want to explore how it intersected with that of other women artists," Romaine Brooks and Hannah Gluckstein (Gluck).[44] My research pursues the line of enquiry that such a shift enables and that feminist scholarship on Gray has been suggesting since Colomina first published her article on E.1027, since Lavin argued that we need to disentangle Gray from Le Corbusier, since Walker urged that we stop simply mentioning Gray's gender and sexuality but explore their significance to the production and reception of her work, and since Elliott took the first steps to doing so by comparing Gray's work to that of other sexually dissident women at the time.

Elliott's article is an exciting start, but a sustained analysis of Gray's work in the shifted context provided by such new historicist feminist research on the significance of gender and sexuality in early twentieth-century modernism is still waiting to be written. While modernist literary studies have been taking questions of sexuality seriously for several years, visual studies and architectural history have only very recently begun to consider the influence of sexuality on modernist visual culture. Whitney Chadwick and Tirza True Latimer point out that

[l]iterary studies....have demonstrated that sexual identity, like gender, is not only what Joan Scott calls a "useful category of historical analysis", but also a determining factor in the production and reception of culture However, the intertwining of lesbian identity and artistic representation ... remains a blind spot in the historiography of modernism in the visual arts.[45]

Several essays in their 2003 anthology, *Modern Woman Revisited*, begin to redress this oversight,[46] but none deal directly with architecture or design. The role of sexuality in the production and reception of modern architecture and design has gone almost entirely unnoticed, and Elliott has published the only article to explore the impact that Gray's non-heterosexuality may have had on her work within the historically and culturally specific context in which she lived.

Katarina Bonnevier has recently attempted to address this blind spot in the literature on Gray by publishing "A Queer Analysis of Eileen Gray's E.1027."[47] Bonnevier explains "[w]hat has been safely disregarded and excluded from interpretations is Gray's sliding sexuality, her non-heteronormative lifestyle and how these might have an effect on her ways of disturbing the order of things."[48] As she notes, the fact that Gray "started to move in the circle of lesbians in Paris, who were leaders of the literary and artistic avant-garde, [has] implications for the understanding of her production."[49] While Bonnevier's article tends too quickly to read contemporary queer theory into Gray's architecture – relying, for example, on work by Judith Butler and Eve Sedgewick to argue that E.1027's complex system of storage space and closets enact a "performative queerness"[50] – thereby obscuring the importantly different ways that gender and sexuality would have mattered to Gray and "the circle of lesbians in Paris" at the time, it poignantly demonstrates the need for new historicist feminist analyses of Gray's work of the sort that Walker suggests, Elliott begins and this book offers.

Outside these few articles urging us to do otherwise, Gray and her work have been read primarily in relation to major male modernist figures and the architectural and aesthetic movements that they have come to represent (Le Corbusier's Purism and machine aesthetic, Walter Gropius' Bauhaus functionalism, J.P.P. Oud's De Stijl abstract minimalism), while the relationships that she and her work had with contemporary women artists, writers and designers have been persistently neglected. This critical gap in the literature on Gray exists despite the fact that even the limited archival information that we have on Gray's architecture, design and personal life suggests that she shared an investment in alternate arrangements of gender and sexuality with many of her female artistic and literary contemporaries. While Adam spends an inordinate amount of time describing Gray's potential heterosexual relationships, he acknowledges her steadfast, if "eccentric," rejection of male suitors and marriage.[51] By 1906, Gray had moved away from her family home in London to purchase an apartment in Paris (her primary residence until her

death 70 years later) on the Left Bank, around the corner from Natalie Barney, whose famed salon, which Gray sometimes visited, served as the hub of that city's primarily female sexual subculture, and several commentators have noted her apparently sexual, intimate relationships with women (Jesse Gavin, Gaby Bloch and Damia being the most well known).[52] In contrast to even the most progressive modern architecture of the time, she eliminated traditional gendered spaces (the masculinized study or the feminized boudoir) in her houses and vacation/cultural centres.[53] She commissioned portraits of herself, with short cropped hair revealing collars and cuffs of masculinized tailoring, from Berenice Abbott (Figure I.3), indexing the sartorial codes of an emerging though still crucially ambiguous lesbian identity and aligning herself with both avant-garde, New Woman fashion and what would become an increasingly intelligible and pathologized mannish lesbian visibility.[54] Moreover, much of her work incorporates aesthetic strategies that other women artists and writers were using at the time to create space for the female sexual dissidents not being accommodated by the modern movement of which, as Constant reminds us, Gray was so consistently critical. If we begin to shift our critical framework, as feminist historians of modernism have argued we must, from an exclusive focus on the relationships that Gray and her work had with major male modernist movements and figures to looking at her life and work from another angle, one which includes the women whose aesthetic works and interests have been bracketed out of canonical modernist history, we can recognize that Gray was not quite so unprecedented as she has been made out to be and can better understand the implications of some of her work's differences from modern architecture.

"Pioneer lady" in context

She had always been a rather isolated figure

Joseph Rykwert[55]

While historians and biographers have noticed that most women in the female-dominated profession of interior decoration between 1890 and 1940 pursued same-sex intimate relationships, the significance that these sexual and social connections had on their professional lives has not yet been explored. As Peter McNeil explains,

If the matter of sexuality is ignored, then the social networks in which women moved, the possible source of commissions and alliances, are also obscured. Eileen Gray, for example, mixed in Paris circles which included Romaine Brooks, Gabrielle Bloch and her lover Loie Fuller, the singer Damia and Natalie Barney. Although Gray's biographer is coy regarding the designer's sexuality, the patronage of her lesbian associates undoubtedly assisted her venture, with Gabrielle Bloch taking charge of her business matters.[56]

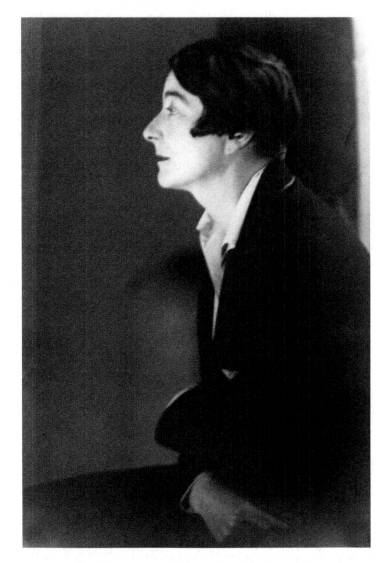

I.3 Gray, photograph by Berenice Abbott, 1926. Reproduced with the kind permission of the National Museum of Ireland.

Gray's client lists[57] from the 1920s as well as her biographer's account of this period between 1906 (when she moved permanently to Paris) and 1930 (when she closed her design shop) suggest that her sexual, social, professional and cultural life developed within a thriving Parisian arts community made up of largely non-heterosexual women which supported several well-known women writers, performers and visual artists. Following contemporary feminist scholarship on literary and artistic modernism, several of these

women who were excluded from or at best marginal to the history of high modernism can now be seen to represent a sort of alternate modernist history with concepts and practices of what we now recognize as lesbianism operating as a central organizing feature.[58] Visual artists such as Romaine Brooks, Gluck, Marcel Moore and Claude Cahun, writers such as Djuna Barnes, Gertrude Stein, Radclyffe Hall, Natalie Barney, Renee Vivien and Lucy Delarus-Mardrus, and performers like Ida Rubinstein, Loie Fuller and Damia each constituted an important aspect of Gray's social life and as client, friend, acquaintance or lover formed a major part of the personal and professional context from which Gray's aesthetic projects came. While Gray's involvement in this network of women has been consistently downplayed in favour of extensive explorations of her relationship to networks of better-known men, I will argue that her "lesbian associates" were significant not only to her business venture but in shaping the aesthetic concerns that would occupy her entire career.

McNeil observes that Gray's biographer "is coy" about her sexuality, but one can be thankful that he suggests the issue at all, as until Adam, the only relationships that architectural historians found necessary to mention were those she had with men. Even in sympathetic reviews by historians like Joseph Rykwert, Stewart Johnson and Reyner Banham, Gray's aesthetic career is represented as a steady progression from painting through design to properly modernist architecture, with each successive phase a result of her relationship to men.[59] While Peter Adam's influential biography, first published in 1986 and again in 2000, is the first to introduce women into the story of Gray's career, these relationships are nonetheless minimized and marginalized in the larger story he wants to tell of Gray and the men who loved or spurned her. In describing Gray's early years in Paris, at the Colarossi and Julian schools of art, Adam takes as his point of reference Gray's good looks and her many male suitors, situating her in a sort of heterosexual romance narrative from the start. He introduces our heroine as "tall and always thin.... Her face was beautiful, with flawless complexion and clear blue eyes,"[60] and while it appears that Gray moved to Paris with a female lover, Adam is quick to contain this possible lesbian narrative disruption by fixating on a long list of male admirers. Gray moved to Paris with Kathleen Bruce and Jessie Gavin, and in Bruce's published memoirs she suggests that Gavin and Gray were lovers from early on. After introducing Gavin as "tall," "dark" and "pretty," and Gray as "remote," "vague," "wonderful" and potentially "mad,"[61] Bruce explains:

I was never at all at ease with them, but it was many years before I discovered why.... One evening a tall, thin, shy, nice-looking youth in corduroys and a Norfolk jacket came in. This was [Gavin], with a wig and a slightly blackened moustache. "We'll go to places and play chess in a café, I can take you to places where you can't go without a man."[62]

While the source of Bruce's dis-ease is not immediately clear, we might read her nickname for Gray, "Hermione," as the subtext of this cryptic little story. It seems possible that Bruce is using the name as a discreet allusion to the lesbian heroine, Hermione, of H.D.'s autobiographical novel *Asphodel*, written between 1921 and 1922. While Adam cannot fathom the origin or resonance of the name, he does recognize the implications of Gavin's and Gray's public cross-dressing, suggesting that "the romantic affection between Jessie and Eileen had grown into something more serious."[63] However, Adam immediately minimizes the sexual significance of this "more or less innocent game of male disguises,"[64] and invents the pretext of a heterosexual female rivalry rather than allow this gender transgression to signify the sexual transgression that Bruce's discomfort implies.

That is, it was not Gray's challenge to early twentieth-century gender and sexual orthodoxy, Adam assures us, but the presence of a coveted male love interest that accounted for the real rift between Bruce and Gray: "[Her] unorthodox behavior was not the only reason that Kathleen [Bruce] fell out with Eileen. Kathleen was very much in love with her cousin Henry ... and [he] soon became enamored of Eileen."[65] Adam, thus, quickly cuts short the potential lesbian story of Gray's early years in Paris to focus on the many heterosexual romances that might have been. He writes that "Henry was not the only admirer of this beautiful quiet girl"[66] and spends the rest of the chapter entitled "To Paris" describing in detail the men in Gray's life. According to Adam, Gray rejected the amorous advances of a long list of attractive and lovingly described male admirers (Gerald Kelly, Aleister Crowley, Wyndham Lewis, Paul Leautaud, Henry Savage Landor, Geoffrey Brailsford, Everard Colthrope, Mr. Lestrop, Stephen Haweis) in her "eccentric" quest for "freedom."[67] However, there remain traces in Adam's story, even as he forecloses the possibility, of a more queer than eccentric disinterest in heterosexuality.

While Adam distances Gray from her neighbors, Natalie Barney and Gertrude Stein, insisting that "Eileen did not care for these powerful lesbian ladies,"[68] it is clear that she did care for several of the "lesbian ladies" associated with the subcultural communities that Barney and Stein came to represent. As she fended off her many male suitors, she continued to frequent nightclubs, dancing all night with her partner Jessie Gavin, "in her brilliant male disguise," who began to call herself Jack.[69] It was perhaps during these drag nights out that she met the dancer Loie Fuller and her then lover and manager Gabrielle (Gaby) Bloch. Adam notes that Gray met Bloch during "these prewar years ... and her life became intertwined with Gaby's for the next fifteen years."[70] In striking contrast to his extended expositions on Gray's male non-lovers, Adam is discreet about Gray's relationship with Bloch, saying only that "Gaby's reserve struck a chord Eileen knew well" and noting that the two travelled ("to America") and dined out together regularly.[71]

Adam indicates neither when their relationship began, nor when it ended, but notes from Gray's archives suggest that they may have been in contact up to the 1960s.[72] We might speculate that Gray would eventually come to meet the famous café-club chanteuse Marie-Louise Damien (Damia) through Gaby's connections in the theatrical world, but by the time Gray and Damia became lovers Gray was already thoroughly connected to the lesbian subculture that Damia occupied. Adam writes that "[Aleister] Crowley continued to send [Gray] all his books" but notes that "she tore out the dedications,"[73] as her cultural choices began to suggest a particular community of interest. She read and collected the serial novels of Colette, kept a dedicated and suggestively kissed copy of a book of poems by Lucie Delarue-Mardrus (a one-time lover of Barney's) and read and transcribed passages from the famously bisexual poet the Comtesse Anna de Noailles[74] – all of whom were regulars at Barney's Friday salons. Adam writes that Gray was an infrequent guest at Barney's and explains that "Eileen casually knew several of these" lesbian salon regulars (he names Djuna Barnes, Janet Flanner, Solita Solano and Dolly Wilde), but he claims that "their passion and domesticity were not for Eileen."[75] This is a peculiar assertion when we consider that Gray had fallen in love with a Parisian chanteuse, the melodramatic symbol of passion in French clubs and films throughout the 1920s,[76] and that domesticity was the space and concept to which she dedicated her life's work. Perhaps Gray did, indeed, have reservations about some among this loosely bound lesbian cultural community, but Barney apparently included her in it: in her 1929 *Aventures de l'esprit* she set a place for Gray at her table of esteemed friends,[77] and in 1919 and 1920 she sent Gray two books of her poetry, each with personal inscriptions, which Gray kept, with the Delarue-Mardrus poems, throughout her life.[78]

By the time Gray opened her storefront, Jean Désert, in 1922, her lovers, friends, colleagues and clients all came from or at least took part in the cultural networks organized around those "powerful lesbian ladies" who, Adam assures us, Gray had never really cared for.[79] Her business partner was Evelyn Wyld, who was in charge of the most profitable aspect of the business, her carpet production. Wyld oversaw the weaving of Gray's designs and would eventually continue her own design business with her lover Elizabeth Eyre de Lanux when Jean Désert closed in 1930.[80] Gaby Bloch left Loie Fuller and continued as Gray's general business manager well after their romantic relationship ended and Gray was involved with Damia. Gray's rugs were bought by her friend, the painter and sometimes interior decorator Romaine Brooks, who was also Barney's life-long lover. Gray designed at least two pieces of furniture specifically for Damia, a lacquer mirror and an uncharacteristically ornate serpentine chair.[81] The first major article on Gray's work to be published in France came in 1922 from another of Barney's lovers, the writer Elisabeth de Gramont (Duchesse de Clermont-Tonnerre),[82]

for whom Gray had worked, with Wyld, Brooks, Gertrude Stein and Alice B. Toklas, driving ambulance in World War I.

Adam mentions all of these relationships but dismisses them as a sort of phase that Gray grew out of: "as always, Eileen soon got bored of the sort of life Damia led, and she stopped seeing her and her friends."[83] Adam suggests that the real reason why Gray grew bored of her lover and lesbian friends was that she "was infatuated with the very persuasive, good-looking Jean [Badovici]."[84] According to Adam, it was not her relationships with the lesbian ladies, occupying the first 20 years of her career, but her encounter with a "handsome," "enthusiastic" and "ambitious" "young architect", Jean Badovici, that was truly most significant for Gray: "Their relationship marked Eileen deeply, personally and professionally, and shifted her entire life into unforeseen directions."[85] However, try as he might, Adam does not fully succeed in making of Gray's life story a heterosexual narrative line. We are left wondering just how deeply Gray was marked by Evelyn Wyld, who Adam claims had motivated Gray to design and weave rugs in the first place, or by Bloch, who he suggests is the reason why Gray opened Jean Désert, or by Damia, who he admits had inspired her lacquer chairs and a set of rugs ("D" and "E," after Damia and Eileen) in homage to their relationship,[86] or by any others among this "boring" lesbian arts community.

Adam takes every opportunity to deny any significant link between the development of Gray's aesthetic and the female colleagues, clients, friends and lovers who defined the development of her career. I want to argue that such a link exists and can be seen as partly responsible for the difficulties that critics have had placing Gray's work into a recognizable modern movement. Rykwert and Johnson attempt to secure her place among the architectural "Modern Masters," though they both admit that she was primarily a designer and that "she explicitly dissociates herself" from much modern architectural doctrine, voicing a perspective on modernist architecture that was "unusual for its time."[87] Banham writes that "her work never aligned with either the International Modern style or the tolerated deviations like Expressionism"[88] and that despite the gallant critical gestures of the men around her, she was so marginal to modernism that "she didn't even become a footnote."[89] Instead, her work was "part of a personal style and philosophy of interior design which was ... too rich for the punditry of the time to take."[90] Indeed, when we turn to Gray's built and written work, only with great effort can we fail to notice its critical differences from the works and theories that have come to represent canonical modern architectural and design history. However, when read from a shifted perspective which allows gender and sexuality to enter the critical picture, we can begin to see that Gray's "too rich" style may have been less personal than cultural, influenced by and contributing to aesthetic strategies being cultivated by other non-heterosexual women artists and writers at the time.

Re-viewing Gray's work

Art is not just the expression of abstract relationships; it must also encapsulate the most tangible relations, the most intimate needs of subjective life.

[L'art n'est pas dans l'expression de rapports abstraits; il doit enfermer aussi l'expression des rapports les plus concrets, des exigences les plus secrètes de la vie subjective.]

Eileen Gray[91]

Throughout Gray's career, her work was designed to accommodate the most *secrètes* or intimate needs of subjective life, and when it is considered within the shifted historical framework that I am proposing, we can begin to recognize that this was a subject being consistently left out of modern architecture but comparably accommodated by other women's aesthetic works at the time. Her lacquer work and interior design schemes from the 1910s and early 1920s, for example her renovation and redecoration of Madame Mathieu-Lévy's rue de Lota flat between 1917 and 1924 and the Monte Carlo room that she showed at the XIV Salon des Artistes Décorateurs in 1923 (Figure I.4), contain elements of De Stijl-like, cubist-inspired abstraction (the block screens used in both, the geometrical designs of both the rug and sofa frame in the Monte Carlo room) which seem to be overwhelmed by the richly textured sensuality of materials (lacquer, inlaid with silver and mother-of-pearl arabesques at the rue de Lota apartment, thick, hand-dyed, hand-woven wool carpets, throw rugs and blankets made of fur and silk). This evocative sensuality prompted early reviewers to note that "willingly or unwillingly ... one is reminded of Baudelaire when one sees those tragic settings which Madame Eileen Grey [sic] creates with artistic refinement and taste, 'syncopated' black velvet wall hangings, low, wide beds, precious furs, unusual objects which are all wonderful.'"[92] And years later, in 1972, Rykwert compares Gray's early work to another prominent nineteenth-century decadent artist, Aubrey Beardsley.[93] As I argue in Chapter 1, "willingly or unwillingly," reviewers in the 1920s invariably associated Gray's work with the decadence that served, as Elaine Showalter explains, as a "fin-de-siècle euphemism for homosexuality,"[94] and which stood by the 1920s for the aesthetic, moral, physical and sexual degeneration that modern architecture was explicitly designed to cure. Moreover, as I explain further in Chapter 2, feminist historians have shown that by the early part of the twentieth century, women artists and writers were strategically appropriating elements of by then archaic nineteenth-century decadent aesthetics as means for imagining female same-sex desire – as an aesthetic strategy, Bridget Elliott and Jo-Ann Wallace argue, for "not simply reflecting or reporting their lives or those of their friends, but making them visible – that is, making their lesbianism visible – by adapting literary and visual conventions which were already coded 'homosexual.'"[95]

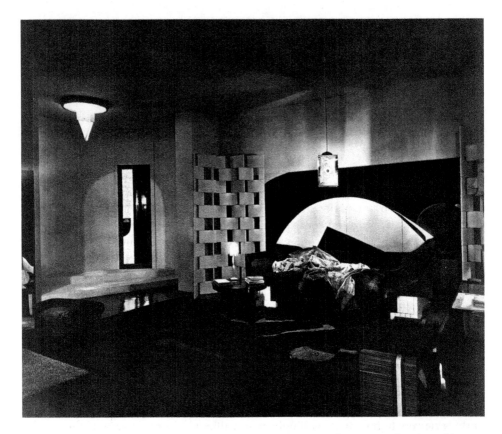

I.4 "Boudoir de Monte Carlo," XIV Salon des Artistes Décorateurs: showing white block screens, beside sofa with black and white frame, piled with silk and fur blankets, on white, black and grey wool rug, lit by parchment lamps, all designed by Gray, 1923. Reproduced with the kind permission of the National Museum of Ireland.

By 1929, when Gray had completed E.1027, her first intricately designed built house, she published a theoretical explanation and detailed description of her work which gives us insight into the carefully conceived critique of modern architecture and design suggested by her earlier works and developed at E.1027. By the 1920s, modern architecture conceived of itself not only as, in Le Corbusier's terms, a "house-tool"[96] (*machine à habiter*) but also as a medical tool: as Colomina explains, "modern architecture was unproblematically understood as a kind of medical equipment, a mechanism for protecting and enhancing the body."[97] Modern architects were in the business of making new and healthy bodies, and in 1925, Le Corbusier advocated that "we concede to decorative art the care of our sentient being."[98] In 1929, Eileen Gray agrees. She writes, however, that this "is not only a matter of constructing beautiful arrangements of lines, but above all *dwellings for people*."[99]

For Gray this means that architecture "should respond to human needs and the exigencies of individual life, and it should ensure calm and intimacy."[100] For Le Corbusier, it means "*to love purity!*"[101] Rather than calm and intimacy, Le Corbusier argues, the sentient being needs clarity: "Every citizen is required to replace his hangings, his damasks, his wall-papers, his stencils, with a plain coat of white ripolin. *His home* is made clean. There are no more dirty, dark corners. *Everything is shown as it is.*"[102] Gray laments that avant-garde architecture is obsessed with the external "at the expense of the interior, as if a house should be conceived for the pleasure of the eye more than for the well-being of its inhabitants."[103] For Le Corbusier, after purging, whitewashing and clarifying (for the pleasure of the eye), "then comes *inner* cleanness, for the course adopted leads to refusal to allow anything at all which is not correct, authorised, intended, desired, thought-out: no action before thought."[104] "Yes!" Gray writes, "We will be killed by hygiene[105].... No, the avant-garde is intoxicated by mechanization.... It is overintellectualized [sic]: an art of thought and calculation, but lacking in heart."[106] For her, the building's design must follow instead from "interpreting the desires, passions and tastes of the individual," geared towards "intimate needs" and "individual pleasures."[107] By 1929, Gray wants us to know that she is building for a different sort of sentient being than that conceived by "the avant-garde" in general, and by Le Corbusier in particular.

Despite Gray having published only this one short written explanation of her work, wherein she appears to be emphasizing her philosophical differences from avant-garde modern architecture and design, those who have taken interest in her since the 1960s have largely chosen to ignore her differences in their attempts to establish her position within the movements she criticized. If we take Gray's written work seriously, we need to reconsider her design and architecture as an ongoing critical project vis-à-vis modernist aesthetic movements, or what she considered the "modern avant-garde". And if we take seriously her career-long investment in what she calls the "secret" or intimate needs, desires, tastes, passions and pleasures of the individual, evident in the decadent aesthetics of her early work and continued commitment to privacy and sensuality in her built architecture, we can begin to recognize the ways in which Gray's critical project overlapped with those undertaken by other women artists and writers at the time. While she was hesitant to pursue the wider cultural implications of her own argument, Constant's work nonetheless opens the door to such recognition. Constant writes that "Gray's focus on the kinaesthetic, tactile, and sensual potential of architecture and furniture ... was unprecedented in Modern-Movement discourse."[108] She argues that Gray's was a mix of architectural avant-garde and French luxury aesthetics, noting that "the French term *luxe* implies voluptuousness and eroticism as well as costliness; it has to do with desire."[109] When read in the context of other women's work on sexually dissident desires and domesticities at the time, however, Gray's sensual aesthetics appear not quite so unprecedented.

In order to understand better both why Gray was engaged in an ongoing critique of modern architecture and what her built alternatives may have meant at the time, we need to admit considerations of sexuality into our analyses of her work. And with recent feminist literature pointing to this critical gap as the promising site of future scholarship on Gray, a historically and culturally specific, comprehensive analysis of the significance of both gender and sexuality to Gray's work is now long overdue. My research, therefore, aims to fill this now glaring gap in the literature.

Chapter 1 argues that at stake in domestic architecture and design at the time was not simply the construction of new and healthy modernized buildings but the constitution of new healthy occupants and subjects. Gray's choice, then, to work in avant-garde interior design and architecture at the start of the twentieth century brought her into a field of discourse on healthy modern subjectivity, which was fundamentally about regulating bodies and sexuality. Establishing that debates about domestic architecture and design were importantly debates about modern bodies and subjects provides the framework for the following three chapters to explain how and why Gray and her contemporaries worked on domestic space to design possibilities for dwelling, or being, outside the bounds of conventional heterosexuality. Chapters 2 to 4 provide specific case studies focusing on Gray's early lacquer work (1912–14) and Romaine Brooks' earliest nude paintings from 1910 (Chapter 2); Gray's first built house, E.1027 (1928), in relation to the content and cultural impact of Radclyffe Hall's 1928 novel *The Well of Loneliness* (Chapter 3); and finally Gray's extremely private house Tempe à Pailla (1932–34) in comparison to Djuna Barnes' opaque and famously non-communicative 1936 novel, *Nightwood* (Chapter 4). Taken together, the four chapters show that as women's various forms of resistance to normative heterosexual femininity were being reduced to a set of recognizable features, desires and behaviours understood to bespeak a singular sexual identity, women like Gray, Brooks, Hall and Barnes seemed intent on preserving sensualities, intimacies, interiorities, modes of living and being not easily subject to the regulatory impulses of identitarian logic.

I have chosen to read Gray's architecture and design in relation to Romaine Brooks, Radclyffe Hall, Djuna Barnes and their works for three interrelated reasons: (1) they have all come to be linked with the rich female sexual subculture of Gray's Left Bank neighbourhood in Paris during the interwar years and connected to its cultural hub, Natalie Barney's salon, located in the house around the corner from Gray's apartment where they all may have met; (2) all three women and their aesthetic works contributed in different ways to changing images and understandings of modern, sexually dissident, female subjectivities and cultures; and (3) these contributions were developed in their aesthetic work through engagements with domestic space. That is, we can see them working out alternate ways of being women and figuring desire by

re-imagining domestic space, design and architecture. Reconsidering Gray's work, from her earliest lacquer screens (ca. 1912–15) to her two most carefully designed built houses, E.1027 (1928) and Tempe à Pailla (1934), in light of aesthetic works by Brooks, Hall and Barnes lets us see the ways in which Gray's differences from modern architecture contributed to a larger critical project invested in creating space, visual, literary, imaginary and architectural, for non-heterosexual female subjects.

Eileen Gray and the Design of Sapphic Modernity hopes to reorient future scholarship on Gray permanently and to contribute to larger interdisciplinary critical reconsiderations of the modernist cultural history of sexuality in three main ways: (1) it shows that modernist architecture and interior design were understood by Gray and her female contemporaries as critical sites for the regulation and contestation of gender and sexuality, and so form important parts of the cultural history of female sexual dissidence; (2) it shows that the existing framework of lesbian history, with its troubling propensity to read contemporary sexual identities back onto historical subjects, is insufficient to account for the complex combinations of female non-heterosexuality and European modernity at the start of the twentieth century; (3) it shows that at a time when communication technologies were playing such a central role in creating both modernist architectural and lesbian identities, sapphic modernists' resistance to communication needs to be understood as part of an effort to cultivate those innovations in domestic architecture and design, as well as gender and sexuality, which were being foreclosed by such reductive identities. My book hopes to shows that sapphic modernists were designing domestic spaces for a non-identitarian and incommunicable moment of possibility before lesbian. This was both a historical moment before the 1928 obscenity trials of Radclyffe Hall's *The Well of Loneliness* and a cultural or conceptual moment before the various visual and erotic possibilities of female masculinities and dissident sexualities were reduced to one fixed and pathologized sexual identity.

Notes

1. See especially Laura Doan, *Fashioning Sapphism: The Origins of a Modern English Lesbian Culture* (New York: Columbia University Press, 2001).

2. See especially Mark Wigley, *White Walls, Designer Dresses: The Fashioning of Modern Architecture* (Cambridge, MA: The MIT Press, 1995).

3. Peter Adam, *Eileen Gray, Architect, Designer: A Biography* (New York: Harry N. Abrams, Inc., 2000), 311.

4. Beatriz Colomina, "War on Architecture," *Assemblage*, no. 20 (1993), 28–29.

5. Beatriz Colomina, "Battle Lines: E.1027," *Center*, no. 9 (1995), 22–31; B. Colomina, "Battle Lines: E.1027," in *The Architect: Reconstructing her Practice*, F. Hughes, ed. (Cambridge, MA: The MIT Press, 1996), 2–25; Beatriz Colomina, "Battle Lines: E.1027," in *The Sex of Architecture*, Diana Agrest, Patricia Conway and Leslie Kanes Weisman, eds (New York: Harry N. Abrams, Inc., 1996), 167–190.

Colomina also included an excerpt of this article in *Privacy and Publicity: Modern Architecture as Mass Media* (1994) (Cambridge, MA: The MIT Press, 1998), 84–88; moreover, as Colomina told me in conversation on July 11, 2004, the article has apparently been translated into at least four different languages. I have been able to find two published translations: "Lignes de bataille: E.1027," *Revue d'esthétique*, vol. 29 (1996), 135–142; "Frentes de batalla: E.1027," *Zehar*, vol. 44 (2000), 8–13.

6. Colomina, "Battle Lines," in *The Sex of Architecture*, 173. This passage is also included in *Privacy and Publicity*, 355, n. 13.

7. Photos of Le Corbusier's murals at E.1027 are published in *L'architecture d'aujourd'hui* (April 1948), with no mention of Gray. In an article entitled "Le Corbusier, muraliste," published in *Interiors* (June 1948), the caption to the murals at Roquebrune-Cap Martin not only leaves out Gray's name, but locates them "in a house designed by Le Corbusier and P. Jeanneret." In several publications between 1944 and 1981, E.1027 and its furnishings are attributed to Le Corbusier and/or Badovici (see Adam, *Eileen Gray*, 334–335).

8. Lynne Walker, "Architecture and Reputation: Eileen Gray, Gender, and Modernism," in *Women's Places: Architecture and Design 1860–1960*, Brenda Martin and Penny Sparke, eds (London and New York: Routledge, Taylor & Francis Group, 2003), 88, 89.

9. Caroline Constant, "E.1027: The Nonheroic Modernism of Eileen Gray," *The Journal of the Society of Architectural Historians*, vol. 53, no. 3 (September 1994), 265–279; Caroline Constant, ed., *Eileen Gray: An Architecture for All Senses* (Wasmuth: Harvard University Graduate School of Design, 1996); Caroline Constant, *Eileen Gray* (London: Phaidon Press Limited, 2000).

10. Walker, "Architecture and Reputation," 102, 88.

11. Colomina writes, "[t]his extraordinary scene, a defacement of Gray's architecture, was perhaps even an effacement of her sexuality" ("Battle Lines," in *The Sex of Architecture*, 171).

12. Shari Benstock, "Expatriate Sapphic Modernism: Entering Literary History," in *Lesbian Texts and Contexts: Radical Revisions*, Karla Jay and Joanne Glasgow, eds (New York: New York University Press, 1990), 183–203; Whitney Chadwick and Tirza True Latimer, eds, *The Modern Woman Revisited: Paris between the Wars* (New Brunswick, NJ, and London: Rutgers University Press, 2003); Doan, *Fashioning Sapphism*; Laura Doan and Jane Garrity, eds, *Sapphic Modernities: Sexuality, Women and National Culture* (New York: Palgrave Macmillan, 2006).

13. Benstock, "Expatriate Sapphic Modernism: Entering Literary History," 183; Shari Benstock, *Women of the Left Bank: Paris, 1900–1940* (Austin: University of Texas Press, 1986).

14. Doan, *Fashioning Sapphism*, xvii–xviii.

15. Doan and Garrity, eds, *Sapphic Modernities*.

16. Bridget Elliott, "Art Deco Hybridity, Interior Design and Sexuality between the Wars: Two Double Acts: Phyllis Barron and Dorothy Larcher / Eyre de Lanux and Evelyn Wyld," in *Sapphic Modernities*, Doan and Garrity, eds, 109–129.

17. Ibid., 110.

18. Ibid.

19. Colomina, *Privacy and Publicity*; Wigley, *White Walls*.

20. Adam, *Eileen Gray*; Constant, *Eileen Gray*.

21. Constant, *Eileen Gray*, 9–11.

22. Ibid., 7.

23. Constant, "Nonheroic Modernism," 265.

24. Constant, *Eileen Gray*, 8.

25. Sylvia Lavin, "Colomina's Web: Reply to Beatriz Colomina," in *The Sex of Architecture*, Diana Agrest, Patricia Conway and Leslie Kanes Weisman, eds (New York: Harry N. Abrams, Inc., 1996), 188.

26. Ibid., 184.

27. Walker, "Architecture and Reputation," 97.

28. Ibid., 89, citing Griselda Pollock, *Differencing the Canon: Feminist Desire and the Writing of Art's Histories* (London: Routledge, 1999), 115.

29. Walker, "Architecture and Reputation," 104.
30. Constant, *Eileen Gray*, 11.
31. Lesbian History Group, *Not a Passing Phase: Reclaiming Lesbians in History, 1840–1985* (London: Women's Press, 1993), 3.
32. Gray published two articles: one entitled simply "Description" and the other, in the form of a dialogue between herself and Jean Badovici, entitled "De l'éclecticisme au doute" ("From Eclecticism to Doubt"), in "Maison en bord de mer," *L'architecture vivante*, Winter 1929, 17–35. Unless otherwise noted, all further references to Gray's published writings will come from the translation provided in Constant, *Eileen Gray*, 238–244.
33. Acquired by the Royal Institute of British Architects Line Drawing and Archives Collection as well as the Victoria and Albert Museum Archive of Art and Design.
34. While Collins Barracks at the National Museum of Ireland now holds the most extensive Eileen Gray archival collection, Gray scholars express considerable, though unofficial, doubt that Adam has indeed sent all of his pertinent Gray archive to the museum.
35. Walker, "Architecture and Reputation," 104.
36. Colomina, "Battle Lines," in *The Sex of Architecture*, 171.
37. Doan, *Fashioning Sapphism*, 63.
38. Gray, letter to Sheila de Bretteville (1973), quoted in Adam, *Eileen Gray*, 373–374.
39. Adam, *Eileen Gray*, 373, 374.
40. Constant, *Eileen Gray*, 13.
41. Walker, "Architecture and Reputation," 104.
42. Bridget Elliott, "Housing the Work: Women Artists, Modernism and the *maison d'artiste*: Eileen Gray, Romaine Brooks and Gluck," in *Women Artists and the Decorative Arts, 1880–1935: The Gender of Ornament*, Bridget Elliott, and Janice Helland, eds (Aldershot, England, and Burlington, VT: Ashgate, 2002): 177.
43. Ibid., 178.
44. Ibid., 177.
45. Whitney Chadwick and Tirza True Latimer, Introduction to *The Modern Woman Revisited*, Whitney Chadwick and Tirza True Latimer, eds), xx.
46. *The Modern Woman Revisited*. See especially Chadwick and Latimer, "Becoming Modern: Gender and Sexual Identity after World War I," 3–19; Bridget Elliott, "Deconsecrating Modernism: Allegories of Regeneration in Brooks and Picasso," 35–51; Paula Birnbaum, "Painting the Perverse: Tamara de Lempicka and the Modern Woman Artist," 95–107; Tirza True Latimer, "Looking Like a Lesbian: Portraiture and Sexual Identity in 1920s Paris," 127–143; Jennifer Shaw, "Singular Plural: Collaborative Self-Images in Claude Cahun's *Aveux non avenues*," 155–167; Joe Lucchesi, "'Something Hidden, Secret, and Eternal': Romaine Brooks, Radclyffe Hall, and the Lesbian Image in *The Forge*," 169–179.
47. Katarina Bonnevier, "A Queer Analysis of Eileen Gray's E.1027," in *Negotiating Domesticity: Spatial Productions of Gender in Modern Architecture*, Hilde Heynen and Gülsüm Baydar, eds (London and New York: Routledge, 2005), 162–180.
48. Ibid., 165.
49. Ibid.
50. Ibid., 166–167.
51. Adam, *Eileen Gray*, 45.
52. Constant, *Eileen Gray*, 9–10; Walker, "Architecture and Reputation," 104–105; Adam, *Eileen Gray*, 34, 68–70, 109–115; Peter McNeil, "Designing Women: Gender, Sexuality and the Interior Decorator, c.1890–1940," *Art History*, vol. 17, no. 4 (1994), 635.
53. For example, Le Corbusier's model house at the Pavillon de L'Esprit Nouveau (1925), Marcel Breuer's contribution to the Werkbund in Paris (1930) and Adolf Loos' Muller House in Prague (1930) all included separate rooms designated for the man and the woman of the house.

54. On this shift from masculinized New Woman chic to mannish lesbian identity, see especially Doan, *Fashioning Sapphism*.
55. Joseph Rykwert, "Eileen Gray: Pioneer of Design," *Architectural Review*, vol. 152, no. 910 (December 1972), 360.
56. McNeil, "Designing Women," 635.
57. See address book entitled "Galerie Jean Désert Clients" in the Eileen Gray archive at the Victoria and Albert Museum, London, England.
58. On lesbian arts culture in early twentieth-century Paris, see first Shari Benstock's groundbreaking study of literary modernism, *Women of the Left Bank*. For more recent work, see Bridget Elliott and Jo-Ann Wallace, *Women Artists and Writers: Modernist (Im)positionings* (London and New York: Routledge, 1994), 31–55; Tirza True Latimer, *Women Together/Women Apart: Portraits of Lesbian Paris* (New Brunswick, NJ, and London: Rutgers University Press, 2005); and Chadwick and Latimer, eds, *The Modern Woman Revisited*
59. Joseph Rykwert goes to some pains to situate Gray among the "masters of her day." He indicates that "Eileen Gray like[Henri] Van de Velde and [Peter] Behrens, started as a painter"; that in 1922 she "met JJP Oud and some other Dutch architects"; that "soon after that she met Jean Badovici" who prompted her to architecture; that her work was matched by nothing "apart from the master's house at the Dessau Bauhaus"; and finally that her "'courageous' and "ground-breaking" "achievements" "can only be compared to the work of the three or four masters of her day" (Joseph Rykwert, "Un omaggio a Eileen Gray: pioniera del design," *Domus* (Milan), no. 469 (December 1968), 33). Stewart Johnson rehearses much of the same material in his short article celebrating this "Pioneer Lady." He associates her with "JJP Oud and other Dutch architects" and with Marcel Breuer, Ludwig Mies van der Rohe, Jean Badovici, Walter Gropius, Erich Mendelsohn, Frank Lloyd Wright and Le Corbusier. Despite connecting Gray to Le Corbusier first through their 1920s steel tube furniture, Johnson judges her comparable connection to Charlotte Perriand, who collaborated with Le Corbusier on those steel tube designs, to be not worth mentioning (Stewart Johnson, "Pioneer Lady," *Architectural Review*, vol. 152, no. 186 (August 1972), 125). Rykwert followed with two long biographical articles, carefully sidestepping any significant relationships that Gray may have had with women. He explains that "the idea of painting and drawing came quite naturally" since her "father was a painter", that her early work was "at first influenced by the linear qualities of [Aubrey] Beardsley" (Rykwert, "Pioneer of Design," 357), and that Jean Badovici made her familiar with "all the latest developments of the modern movement which Eileen Gray herself probably lacked" ("Eileen Gray: Two Houses and an Interior, 1926–1933," *Perspecta*, vol. 13, no. 14 (1972), 68). The (hetero)sexist implications of Rykwert and Stewart's reviews before him, which reduce Gray's professional significance to her relationships with prominent men, are taken to their logical extensions by Banham. The special issue of *Architecture vivante* dedicated to E.1027 is reduced to a gesture of Badovici's professional gallantry, and the house itself becomes a nameless vessel whose only historical significance is the result of its operating as receptacle for Le Corbusier's famed expression (Reyner Banham, "Nostalgia for Style," *New Society*, February 1973, 249).
60. Adam, *Eileen Gray*, 27.
61. Kathleen Bruce (Lady Scott), *Self-Portrait of an Artist* (London: Hazell Watson & Viney, 1949), 25.
62. Ibid., 25, 36, as quoted in Adam, *Eileen Gray*, 34.
63. Adam, *Eileen Gray*, 34.
64. Ibid.
65. Ibid.
66. Ibid.
67. Ibid., 34–45.
68. Ibid., 109.
69. Ibid., 40.
70. Ibid., 68–69.
71. Ibid., 69.
72. In the late 1950s, Gray's handwriting became so shaky that she took to typing her personal notes, lists and letters. Among several typed but undated notes, I found a list entitled "things to tell

Prunella [Clough, her niece, to whom she was very close]," which dealt with "disposing" of her belongings, and includes "Books those belonging to Gaby Bloch." While there is no way to be sure, it seems likely that Gray wrote this list in the 1960s at the earliest, and suggests that she still had some contact with Bloch (if only through her books). Eileen Gray archive, Collins Barracks, National Museum of Ireland, Dublin.

73. Adam, *Eileen Gray*, 44.

74. On two separate sheets of paper, Gray transcribed: "Il me semble que le ciel me questionne; etonné. Je me retourne pour répondre, mais dans toute l'espace Je ne retrouve que la longue nuit bleue de ton regard. Anna de Noailles." Eileen Gray archive, Collins Barracks, National Museum of Ireland.

75. Adam, *Eileen Gray*, 109.

76. For more on Damia's role in 1920s French popular culture, see Kelly Conway, *The Chanteuse at the City Limits: Femininity, Paris and the Cinema*, Ph.D. dissertation, University of California, Los Angeles (Ann Arbor: UMI Dissertation Publishing, 1999).

77. See the frontisleaf to Natalie Barney, *Aventures de l'esprit* (Paris: Éditions Émile-Paul Frères, 1929).

78. Books of poetry by Barney and Delarue-Mardrus are among her very few books in the Eileen Gray archive, Collins Barracks, National Museum of Ireland.

79. See the address book entitled "Galerie Jean Désert Clients" in the Eileen Gray archive at the Victoria and Albert Museum.

80. For more on Wyld's work with Eyre de Lanux after the closing of Jean Désert, see Isabelle Anscombe, "Expatriates in Paris: Eileen Gray, Evelyn Wyld and Eyre de Lanux," *Apollo*, vol. 115, no. 240 (February 1982), 117–118.

81. Receipts for Damia's purchases from Jean Désert are held in the Eileen Gray archive at the Victoria and Albert Museum.

82. Elisabeth de Clermont-Tonnerre, "Les laques d'Eileen Gray," *Feuillets d'art*, no. 3 (March 1922); republished in English as "The Laquer [sic] Work of Miss Eileen Gray," *The Living Arts*, no. 3 (March 1922), 147–148.

83. Adam, *Eileen Gray*, 115.

84. Ibid., 172.

85. Ibid., 149.

86. Ibid., 161.

87. Rykwert, "Two Houses," 69.

88. Banham, "Nostalgia," 249.

89. Ibid., 248.

90. Ibid., 249.

91. Gray, "From Eclecticism to Doubt," in Constant, *Eileen Gray*, 239 ("De l'éclecticisme au doute," 19).

92. Guillaume Janneau, *Art et décoration* (1924), as quoted in Adam, *Eileen Gray*, 140.

93. Gray "was at first influenced by the linear qualities of Beardsley" (Rykwert, "Pioneer of Design," 357).

94. Elaine Showalter, *Sexual Anarchy: Gender and Culture at the Fin de Siècle* (New York: Viking, 1990), 171.

95. Elliott and Wallace, *Women Artists and Writers*, 39.

96. Le Corbusier, *Towards a New Architecture* (1923), F. Etchells, trans. (New York: Dover Publications, 1986), 277.

97. Beatriz Colomina, "The Medical Body in Modern Architecture," *Daidalos: Architektur, Kunst, Kultur*, 64 (1997), 61.

98. Le Corbusier, *The Decorative Art of Today* (1925) (Cambridge, MA: The MIT Press, 1987), xxvi.

99. Gray, "Description," in Constant, *Eileen Gray*, 240.

100. Ibid., 240.
101. Le Corbusier, *The Decorative Art*, 188, italics in original.
102. Ibid., italics in original.
103. Gray, "Description," in Constant, *Eileen Gray*, 240.
104. Le Corbusier, *The Decorative Art*, 188.
105. Gray, trans. in Constant, ed., *An Architecture*, 70. In the original, Gray writes: "De l'hygiène à en mourir!" This 1996 translation seems more accurate than the 2000 one, which reads: "Hygiene to bore us to death!" (Gray, "From Eclecticism to Doubt," in Constant, *Eileen Gray*, 239).
106. Gray, "From Eclecticism to Doubt," in Constant, *Eileen Gray*, 239.
107. Ibid., 238, 239.
108. Constant, *Eileen Gray*, 7.
109. Ibid.

1

Decadent perversions and healthy bodies in modern architecture

> We are to be pitied for living in unworthy houses, since they ruin our health and our *morale*.... Let us purge our houses.
>
> Le Corbusier[1]

> Willingly or unwillingly ... one is reminded of Baudelaire when one sees those tragic settings which Madame Eileen Grey [sic] creates with artistic refinement and taste, "syncopated" black velvet wall hangings, low, wide beds, precious furs, unusual objects which are all wonderful
>
> Guillaume Janneau[2]

That early twentieth-century modern architects and designers were interested in reforming more than just a building's shape and style is perhaps so obvious now as not to need saying. The sheer volume of modernist architectural theory, let alone its utopic and revolutionary tenor, points to the fact that there was more at stake in debates about buildings, furnishings and their design than style alone. "It is by now a commonplace to point out that ... [modern architects] sought above all to reform the occupants of their architecture."[3] As Steven Mansbach put it, "their objective was not to create a new philosophy but to articulate a 'new vision' of a 'New Man.'"[4] Even just briefly skimming through the writings of the most influential architects of the twentieth century – from Piet Mondrian, Theo van Doesburg and J.P.P. Oud of the Dutch De Stijl, Adolf Loos and the Austrian Vienna Secession, and Peter Behrens and Walter Gropius of the German Werkbund and Bauhaus, to Le Corbusier in France – reveals that the founding texts of modernist architecture are consistently as much concerned with descriptions of a new kind of people and society as they are with new buildings or projects. While explaining the virtues of new abstract interior design, for example, Piet Mondrian exclaims, "Such rooms call for new people!" and states that ultimately, "to a new beauty corresponds a new man."[5] Theo van Doesburg argues that a new architecture, "[i]n France ... would mean a radical change in the way of life."[6] As the president of the Bauhaus, Walter Gropius explains that the new architecture and interior

design "aesthetic meets our material and psychological requirements alike,"[7] just as his teacher Peter Behrens, while president of the Werkbund, describes "the psychological delight in the useful and the functional."[8] As Mark Peach explains,

> According to modernists, not only architecture had lagged behind technological advances, but so had the society that utilized that architecture. The same technological inventions that were inexorably changing architecture would also change the users of that architecture as well. As envisioned by its proponents, modern architecture would not only incorporate and reflect technological innovation, it promised to reform and modify the architecture's occupants.[9]

Perhaps more than anything else, modern architecture and design was dedicated to the task of making these new occupants – that is, to making modern subjects better adapted to the increasingly hazardous demands of urban life.

Fundamental to these occupants' reform, moreover, was the idea of health. Beatriz Colomina argues that "The [modern] house is first and foremost a machine for health, a form of therapy."[10] Modern architecture was interested in making not only new modern occupants, but primarily technologically enhanced, high-performance healthy bodies. And the house was as much a form of physical as of psychological therapy. Sylvia Lavin concludes that since the start of the twentieth century, "architects had perhaps no choice but to become psychiatrists":

> From the work of architects such as Richard Neutra, who deliberately fashioned himself as a psychoanalyst, to the wider phenomenon of using architecture to ensure mental hygiene, to the establishment of environmental psychology, the discipline of architecture structured a world of object relations in which inanimate buildings assumed key roles in the emotional lives of the nonprofessional public while architects mediated this psychic organization.[11]

By the early twentieth century, a convergence of physical and psychological therapy enabled modern architects to imagine themselves, along with a nexus of legal and medical professionals (police, psychologists, sexologists), to be in the business of making healthy bodies. And at least since the nineteenth century, if we follow Michel Foucault's periodization, the importance of sex in definitions of health cannot be underestimated.[12] Particularly in post-World War I France, the promise of healthy, regenerative modern architecture gained currency in a climate of widespread anxiety around hetero-gender reconstruction. Post-war concerns about the rapid social and cultural changes of modernity tended to be expressed and experienced in France as profound concerns about the loss of "traditional" femininity, and a sense of gender instability more generally. Moreover, as Mary Louise Roberts has pointed out, the stabilization of gender division was explicitly linked to French architecture.

In the quotation structuring the title and topic of Roberts' book, the French senator Pierre Drieu la Rochelle "used gender to signal a crisis in French culture after the war. The blurring of the boundary between 'male' and 'female' – a civilization without sexes – served as a primary referent for the ruin of civilization itself." Importantly, "[i]t also implied that gender, no less than architecture or literature, was one of the great cultural achievements of French civilization."[13] Indeed, gender and architecture were so ideologically intertwined at the time, especially in popular and powerful natalist discourses, that the achievement of "traditional" femininity crucially depended on the occupation of exclusively domestic spaces. In a historical and cultural context where the future of civilization and the health of a nation relied so heavily on the architecture of strict gender divisions and maternal femininity, the modern project of producing healthy bodies was also the project of regulating and producing hetero-gendered sexuality. Modern architecture was invested in making not only new occupants, but physically, psychologically and heterosexually healthy bodies, and as such needs to be understood as engaged in the constitution of new subjects. That is, modern architecture was not simply creating new places for people, but creating new people for their places.

While post-1960 readers have struggled to place Gray's work in the history of modern architecture, if we turn to the literature by her confused reviewers in the 1910s and 1920s we can see that Gray's place within the history of modern architecture and design has always been difficult to recognize. Just as Gray's work needs to be seen as a "critical engagement with contemporary approaches to the modern dwelling,"[14] it needs to be understood as a critical engagement with the kinds of occupants or subjects that modern dwellings sought to accommodate. I would like to suggest that the bewildering, sometimes disturbing, nearly unrecognizable places that Gray created were related to the bewildering, sometimes disturbing and nearly unrecognizable people that she was creating places for. Gray was not only invested in a critical commentary on modern architectural and design aesthetics, but in creating critically different places for those people who were left out of modern architecture and design.

This chapter is structured according to five main points. First, I show that Gray's reviewers in the 1920s struggled to make sense of her unusual aesthetics, and that they were confused and disturbed primarily by her use of sensual decadence in otherwise distinctly modern designs. Second, to account for why her contemporaries may have been so troubled by this decadence, or why her incorporation of nineteenth century aesthetic elements would have been so disturbing and suggestive of sexual perversions, I examine the history in France of the relationship between decadence and interior design to show that it was structured by nineteenth-century theories of degeneration. I show that by the early twentieth century, architects had adopted from the nineteenth century the faith that changes in interior design would have therapeutic

affects and that modern architecture was built as a medical technology to treat and cure the degeneration symptomized by decadence. Third, I focus on the work of Le Corbusier to show that by the 1920s modern architecture sold itself as a form of medically enhanced self-protection against the threat of degeneration, primarily conceived as the threat of the homosexual, non-productive or non-reproductive, decadent subject. Fourth, I argue that Gray's work was not interested in curing, suppressing or expelling this subject and show that her only published writings criticize modern architects precisely for their suppression of decadent elements and their neglect for the "relations ... [and] most intimate needs of subjective life"[15] that these decadent elements enable. Finally, I show that Gray was not alone in using decadent aesthetics to accommodate and enable the relations, intimate needs and lives of new subjects. Modern women writers, artists and performers were also capitalizing on the degenerate homosexual connotations of decadent aesthetics to create images, languages and spaces for female sexual dissidents. These women were just as much invested as modern architects and designers in developing not just new aesthetics but modern subjects, but as in Gray's case the subjects they were invested in were those that modern architecture was created to purge.

Looking back: reading Gray in the 1920s

Gray's first work to draw extensive critical attention was her "Boudoir de Monte Carlo" (1923), which was displayed at the Salon des Artistes Décorateurs (FI.4) and was described in both popular press and professional journals as "unsettling," "abnormal," "disquieting" and "maddening." *Art et décoration* (1923), for example, published a finally praising but confused and contradictory review:

Likewise behold the strange bedroom by Madame Eileen Gray in black and white: here and there are floor lamps, ceiling fittings, and wall fixtures with disquieting appearances, giving off flashes of striped light that spiral snake-like through openings like a blue eye with a dilated pupil, the faint light of which allows one to perceive a bed that is piled high with gold and silver cushions and surmounted by a cubist fresco. It is both droll and abnormal. Nevertheless it exudes an atmosphere the harmony of which one cannot deny, and which, despite its excesses, reveals an obvious talent.[16]

Another critic describes her unusual furniture, "even stranger lighting fixtures" and the bedroom's "melancholic but spiritual tone."[17] Both reviews suggest a kind of mysticism and decadence that would have been out of place by 1923, when the decorative arts in France were dominated by on the one hand a nostalgic nationalism in the style of Louis XV "classics" and on the other by a functionalism inspired by the German Bauhaus and popularized

in French by Le Corbusier as Purism, or the "machine aesthetic."[18] An unidentified press clipping describes Gray's room as not simply disquieting or strange, but "frightening, with its chrysalid lamps in parchment and wrapping paper; it is the room of the daughter of Doctor Caligari in all its horror."[19] In post-war France, this reference invoked both the then well-known horror film *The Cabinet of Doctor Caligari* (Robert Wiene, 1919) and the horror of German Expressionism in its set decoration. But critics struggling to place Gray's work into a recognizable movement were confounded by her genre-crossing, aesthetic mixed messages. The reviewer in *L'amour de l'art* was at a loss for words: "Willingly leaving aside the "bedroom/boudoir de Monte Carlo" of Madame Eileen Gray, an endeavor on which, with respect and despite all the tendencies that it manifests and some antipathy that it inspires in me, I prefer not to express an opinion."[20] Gray's work seems to have posed a critical challenge, and her reviewers can be seen struggling, and in this case failing, to make sense of her "frightening" "tendencies." Much of the challenge appears, as Banham suggests, to revolve around the difficulty critics faced with contextualizing the unfamiliar modernism of Gray's "too rich personal style."[21]

Given that avant-garde modernism was defining itself in polemic opposition to previous aesthetic movements, it seems curious that even those critics who sought to champion Gray's modernist vision commented on its unexpected romanticism. This is particularly peculiar in architectural and design discourses which were most adamantly rejecting styles associated in any way with nineteenth-century interior decoration – with its emphasis on domestic interiors, luxury and sensuality. For example, in 1924, while Jean Badovici declares Gray to be "at the heart of the modern movement," he also admits that she "remains, in our machine age, profoundly romantic in her love of fantastic environments."[22] This is 16 years after Adolf Loos published his infamous and extremely influential condemnation of the ornamental, or fantastic, in modern design and architecture.[23] It is four years after Le Corbusier and Amadée Ozenfant published their Purist manifesto in defense of aesthetic rationalism, geometric order and mechanical selection; where they famously placed aesthetic sensations on a hierarchy, with the "mathematical sort … [at the] highest level of this hierarchy … [because] it is superior to the brute pleasures of the senses."[24] It is also just one year after Le Corbusier published *Vers une architecture* (1923), which served as a kind of textbook to modernist architectural theory, applying the concept of "mechanical selection" to architecture and advocating the "House-Machine" as the only antidote to the "demoralizing" and "sickening" sensuality of nineteenth-century domestic design.[25]

In this context, descriptions of the romanticism, mysticism and sensuality of Gray's work would have sat at best uneasily with assertions of its modernism. Badovici's own modernist aspirations are almost palpable

when he strains to describe the purely "abstract geometrical elements" that Gray uses to create environments "according to purely intellectual conventions," but which can express the complexities of modern life "wrapped and sung in the curl of ideal arabesques."[26] Louis Vauxcelles also struggles to place the aesthetic discourses used in Gray's work, describing it as both twentieth-century abstraction and nineteenth-century romantic mysticism. He calls her aesthetic rationale "Picassean," suggests her work's cubism and finds that she "walks a parallel path to our logician painters" but concludes on a more lyrical note that her designs are "mysterious to the point of esoteric" and finally declares that in her work "the hymn to geometry is miraculously sung."[27] The De Stijl architect Jan Wils, whose own work and other writings tend to celebrate abstraction to the point of immateriality, and betray no predilection for sensuality, luxury or mysticism, describes abandoning these modernist critical categories, suddenly made irrelevant in the face of Gray's designs. He recalls a visit to her shop, Jean Désert, and the fantastical discovery of furniture that seemed to be "born in a dream."[28] The closer he came to the "richness of the materials," the more he realized that with Gray's work there is no longer a "question of reasonable judgment or contemplation from a critical eye; the 'how' and the 'why' are insignificant. At no time did I feel forced to judge the work coldly and mathematically."[29] While Badovici and Vauxcelles both appear interested in finally situating Gray's mixed aesthetics into some kind of recognizable twentieth-century modernist movement, Wils is reluctant to wake from the design-induced dream state and submit her work to "cold" critical reason: "I know full well that later ... [her furniture] will be judged with rigor, and their qualities and flaws will be discovered.... But I don't want to know [these qualities and flaws] ... since all that desperately heavy reasoning makes no sense here."[30] Instead, Wils basks in the unreasonable pleasure of design "drawn from the inexpressible richness of spirit and of desire for luxury."[31] Not all reviewers, however, found their critical categories insufficient to the challenge of Gray's work, and after a lengthy quote from Wils' reveries, the *Handelsblad* review concludes soberly that her furniture was "more bizarre than beautiful."[32]

Whether in praise or condemnation, delight or disgust, nearly every critical review struggles to make sense of Gray's bizarre, disquieting, mystical aesthetics. Another De Stijl architect, Albert Boeken, seems to articulate the critical crisis that left other reviewers so conflicted:

Are they modern works of art? Are they of this time? Her latest furniture in its geometrical abstraction, like her interiors, with their elementary contrasts, are certainly of this time. In considering these lamps all analysis ceases. The lamps are much more than mere demonstrations of constructions and techniques of modern aesthetics.... Certain new things, a certain character, strength, purity bordering on perversity emerges which places the artist in a category of her own.[33]

While somewhat disoriented, and unable to place Gray within any familiar modern aesthetic movement, Boeken concludes that Gray's works are "of this time" but "in a category of her own" characterized by a whiff of perversity. This seemingly contradictory conclusion, that Gray's aesthetics are not exactly modern, but certainly of this somewhat perverse time, might be explained by what Caroline Constant argues was an association between Gray's aesthetics and outdated decadence. After the social and political upheaval of World War I, France experienced a socially and politically conservative "call to order," characterized by traditional cultural values and gender roles.[34] Constant explains that in this post-war era, Gray's "swirling arabesques and emotional appeal of color" would have been associated with a culturally threatening and morally suspect "prewar decadence."[35] Moreover, this kind of richly mystical, romantic and sensual aesthetic would have carried more than a hint of sexual perversity, since, as Elaine Showalter notes, the term "decadence" served as the "fin-de-siècle euphemism for homosexuality," at least since Oscar Wilde's 1895 obscenity trials.[36] By the 1920s, the use of decadent aesthetics was not simply out of place in the decorative arts, which were leaning to either French classicism or Corbusian Purism, but may have been sexually provocative as well as socially and politically defiant.

The mixed aesthetics of Gray's interior designs, simultaneously rich and sensual nineteenth-century decadence and "purely intellectual"[37] abstract modernism, evoked such bewildered responses from her reviewers because they accommodated the disquieting and faintly perverse aesthetic elements that by the start of the twentieth century were firmly associated with the pathologically degenerate, sick and sickening people that modern architecture was designed to inoculate its reformed subjects against. That is, Gray's designs were so disturbing because they provided in some way recognizably modern places for subjects that modern architecture and design had recognized as pathological threats to their reformed occupants. In the section that follows I explore the therapeutic aspirations of early twentieth-century architecture and their history in late nineteenth-century cultural and medical understandings of degeneration and decadence, to show that Gray's work accommodated precisely those sick subjects that modern architecture promised to cure.

Decadent interiorities and moral panic: a history of aesthetic health

Since the nineteenth century, architecture and interior design was constructed on the belief that design reform was not simply a matter of individual taste, but that aesthetic changes in one's built environment will affect physical, psychological and lifestyle changes in the ones who occupy it. As Leslie Topp explains,

The redemptive goals of modern architecture from William Morris to Le Corbusier are well known. The power of architecture to change people and society for the better could be asserted using medical metaphors: modern architecture, it was proclaimed, could heal a sick society. Le Corbusier's statement of 1933 is an example: "On the day when contemporary society, at present so sick, has become properly aware that only architecture ... can provide the exact prescription for its ills, then the time will have come for the great machine to be put in motion."[38]

The lofty ideals of social reform introduced by figures like John Ruskin and William Morris and the Arts and Crafts movement in the nineteenth century, which held that the problems faced by new industrial societies could be solved by aesthetic changes in domestic design, were bolstered by developments in the new medical science of human psychology in the late nineteenth century. Concentrated primarily in France, Austria and Germany, this new science of human psychology determined that a wide array of the most pressing social, physical and mental pathologies were both caused and so could be treated by external stimuli. This discovery, of the affective power of external stimuli, paved the way to twentieth-century understandings of the physically, psychologically and socially reformative powers of architecture and design.

Le Corbusier was perhaps most articulate, prolific and influential on the topic. In 1925, he declared that the *machine à habiter*, "the 'House-Machine', the mass-production house, [is] healthy (and morally so too)."[39] He explains that since "[p]eople still believe here and there in architects, as they believe blindly in all doctors.... Our diagnosis is that ... architecture SHOULD USE THOSE ELEMENTS WHICH ARE CAPABLE OF AFFECTING OUR SENSES."[40] Beatriz Colomina points to the many hospital and sanatorium projects undertaken by modern architects to argue that while "[t]he history of modern architecture is full of sanatoriums.... Even more significant is the impact of medical thought on domestic architecture.... It would seem as if modern architects and their promoters were advocating life in a sanatorium."[41] Modern architects were in the business of making new and healthy bodies, and "modern architecture was unproblematically understood as a kind of medical equipment, a mechanism for protecting and enhancing the body."[42] Le Corbusier's famous *machine à habiter* was not only a machine for living in, but a technologically enhanced medical machine for healthier living, developed at a time when physical health was increasingly informed by ideas about psychological health. Le Corbusier advocated aesthetic changes in the objects that constitute domestic space on the faith that "These forms ... work physiologically upon our senses,"[43] to promote both physical and moral health. But where did this faith come from? From where did the architects of these modern medical machine houses adopt their conviction that domestic architecture and design could cure ailing bodies? And what sort of ailments were they hoping to cure?

Sylvia Lavin has argued that this modern belief in the affective powers of architecture was produced by new understandings of the relationship between

interior mental states, or psychologies, and the built environment. To account fully for the reformative aspirations of modern architecture we need

> to recognize that the house was not merely a passive receiver of imported technologies but an active producer of new instruments of psychospatial intervention. For this production to take place, an understanding of the psyche as subject to environmental influences was required just as were techniques for exploring the psychological consequences of space.[44]

While Lavin is dealing with the psychoanalytically informed architectural theory of Richard Neutra, and so focuses primarily on Freud's impact on modern architecture's psychospatial interventions, this new understanding of the relationship between the psyche and the built environment seems to have emerged less from psychoanalysis than from experiments in *psychologie nouvelle* in France in the 1880s.

Both the idea that early twentieth-century architects were dealing with a population of ailing bodies, not properly equipped for life in the new century, and the idea that they could provide the medical tools, in the form of new home and furniture design, to cure them can be traced back to the late nineteenth-century experiments and discoveries of new psychologists, particularly in France. As Debora Silverman explains, modern conceptions of the social and psychological significance of interior space were the result of new medical theories on the powers of suggestion, or the relationship between external stimuli and mental health.[45] Throughout the 1880s, the French psychologist Jean-Martin Charcot conducted public demonstrations of therapeutic hypnosis at the Salpêtrière hospital in Paris. Charcot demonstrated that patients suffering from nervous pathologies (alternately termed neurasthenia, nervous degeneration and hysteria) were particularly susceptible to hypnosis, and that while under hypnosis various forms of suggestion would trigger emotional and behavioural reactions. However, "[o]f the many types of suggestion that provoked automatic behaviour among hypnotised patients, Charcot found that visual material – coloured discs and signs – were often more effective than verbal commands…. Not only did they find that visual stimuli provoked an immediate and visible set of gestures among patients, but the clinicians were able to correlate specific colours with emotional states."[46] Charcot's hypnotic performances at the Salpêtrière, demonstrating the affective powers of visual suggestion on the nervously fragile, proved to be widely influential in nearly all of the arts of the twentieth-century,[47] and architecture was no exception. While less spectacular, the discoveries of Charcot's closest medical rival, Doctor Hippolyte Bernheim in Nancy, were even more significant to redefinitions of consciousness and modern architecture and design's psychospatial interventions. Bernheim argued that "suggestive phenomena do have their analogies in everyday life…. We are all suggestible and can experience hallucinations by our own or

other peoples' impressions.... No one can escape the suggestive influence of others."[48] And by "others," here, Bernheim meant objects as well as people. As Silverman explains, Bernheim "found that the particular potency of imagistic suggestion ... identified by Charcot as the exceptional features of nervous pathology, were in fact characteristic of normal subjects."[49] The power of the external environment to influence thoughts, feelings and actions was not restricted to the sick. "Energy, visual impressions and intangible forces emanating from the external environment were elements as powerful as conscious decision making or assimilation of information about the world.... Doctor Bernheim proclaimed, with scientific authority, the dissolution of the stable boundaries between inner and outer, subjective and objective, reality."[50] With such authoritative scientific support, decorative artists and sponsors of the decorative arts movement in France at the end of the nineteenth century began to take seriously the therapeutic responsibility of redesigning domestic space.

With this new medical evidence showing that the built environment could both positively and negatively affect one's mental and physical states, interior decoration became invested with the task of ensuring the mental health of the citizens of France, who were understood to be suffering the physically and mentally degenerative effects of modern urban life. The city itself came to be seen as an agent of degeneration, where the benefits of "international communication networks, travel, journalism, and such technology as electricity and telegraphs" took their psychological toll: "The expansion of information to be assimilated and the speed of city life developed the urban dweller's mental sensitivities at the expense of his physical vitality."[51] As Silverman notes, much of the evidence for this national crisis of degeneration was based on the literature of decadent writers. And these decadent writers, in turn, based much of their literature on the medical theories of psychologists working on the crisis of nervous degeneration caused by modern urban living.

By 1885, French creative artists had assimilated Charcot's elaboration of nervous pathologies, with particular emphasis on a condition called neurasthenia. This was a clinical state of mental hypersensitivity and physical debility, resulting from continuous mental exertion unrelieved by physical action ... The urban metropolis, whose inhabitants faced a relentless barrage of sensory excitation and lived at an accelerated pace, threatened to transform France into a nation of physically exhausted and mentally hypersensitive Des Esseintes.[52]

Des Esseintes is the aristocratic, effete hero of J.-K. Huysmans' infamous novel À rebours (1883), which Silverman calls the "Symbolist manifesto"[53] and others call the first decadent novel.[54] Huysmans claimed to have based Des Esseintes on medical cases of nervous excitation and exhaustion that he had studied in Doctor Alexander Axenfeld's 1883 text *Traité de névroses*,[55] and this character came to occupy a privileged position in the history of nineteenth-century

decadence. Hypersensitive to the stimulations of the urban metropolis, he retreats from Paris, and the novel describes the various emotional states that unfold according to the elaborate and sensual interiors that he designed for himself. His designs are characterized by rich materials and dark colours: his books and walls were bound in orange "crushed morocco," mouldings in "deep indigo blue lacquer," and his floor scattered with "tiger skins and blue-foxes' pelts," and given pride of place in his "marvellously wrought" bookshelf were three "exquisitely adorned" editions of Baudelaire's poetry.[56] His nervous pathology was both triggered and treated by the appearance of the things around him, and as Silverman notes, "his dependence on this continuous aesthetic stimulation consigned him to physical lassitude and nervous hypersensitivity."[57] His mental and physical health was directly dependent on the right choice of interior decoration.

Des Esseintes came to stand for all the dangers associated with the urban metropolis, and his qualities of degeneration were transposed onto the French nation as a whole. In 1895, Doctor Max Nordau published the book *Degeneration*, which was perhaps the most influential synthesis of developments in new psychology and in the decadent arts of the fin-de-siècle Parisian cultural scene. Silverman explains that Nordau's book had two main claims: "The first was his scientifically based redefinition of artistic decadence as a condition caused by nervous disorder.... [The second was that he] identified nervous pathology as a collective pathology, not a condition limited to a small coterie of debilitated aesthetes."[58] Decadent arts, and the dandies like Des Esseintes that they produced, were part of a widespread, degenerative health crisis that threatened to destroy the French nation.

While Silverman does not mention it, the spectre of male homosexuality in decadent arts contributed to the urgency of this crisis of national degeneration. Nordau's internationally best-selling study indelibly linked aesthetic decadence, national degeneration and sexual perversion for generations of European readers. As Jason Edwards puts it in a brief history of degeneracy and male homosexuality, Nordau convincingly

identified degeneracy in any kind of sexual practice or identity that did not subordinate itself to the racial imperative of reproduction, stigmatising masturbation, fetishism, frigidity, homosexuality and the use of prostitutes and pornography.... *Degeneration* also singled out Oscar Wilde as the paradigm of sexual degeneracy.[59]

Degeneration was a national crisis of sexual perversion and decadence was its most obvious symptom. Oscar Wilde had, of course, based his most famous literary portrait of a degenerate decadent aesthete, Dorian Gray, on Huysmans' Des Esseintes, who was based, in turn, on medical portraits of degeneration.[60] This circle of influence was perhaps finally sealed when Wilde used *Degeneration* as his defence in a petition to be released from prison, claiming that Nordau's work proved him to be a degenerate, not a criminal,

in need of medical treatment rather than penal time. The fact that degeneration was as much a pathology of homosexual perversion as of nervous exhaustion is the crucial missing link in Silverman's study of the relationship between late nineteenth-century decadence, psychology and the decorative arts.

The new psychology in France was but one of the medical disciplines developed in the late nineteenth century to address the problem of degeneration. As Jane Caplan explains,

Continental Europe nurtured a culture of disciplinary practices and human sciences that, by the second half of the nineteenth century, had placed the degenerated body at the heart of its model of organic social health and disease.... It turned essentially on a linkage of hereditarian concepts from the biological and the social sciences to present an alarming scenario of potentially fatal national and racial decline that unfolded in the very process of individual and social reproduction: degeneration was, in a sense, decadence understood as pathological and hereditary.[61]

And it was within this culture that the new discipline of human sexology emerged to identify and account for perversions of the functional reproductive sexual impulse, and most significantly male and female homosexuality, as symptoms of degeneration. Richard von Krafft-Ebing was the first to study the phenomenon of same-sex desire extensively, in his widely influential *Psychopathia sexualis* (1886), and to make sense of this perversion as "a manifestation of functional degeneration."[62] By the time Nordau published his attack on cultural decadence as a sign of degeneration, and Wilde and his writings were tried as the sexually criminal cultural manifestation of degeneration, Krafft-Ebing's work had indelibly left its mark on the European popular imagination. "The popular press viewed Wilde's predatory sexual relationships with younger men of lower social standing as pathological and ... representative of a widespread breakdown of moral standards and of the increasing prevalence of degenerative influences in society at large."[63] Silverman's important argument that late nineteenth-century interior decoration had joined forces with new psychology to treat the problem of degeneration needs to be informed by the social and medical understanding, so powerful by the time of Wilde's trial, connecting degeneration to decadence and homosexuality.

However, if we keep in mind this important but neglected connection, Silverman's work takes us some way to understanding the highly sexualized significance of modern interior spaces. She argues that the psychologists who turned their attention to this crisis of national degeneration "yielded a reevaluation of rational consciousness."[64] Charcot's hypnotic therapy performances and the radical implications of the power of suggestion and visual thinking would result by the early twentieth century in the conception of interior space as the hypercharged interface between the individual unconscious and the outside world. The official reaction to this psychological

re-evaluation of consciousness is reflected in dramatic shifts in the definition of the terms "art nouveau" and "modern" that took place between the two Paris World Exhibitions in 1889 and 1900. At the 1889 exhibition, art nouveau modernism was represented by large-scale wrought-iron monuments to industrialism, such as the Gallery of Machines and the Eiffel Tower, celebrating the national "values of youth, virility, production and democracy."[65] By the exhibition in 1900, the terms "art nouveau" and "modern style" had come to mean the opposite of what they had eleven years earlier. As Silverman explains,

> if the 1889 exhibition glorified the wrought-iron column, the 1900 exhibition signalled the reinvocation of conventional overwrought masonry structures ... and the retreat to an ornamental fantasy in the organicised private interior.... Replacing the public iron monument with the private iron ornament, art nouveau celebrated modernity in domestic ensembles of nature and interiority.[66]

This shift from public, monumental and heroic to private, ornamental and domestic modernism had everything to do, Silverman argues, with medical theories of nervous disorders and degeneration, brought on by the over-stimulations of public space and their dissemination through the decadent arts. Domestic, interior decoration became invested with the healing powers of the psychologist, hypnotically easing the citizens of France out of degenerate decadence, with all of its aesthetically, psychologically, physically and sexually pathological connotations, and into healthy modern subjecthood. By the start of the twentieth century, the problem of the domestic interior was serious business: the health of the modern subject and the future of the nation depended on it.

Building health

Early twentieth-century modern architecture would put this production of "healthy" living spaces at the centre of its modernist project. Rather than proclaim the regenerative effects of ornament, privacy and domesticity, however, early twentieth-century architectural discourse managed to conflate these values with the decadent tendencies and degenerative diseases they had been introduced to combat, and thereby was able to proclaim itself modernity's only healthy option. At the turn of the century, Adolf Loos published vehement condemnations of nineteenth-century architecture, fashion and interior design, equating the development of "civilization" with the eradication of ornamentation of any kind. "The march of civilization," he writes, "systematically liberates object after object from ornamentation."[67] For early twentieth-century modern architecture, ornament was no longer a treatment against but a sign of the degeneration of civilization. And in

his canonical 1908 essay, Loos not only criminalizes but also sexualizes ornamentation: "The first ornament that came into being, the cross, had an erotic origin.... But the man of our time who daubs the walls with erotic symbols to satisfy an inner urge is a criminal or a degenerate."[68] Of course, by 1908, 13 years after Wilde's sensational and infamous obscenity trials, the erotic degenerate was also a criminal. As Beatriz Colomina notes, "when this 'degeneration' becomes clearly identified as homosexuality, Loos' raid against ornament is not only gender-loaded by openly homophobic."[69] And with Loos, modern architecture joins the psychologized decorative arts to fashion itself as a tool created in the service of national, sexual and aesthetic health.

During the 1920s, Le Corbusier was able to sell his modern architectural vision in France by relying on the familiar themes of disease and degeneration and insisting on the healthy and hygienic regenerative powers of his industrial, utilitarian aesthetic. This vision developed out of Loos' homophobic repudiation of ornament and all of the decadent arts that it was able to represent, and depended on a revolution in the decorative arts. While he rarely acknowledges it, Le Corbusier's anti-ornamental project "is everywhere indebted to Loos."[70] This is perhaps most evident in his 1925 collection of essays on the poisonous state of "the decorative art of today," where he echoes Loos, declaring that *"the more cultivated a people becomes, the more decoration disappears. (Surely it was Loos who put it so neatly)."*[71] "Cultivation" for Le Corbusier is, as it was for Loos, as sexual as it is moral, physical or aesthetic. He explains that "this taste for decorating everything around one is a false taste, an abominable little perversion."[72] The solution to this problem of perversion is simply a coat of white paint: "It is healthy, clean, decent."[73] Le Corbusier observes that those enthusiasts of "beautiful materials," like rare wood and lacquer, will, through over-indulgence in their perverse pleasures, soon kill themselves off: "the almost hysterical rush in recent years towards quasi-orgiastic decoration is no more than the final spasm of an already foreseeable death."[74] But before the situation degenerates further, Le Corbusier advocates sending in the whitewashing moral brigades: "Whitewash is extremely moral. Suppose there was a decree requiring all rooms in Paris to be given a coat of whitewash. I maintain that that would be a police task force of real stature and a manifestation of high morality, the sign of a great people."[75] Whitewash will spearhead the police raids on these orgiastic rooms. Le Corbusier's architectural vision depends on whiting out any trace of these hysterics and decorating utilitarian spaces for the modern man. He proclaims that "the time is past when we – men of vigour in an age of heroic reawakening ... can lounge on ottomans and divans among orchids in the scented atmosphere of a seraglio and behave like so many ornamental animals or humming-birds in impeccable evening dress."[76] This image of men lounging in their finest dress on divans would have been an obvious reference to Des Esseintes, Dorian Gray and the decadent aesthetes who

championed them. Le Corbusier's architecture was designed to reawaken the heroic modern man and drive out the lounging, orgiastic perverts – raiding the decadent hothouses of Paris.

While the metaphors tend to shift, modern architecture was envisioned less often as a police raid than as a medical tool to be used in the service of producing proper bodies. Colomina argues that "Modern architecture was unproblematically understood as a kind of medical equipment, a mechanism for protecting and enhancing the body."[77] In the face of perceived health and moral crises, early twentieth-century modern architecture committed itself to the task of making modern bodies – which suggests that Le Corbusier's architecture was more concerned with policing the body than with policing space. Colomina finds that modern architecture addressed itself to the treatment of tuberculosis particularly. "Indeed" she writes, "the architecture of the early 20th century cannot be understood outside of tuberculosis."[78] I would like to suggest that neither can it be understood outside of degeneration.

Le Corbusier refers to tuberculosis, but the moral urgency of his architectural project borrows from the nineteenth-century crisis of degeneration that, Silverman explains, had gripped and guided fin-de-siècle decorative arts. Indeed, conceptions of tuberculosis were particularly tied in France to fears of degeneration. As David Barnes explains in his study of the history of tuberculosis in France,"The notion of 'degeneration', as applied to societies' physical and moral well-being, was widespread throughout late-nineteenth-century Europe. In France, however, it fused with the continuing anxiety over low birth rates and demographic decline ... and fashioned a peculiarly French anxiety of national decline."[79] This anxiety over national decline was exacerbated by the losses suffered in World War I and contributed to the sense of moral crisis and resulting "return to order" in the post-war period in France. Of course, the crisis of degeneration was as much racialized as it was sexualized – betraying anxieties about the waning strength of heterosexual and white supremacy.[80] The fear of national decline in France, as in most Western European and North American countries, was informed by the burgeoning science of racism, and architectural and design discourses on degeneration were invested not only in (hetero)sexual but in racial health. As Christina Cogdell has shown, the appeal of rationalized modern architecture and design relied on the eugenic promise of rationalized racial reproduction: "[b]oth were obsessed with increasing efficiency and hygiene and the realization of the 'ideal type' as the means to achieve an imminent 'civilized' utopia."[81] The degeneration of decoration was understood as both racially and sexually backward, being easily associated by Loos and Le Corbusier with the "perverse" racialized sexualities of various "primitives," and the curative anti-ornamental march of modern civilization promised to restore the strength of racial, sexual and aesthetic purity.

Le Corbusier's writings from this period reflect this convergence of fears, and his architecture is proposed as an antidote to moral, physical, sexual and racial degeneration. In his earliest and perhaps most influential writings, collected from 1919 to 1922 and published as *Towards a New Architecture* (1923), he explains that the national crisis is first and foremost "the problem of the house."[82] He describes the house as "a coach full of tuberculosis,"[83] but as full also of "consumption"[84] and in a general state of diseased decay. He characterizes the problem of the house as a health issue, but concludes that it is "above all a moral crisis."[85] He laments the sorry state of French living conditions: "We are to be pitied for living in unworthy houses, since they ruin our health and our *morale*.... Our houses gnaw at us in our sluggishness, like a consumption. We shall soon need too many sanatoriums.... Our houses disgust us ... we are becoming demoralised."[86] To heal this crisis, he urges, "let us purge our houses."[87] What he hopes to purge is both a physical and moral health threat, which by 1925 is clearly coded as the threat of decadence and degeneration. Already here he insists that this moral crisis is a sexual and reproductive crisis. The source of the problem is "the cult of the house,"[88] which prevents "the man of to-day" from following "the organic development of his existence, which is to create a family.... In this way society is helping forward the destruction of the family."[89] Le Corbusier's housing project is explicitly aimed at treating the moral crisis, which has led to the physical and sexual decay that threatens to destroy the family and the future of society.

If the root of this national crisis is the problem of the immoral house, the solution turns out to be moralizing industrial productivity. Le Corbusier incorporates the debates that Silverman describes which resulted in the shift from industrial monumentality in 1889 to domestic ornamentation by 1900. In place of the "putrid and useless and unproductive" house[90] he proposes the "House-tool"[91] conceived according to the logic of the engineer – "Our engineers are healthy and virile, active and useful.... The engineer who proceeds by knowledge shows the way and holds the truth."[92] Anything that detracted from healthy, virile productivity was anathema to his vision of modern life, and in this post-war period he came to identify "the cult of the house"[93] as the main obstacle in the way of realising this engineering truth. Rather than saving us from moral and physical degeneration, the ornamental domestic interiors advocated by the 1900 World Exhibition were just spreading the disease. Domestic interiority was still the key to national health but it needed to be radically redesigned. Rather than serving as a refuge from the industrial aesthetic celebrated at the 1889 World Exhibition, domestic interiors needed to incorporate its virility and activity. The domestication of modernity advocated by the 1900 exhibition was not the solution to the problem of degeneration, but the cause. Le Corbusier asks us to consider our heroic businessmen, bankers and merchants,

away from their businesses in their own homes, where everything seems to contradict their real existence – rooms too small, a conglomeration of useless and disparate objects, and a sickening spirit reigning over so many shams ... styles of all sorts and absurd bric-a-brac. Our industrial friends seem sheepish and shrivelled like tigers in a cage.[94]

Domestic interiority needs to be modelled on "big business [which] is today a healthy and moral organism."[95] The health and morality of today's big industrial business is contrasted with the ornamental poison of yesterday's domesticity. But yesterday's belief in the power of interior decoration to cure today's threat of degeneration remains.

Building (for) other bodies

Le Corbusier was only the most outspoken and influential on the regenerative powers of modern architecture and design, but the fundamental unifying feature of early twentieth-century architecture was its preoccupation with the idea of health. This is perhaps most obvious in the white walls that became modern architecture's iconic look. Le Corbusier popularized the healing powers of the white wall as an antidote to decadent and degenerate nineteenth-century interiors, throughout his writings in the 1920s, and by 1927 the therapeutic coat of white paint came to be modern architecture's official dress code and most salient identifying feature. As Mark Wigley explains, it was at the Weissenhofsiedlung exhibition "The Dwelling," in Stuttgart in 1927, that architects and interior designers, reviewers and subsequently their historians first identify a unified modern architectural movement and international style revolving around the white wall: "The exhibition ... facilitated the reduction of the diverse tendencies and contradictions of the avant-garde into a recognizable 'look' that turns around the white wall."[96]

From this moment on, modern architecture comes to be recognizable as such through its white walls, its visible commitment to the ideas of moral, psychological, physiological and racialized social health that Le Corbusier had explicated throughout the 1920s. Modern architects and historians have naturalized the white wall as the obvious result of a building stripped of the superfluous ornament of the nineteenth century: "[s]upposedly, modern architecture strips off the old clothing of the nineteenth century to show off its new body, a fit body made available by the new culture of mechanization."[97] However, as Wigley explains, the "natural look" enabled by this white coat was carefully constructed and invested in not only revealing but producing new bodies: "The thin white garment produces the image of a physical body behind it, but it is a body that did not exist as such before."[98] The body that modern architects and interior designers collaborated to produce with their white outfits

was defined against the degenerate body that nineteenth-century architects and designers were understood to have produced with their decadent style.

While rejecting its aesthetic prescription, twentieth-century modern architecture continued the nineteenth-century faith in the healing powers of domestic space. The white coat that unified the various architects and designers in the early part of the twentieth century represents more than anything else their shared commitment to the production and definition of healthy bodies and subjects. And as Michel Foucault reminds us, the modern project of regulating and disciplining bodies was also the project of producing sexuality.[99] We might think, then, of the conflation of decadent aesthetics and ornamentation with degeneracy and homosexuality, of Le Corbusier writing on the moral crisis of the non-productive, sickening house, as architecture's most influential contribution to the proliferation of modern discourses on sex. Modern architecture joined medicine, psychiatry and the criminal justice system in addressing the "problematic of the 'flesh', that is, of the body, sensation, the nature of pleasure, the more secret forms of enjoyment of acquiescence."[100] If Colomina is right to claim that modern architecture conceived of itself as a "kind of medical equipment, a mechanism for protecting and enhancing the body,"[101] I would like to add that it was thereby joining modernity's "great family of technologies of sex," wherein the medical theory of degeneration was central.[102] Foucault argues that this "great family" was composed of "psychiatry, to be sure, but also jurisprudence, legal medicine, agencies of social control, the surveillance of dangerous or endangered children [which] all functioned for a long time on the basis of 'degenerescence' and the heredity-perversion system."[103] As we have seen, twentieth-century architecture adopted from the nineteenth century the faith that domestic space could be deployed as a therapeutic tool against degeneration, and their medical technology was the house-tool, purged and whitewashed, invested with the power to ensure the healthy body – industrially and sexually productive and designed in contrast to the fruitless, decadent, primitive, lounging body that threatened the future of the family and the nation.

Despite modern architecture's dedication to the problem of the house, historians have argued that modern architects and their promoters, like modern artists and theirs, defined modernism as the opposite of home – with its non-heroic correlates of mundane domesticity, privacy and femininity. This, as we have seen, involved no simple rejection or neglect of the home, but an ongoing suppression and repudiation of all those values associated with it. In the introduction to his anthology *Not at Home: The Suppression of Domesticity in Modern Art and Architecture*, Christopher Reed explains that "this has been the standard of modern art: a heroic odyssey on the high seas of consciousness, with no time to spare for the mundane details of home life and housekeeping."[104] Far from being ignored, home was a space and concept that was obsessively attended to, and proved central to the constitution of

modernism. "The domestic, perpetually invoked in order to be denied, remains throughout the course of modernism a crucial site of anxiety and subversion."[105] Domestic space was clearly modern architecture's primary site of anxiety, its design conceived in the service of regulating subjectivity, which was fundamentally the "problematic of the 'flesh'" that Foucault describes.[106] In her only published writing, Gray signals her attention to this problematic of the flesh, and criticizes modern architecture precisely in terms of its suppression of intimacy and the private passions, needs, tastes and pleasures of the modern body. She argues that

External architecture seems to have absorbed avant-garde architects at the expense of the interior ... [which] leads to an impoverishment of the inner life by suppressing all intimacy.... [Whereas today's architecture demands] knowledge of the conditions of existence, of human tastes and aspirations, passions and needs ... it must also encapsulate the most tangible relations, the most intimate needs of subjective life ...only the human being should be considered – but the human being of a particular era, with tastes, feelings, and gestures of this era.[107]

She published this criticism in the avant-garde journal *L'architecture vivante* (1929), alongside a built example of her architectural alternative, E.1027, which together made a strong claim for the inclusion of many of those domestic values that modernism was repudiating. Gray's work by the late 1920s was much less overtly engaged with decadent aesthetics and incorporated the modernist architectural innovations of Adolf Loos and Le Corbusier, but she continued to produce spaces based on the sensuality and intimacy that were antithetical to the modernism they stood for.

Her first house used the most recent innovations of modern architecture, incorporating elements from Loos' anti-ornamentalism, Bauhaus functionalism and most obviously Le Corbusier's not yet widely published five points for new architecture.[108] With a quote from Baudelaire on the living room wall, "Invitation au voyage," the visitor was invited into a space that would have been by then familiar, and she would have expected an open floor-plan, furnished sparsely with aluminium and chrome in the camping style, a boudoir for the lady of the house, a study for the man and an overall arrangement that encouraged maximum action and productivity. She would not have expected an invitation to luxuriate. She would not have expected soft wool, multi-layered rugs, an extendable divan piled with cushions and fur blankets, below a nautical map stencilled with a quote from Baudelaire to form the centrepiece of the main room (see Figure 1.1). She would not have expected the elimination of gendered spaces, an architecture designed for the prone, lounging body with divans in every room equipped with trays for holding drinks and cigarettes, lights for reading and writing, electrical outlets for hot water. She would never have expected an architecture of such intimacy and sensuality, an architecture incorporating so much of the decadence that

1.1 E.1027, main living room, nautical map with "L'invitation au voyage" stencil visible on the right, 1929. Reproduced with the kind permission of the National Museum of Ireland.

it would have looked, from the outside, to have rejected. Before Le Corbusier went on to mural "graffiti" throughout this first house, he would praise its "rare spirit."[109] We might speculate that Gray's incorporation into modern architectural forms those elements which modern architecture, and Le Corbusier especially, was so energetically and publicly denouncing would have struck him as somewhat more than "rare." I would like to suggest that when Gray included elements of these vilified, racialized, criminalized and pathologized aesthetics in her interior design, she was making a claim for the inclusion of subjects, values and desires that were being denied a space by twentieth-century modernism.

Gray's use of a quote from Baudelaire in the house, which critics have read as her most decisive move away from decadent "figuration to more abstract and generalised forms"[110] or from "the sins of her youth" to "pure architecture,"[111] prominently signals an ongoing interest in the decadent themes and styles that confounded her early reviewers and that the later literature on Gray has seemed all too eager to overlook. Constant has been the only scholar to address the Baudelaire reference, to suggest that "the spirit of her architecture

draws ... inspiration from Baudelaire."[112] However, when Constant seeks the source of that inspiration, she refers to the 1869 prose version of the poem, published in Baudelaire's *Paris spleen*, and conspicuously neglects to mention its earlier version, first published in the more controversial and widely known collection of poems *Les fleurs du mal* in 1857. Baudelaire had first intended to title this collection *Les lesbiennes*, indicating, as Chelsea Ray explains, that "the figure of the lesbian was central to the work from its inception."[113] Indeed, his focus on lesbianism was deemed too central, and two of the three poems on female same-sex desire were banned from the work's first publication – unsurprisingly, the censored poems have been read as the least negative portrayals of lesbianism, leaving only the unambiguous "Condemned Women" (*Les femmes damnées*) fit for publication.[114] With interests fuelled by the censorship trial, the first printing of *Les fleurs du mal* quickly sold out, and when the banned poems were eventually included their scandalous significance touched even the less inflammatory pieces like "L'invitation au voyage." The work's focus on "sexual ambiguity or 'perverse' sexuality ... both influenced decadent literature and was a part of it ... [and] would greatly influence subsequent portrayals of lesbian love in French literature."[115] I agree that the spirit of Gray's architecture is inspired by Baudelaire, but we need to recognize that Gray's decision to use a quote from his poetry, and particularly from *Les fleurs du mal*, in the main room of her first house evokes the sexualized implications of what Constant describes as a decadent spirit of *luxe*. That is, as Constant mentions but does not explore, "[t]he French term *luxe* implies voluptuousness and eroticism as well as costliness; it has to do with desire."[116] We need to recognize that using a quote from *Les fleurs du mal* signals Gray's ongoing interest in one of decadent literature's most influential representations of perverse lesbian desire.

The original 1857 version of "L'invitation au voyage" is similar in style and theme to the later, longer prose version that Constant quotes from. While neither makes explicit reference to lesbianism, condemned women or perverse female sexuality, they both describe a sensual seaside utopia whose beauty is perfected by artifice and human intervention, a conceivable reference to Gray's sensually engaging first house, constructed on an isolated plot of land overhanging the French Mediterranean Sea. Moreover, both versions of the poem are structured as invitations extended to a female (or at least feminized) lover who resembles this perfected sensual paradise. In 1857, the poem begins:

Mon enfant, ma sœur,
 Songe à la douceur
Daller là-bas vivre ensemble!
 Aimer à loisir,
 Aimer et mourir
Au pays qui te ressemble!

... Là, tout n'est qu'ordre et beauté,
Luxe, calme et volupté.

[My child, my sister,
 Think of the rapture
Of living together there!
 Of loving at will,
 Of loving till death,
In the land that is like you!

... There all is order and beauty,
Luxury, peace, and pleasure.][117]

In 1869, the poem begins:

Il est un pays superbe, un pays de Cocagne, dit-on, que je rêve de visiter avec une vieille amie. Pays singulier ... un vrai pays de Cocagne, où tout est beau, riche, tranquille, honnête; où le luxe a plaisir à se mirer dans l'ordre ... où tout vous ressemble, mon cher ange Il est une contrée que te ressemble ... C'est là qu'il faut aller vivre, c'est là qu'il faut aller mourir!

[There is a superb country, an earthly paradise, they say, which I dream of visiting with an old female friend. A country unlike any other ... truly a paradise on earth, where everything is beautiful, opulent, quiet, authentic; where luxury delights in reflecting itself in order ... where everything resembles you, my beloved angel ... There is a land resembling you ... There we must go to live; there we must go to die.][118]

While Constant suggests that the "Luxe, calme et volupté" resembles Gray's architecture, Baudelaire emphasizes in both versions of the poem that it also resembles a certain image of femininity: "honnête" or "authentic" but also one in which nature has been "corrected and beautified and remoulded ... just as Art is superior to Nature."[119] This is a standard Baudelairian and decadent trope, the naturally superior beauty of the unnatural, one that appealed to the carefully crafted self-fashioning of decadent dandies in the nineteenth century (like Huysmans, Wilde and Baudelaire himself), and one that apparently appealed as well to women in the early decades of the twentieth century who were remoulding their female identities to correct traditional images of natural maternal, domestic and heterosexual femininity.

 Historians have noted that the interwar period in France was marked by an official endorsement of conservative gender roles, a "call to order," where the conventional image of maternal femininity and the "femme de foyer" were heralded as symbols of hope, regeneration and "cultural endurance"[120] that affected the work of even those artists who were most anti-naturalist, anti-traditionalist before World War I. Kenneth Silver and Bridget Elliott point to Picasso's *Woman in White* (1923) as an example of the "many *maternité* themes that preoccupied avant-garde painters during the early twenties when the

French government mounted a campaign around all sort of reproductive propaganda, including posters of ... images of round and fecund women."[121] Women who sought to distance themselves from these traditional definitions of natural, maternal and heterosexual femininity mobilized the decadent trope of culturally corrected, unnatural or anti-natural beauty epitomized by both the "dandy and New Woman, [which] counters the nationalist vision of hope and all it entailed for women that was promoted by artists like Picasso and various French government agencies."[122] Elliott argues that this archaic, unnatural decadent imagery allowed an artist like Romaine Brooks, as well as the women that she painted, to fashion images of lesbian visibility and to imagine new kinds of female subjectivities for an elite group of women in the 1920s.

Both versions of "L'invitation au voyage," while not explicitly lesbian in theme, invoke a space of such unnatural imaginative possibilities for women. In 1857, the narrator invites a sister/lover, in 1869 "la femme aimée ... la soeur d'élection,"[123] to this paradise of such unnatural beauty that it resembles her, where the furniture whispers sensual mysteries in a secret language, where "dreams outstrip the possible,"[124] "to breathe and dream, and to prolong the hours with an infinity of sensations."[125] While Caroline Constant has argued that E.1027 is "[m]uch like the imaginary country that Charles Baudelaire conjured up in his prose poem 'L'invitation au voyage,'"[126] Constant forgets that this poem is part of an earlier and larger work in which "the figure of the lesbian was central,"[127] as well as the description of a decadent imaginary space which informed so many women's attempts, in the 1920s, to conjure up new, non-traditional and non-heterosexual female identities.

Gray in context: sapphic decadence

To get beyond thinking of Gray's architecture "simply as an 'other' approach to the Modern Movement" and to see it "as an extensive commentary on the Movement itself,"[128] as Constant has suggested, we need to start by taking Gray's critical writings seriously and let them inform our readings of her unusual and apparently disturbing designs. Who was the human being of her era, the early twentieth-century modern subject, whom modern architecture was neglecting? And what intimate pleasures, passions, needs and tastes was she accommodating in the early part the twentieth century with her conspicuously nineteenth-century elements of decadent design aesthetics – elements like lacquer screens and wall panelling, divans piled with pillows and blankets, plush materials like fur and velvet that architects were vilifying as distinctly anti-modern and that Le Corbusier was associating with the criminally degenerate orgiastic hot-houses of Paris?

Feminist historians have found that particularly in the Paris of Gray's era, several women artists and writers were also incorporating elements of by then

outdated, pathologized decadent aesthetics into their work. Moreover, these women's use of decadence in their aesthetic work seems to have been related to the same modern subject whose intimate pleasures, passions, needs and tastes that Gray criticizes modern architecture for not accommodating. Indeed, scholars have suggested that writers like Renee Vivien, Natalie Barney, Djuna Barnes, Radclyffe Hall and Hilda Dolittle (H.D.), visual artists like Romaine Brooks and Marie Laurencin, designers like Gray's first professional partner Evelyn Wyld and Eyre de Lanux and performers like Gray's lover Damia and Ida Rubinstein were strategically mobilizing the degenerate implications of decadent aesthetics in attempts to forge identities for new sexually dissident female subjects who were not yet accommodated by early twentieth-century visual, literary or architectural practices. By capitalizing on the common conflation between decadent aesthetics and degenerate male homosexual identity developed in the nineteenth century, women in the early decades of the twentieth century attempted to render new female identities, revolving around same-sex desire, intelligible. Modern women artists, writers, performers and, I would like to add, designers were engaged, like modern architects, in not simply revealing a new subject but fundamentally creating one. However, these women's creations relied not on purging or suppressing but, as Gray's work shows, on incorporating and accommodating the degenerate decadent.

Bridget Elliott and Jo-Ann Wallace study the works of Romaine Brooks and Natalie Barney and find that they were capitalizing on the sexual deviance and class privilege associated with fin-de-siècle decadence in order to invent and communicate modern lesbian identities. Elliott and Wallace explain that Brooks and Barney "consciously and consistently *fashioned themselves* out of a decadent philosophy and aesthetic. They were not simply reflecting or reporting their lives and those of their friends, but *making* them visible – that is, making their lesbianism visible – by adapting literary and visual conventions which were already coded '"homosexual.""[129] Barney, for example, emphasized her "profound sympathetic identification with [Oscar] Wilde,"[130] both in memoirs and interviews and in her adoption of a Wildean epigrammatic writing style. Moreover, Ray argues that Barney's writing borrows explicitly from Baudelaire's *Les fleurs du mal*, to counter his condemnation of alienated, monstrous women doomed by their desire for other women with a positive poetic rendering of female same-sex desire and sexual relationships.[131] Brooks' identification with decadence can be seen in her 1923 *Self-Portrait*, as well as her portraits of Lady Una Troubridge and Gluck and the sartorial codes of dandyism highlighted so conspicuously in all of them. Moreover, Brooks' visual aesthetics, her use of dark, muted colours – primarily black, white and grey – were associated with late nineteenth-century painters, especially Whistler, and her unpublished memoirs, full of allusions to Baudelaire, resonate in style, theme and tone with literary decadence. Elliott and Wallace stress that Brooks and Barney were not "reflecting" or "reporting" lesbianism

because at the time there was no such stable subject to simply refer to. For early twentieth-century women, the task of making lesbianism visible was also the task of creating an imaginative space for such an identity. As Laura Doan notes, "[i]n the early 1920s lesbianism was not a 'fact' marked on the body, nor was it commonly understood as a particular sexual object choice or sexual practice between women, nor was it (as yet) a modern identity or subjectivity."[132] Elliott and Wallace argue that women like Brooks and Barney were using decadence as one aesthetic strategy to not only represent but also invent a positive lesbian subjectivity. While Gray's decadent tendencies struck some as "perverse," "horrific" or simply confusing, they may have been understood relatively unproblematically by women such as Brooks and Barney as contributing to the production of a modern visual language of sexual dissidence.

Indeed, one of the few reviews from the 1920s that does not appear to struggle with Gray's mixed aesthetics is written by a regular visitor to Barney's weekly salons and a friend to both Brooks and Gray, the Duchesse de Clermont-Tonnerre. Most likely referring to Gray's redesign of the rue de Lota apartment (1919–22), Clermont-Tonnerre describes the "mystery" of Gray's lacquer works, encrusted with "floating phantasmagoria" "which affect the senses like dark mirrors,"[133] and the "voluptuous tactile sense ... of her satisfying and unusual art."[134] But rather than suffer the critical crisis that these unusual voluptuous elements produce in other reviewers, Clermont-Tonnerre concludes simply that Gray achieves "interiors suited to our existence ... and in accordance with our aspirations and feelings."[135] This conclusion was not entirely self-evident, since, as we have seen, not everyone recognized the existence, aspirations and feelings to which Gray's work was most suited. Even Wils, perhaps the most self-consciously avant-garde of all of Gray's critics, had trouble in imagining a waking world that would be in accord with Gray's designs, and could recall them only as a mystical daydream.

Much like Brooks, Gray relied on dark muted colours – dark greens, blues, deep reds, grey, black and white – which she combined in rich, luxurious, sensual materials – lacquer, fur, velour, soft wools and leathers – to create decadent effects that seem to have been part of a larger effort to produce new space for modern lesbian subjects. Bridget Elliott has recently written on the interior design work of Gray, Brooks and Gluck, suggesting that reading Gray's work in the context of such a larger effort may offer new critical perspectives on the gender and sexual implications of Gray's work:

Given that Gray's "decadent" tendencies were echoed in the work of other women artists of the period, such as Brooks, and highly praised by women art critics, such as the Duchesse de Clermont-Tonnerre, it is tempting to speculate that their work might have constituted some sort of departure from (or even resistance to) the general trends that have been charted.[136]

While Gray's departure from modern design trends may have been, as Joseph Rykwert suggests, "unusual for its time,"[137] her motivations become less oblique when read in the context of a potentially resistant sexually dissident aesthetic culture. What Reyner Banham describes as her "personal style and philosophy of interior design"[138] may have been less personal than cultural, and her aesthetic innovations may have been intentionally "too rich"[139] for the modern canon but just right for a resistant, decadent and sexually dissident sapphic modernity.

Shari Benstock has argued that just such a modernist lesbian resistance movement existed for women writers who circulated in Gray's Left Bank neighborhood, a movement which she provisionally named sapphic modernism.[140] She postulates such a movement as a way to recognize a common "woman-centered" resistance to canonical modernism in the thematically and stylistically diverse writings of several women, such as Radclyffe Hall, Djuna Barnes, Natalie Barney, Gertrude Stein and Virginia Woolf.[141] Cassandra Laity finds, moreover, that this sapphic modernism located its creative roots in the nineteenth-century decadent poetry and fiction of writers like J.K. Huysmans, Aubrey Beardsley and A.C. Swinburn. As Laity argues,

The Decadence of the 1890s provided ... a "female" tradition for modernist women ... H.D. and others "used" the Decadents to fashion a feminist poetic of female desire. While Yeats, Eliot, and Pound found Swinburne's experimental articulations of desire "perverse", several women modernists ... discovered in Swinburne's more fluid explorations of sexuality and gender roles a radical alternative to the modernist poetics of male desire which, as Shari Benstock and others have noted, silenced and effaced the twentieth-century woman writer.[142]

The idea of a "woman-centered" modernist movement or culture, with the development of a radically alternate poetic of female desire as its conceptual centre, has been discussed primarily as a literary phenomenon. Elliott's recent work, however, has introduced this discussion to art history, speculating, as we see above, that decadence may provide a crucial link between modern women's literary and visual fashionings of female sexual dissidence and subjectivity.

Elliott argues that the painter Marie Laurencin, while representing a very different version of femininity than Romaine Brooks, was also strategically borrowing her visual language from nineteenth-century decadence. In her essay on Laurencin's use of the ornamental figure of the arabesque, Elliott suggests that Laurencin was able to capitalize on both the highly feminized implications and the spectre of perverse same-sex couplings that decadent aesthetics promised by the early twentieth century. Elliott argues that Laurencin combined elements of cubism with decadent ornamentation and decoration to produce a "tactical indeterminacy" in her representations of femininity: "Readers 'in the know' were alerted to the fact that Laurencin's femininity

was not to be taken entirely at face value."[143] According to Elliott, decadence allowed Laurencin to display and render problematic early twentieth-century conceptions of femininity and heterosexuality.[144]

In her essay on Gray, Brooks and Gluck, Elliott does not pursue the compelling significance of decadence in Gray's work (but suggests that she will, in a forthcoming publication). Instead, she focuses on the three artists' shared concern for housing their work, which led Gray from designing individual pieces of furniture to full interior design schemes and finally to architecture, Brooks to distinctive redecoration of her apartments and studios, and Gluck to home renovations and the eventual construction of a custom-designed separate studio. They were each known to be dissatisfied with the conventional spaces in which their work was shown, in galleries or group exhibitions, and seemed compelled to create alternate spaces: "As these three women became progressively more interested in designing appropriate surrounding for what they produced, their living spaces took on various qualities associated with the experimental form of the *maison d'artiste*."[145] Elliott notes that these hybrid living and working spaces were historically associated with the elaborate interiors of decadent aesthetes like the Comte de Montesquiou and Joris Karl Huysmans' Des Esseintes, which included "sensuous areas of display for exhibiting art and seducing models and viewers."[146] Elliott argues that Gray mixes elements of the sensual, feminized boudoir with the austere, masculinized study to produce gender-free living and working spaces, whereas Gluck and Brooks both produce a specifically "woman's version of the *maison d'artiste*."[147] Both Brooks and Gluck incorporated their bachelor ateliers into paintings; "however, the seductions of the interior were given a new twist by openly catering to lesbian desire":[148] Brooks staked a claim to the body of her lover, Ida Rubinstein, by posing her as Manet's Olympia in surroundings that would have been recognized by viewers" through publicity photos of Brooks' apartment;[149] and Gluck produced several paintings of all-white flowers, set in her studio, that would have been recognized as arrangements by her lover Constance Spry, whose all-white floral signature was well known.[150] Elliott concludes that this

generation of women artists and designers worked in and on their homes to advance aesthetic positions that laid claim to new possibilities for women –
either by denying the importance of gender and effacing its traces in the
built environment as in the example of Gray, or by finding ways to visualize
and house lesbian desire as in the cases of Brooks and Gluck.[151]

This generation of women artists and designers focused on the design of their living spaces to fashion new ways of living their gender and sexual identities. Elliott's argument, that interior design promised "new possibilities for women," relies on the unstated assumption that these women understood interior space to have the power to create or at least enable new identities or subjects.

Conclusions

I will return to Elliott's essay on Gray, Brooks and Gluck in the next chapter, but for now I hope to have shown that the assumption underlying her argument, that redesigning domestic space at the start of the twentieth century was linked to redesigning subjects, is critical to understanding not only women's practices of interior design but all of the major modern architectural and design practices and theories of the early part of the twentieth century. Moreover, I hope this chapter has shown that this belief in the affective powers of architecture and interior design has a very particular history in France, being linked to late nineteenth-century theories of degeneration and decadence. Discoveries in *psychologie nouvelle*, particularly by Charcot and Bernheim, that the built environment has physiological and psychological effects, and so could be used in therapeutic treatments of a French population understood to be suffering a crisis of degeneration, fundamentally influenced architectural theory and practice into the twentieth century. Modern architects came to understand not only that modern bodies were ailing but that architects and designers had the power and scientifically bolstered authority to heal them. And from the moment when modern architecture came to be invested in the body it joined modernity's "great family of technologies of sex"[152] in regulating, defining and producing viable sexual subjects.

The bond between modern subjectivity, interior design and architecture was first forged, then, in the nineteenth century through the convergence of new psychology, the decorative arts and decadent aesthetics, and by the early twentieth century this unlikely triad had naturalized into a commonsense architectural understanding: the healthy psychological, physical and sexual constitution of the modern subject depended on interior design, and for those architects who have come to define modernism's international style this was an interior that had been radically stripped of any suggestion of decadence. While women writers were using decadence to formulate a poetics of female desire, and women artists may have used it to fashion a sexually dissident visibility, when Gray uses decadent aesthetics in the context of interior design, her sexual politics are less explicit. However, by the early twentieth century her choice to work in avant-garde interior design and architecture brought her directly into a field of discourse on healthy modern subjectivity, which was fundamentally about regulating bodies and sexuality. And the healthy body in this discourse, which borrowed from nineteenth-century psychology and decorative arts, was that which strictly disciplined its degenerate tendencies by purging any trace of decadent aesthetics from its (psychological and architectural) interior spaces. I hope to have shown that Gray's critically different, and not simply or benignly "other," architectural and design works signal an investment in the intimate passions, pleasures, needs, tastes and lives of subjects who were left out of modern architecture's plans. Above all,

I hope this chapter provides something of an introduction to the argument that I will be pursuing throughout this book, which is that Gray shared with her female friends, lovers, clients, colleagues and contemporaries an investment in creating space, visual, literary, imaginary and architectural, for non-heterosexual female subjects.

Notes

1. Le Corbusier, *Towards a New Architecture* (1923), F. Etchells, trans. (New York: Dover Publications, 1986), 14, 20.
2. Guillaume Janneau, *Art et décoration* (1924), as quoted in Peter Adam, *Eileen Gray, Architect, Designer: A Biography* (New York: Harry N. Abrams, Inc., 2000), 140.
3. Mark Peach, "'Der Architekt denkt, die Hausfrau lenkt': German Modern Architecture and the Modern Woman." *German Studies Review*, vol. 18, no. 3 (October 1995), 441.
4. Steven Mansbach, *Visions of Totality: Laszlo Moholy-Nagy, Theo van Doesburg, and El Lissitzky* (Ann Arbor, MI: UMI Research Press, 1979), 9.
5. Piet Mondrian, *Natural Reality and Abstract Reality: An Essay in Trialogue Form 1919–1920* (New York: George Braziller, Inc., 1995), 90, 67.
6. Theo van Doesburg, "Persisting Life-Style and Architectural Innovation" (1924), in *On European Architecture: Complete Essays from Het Bouwbedrijf 1924–1931*, Charlotte I. Loeb and Arthur L. Loeb, trans. (Basel, Switzerland: Birkhäuser Verlag, 1990), 17.
7. Walter Gropius, *New Architecture and the Bauhaus* (London: Faber and Faber Limited, 1935), 31.
8. Peter Behrens, "Introductory Comments, Exhibition Catalogue, Darmstadt, May 1901," in *Industriekultur: Peter Behrens and the AEG, 1907–1914* (London, England: MIT Press, 1984), 207.
9. Peach, "Der Architekt denkt," 441.
10. Beatriz Colomina, "The Medical Body in Modern Architecture," *Daidalos: Architektur, Kunst, Kultur*, vol. 64 (1997), 64.
11. Sylvia Lavin, "New Mood or Affective Disorder," *Assemblage*, no. 41 (2000), 40.
12. Michel Foucault, *The History of Sexuality*, vol. I: *An Introduction* (1978) (New York: Vintage Books, 1990).
13. Mary Louise Roberts, *Civilization without Sexes: Reconstructing Gender in Postwar France, 1917–1927* (Chicago: University of Chicago Press, 1994), 4.
14. Caroline Constant, *Eileen Gray* (London: Phaidon Press Limited, 2000), 7.
15. Eileen Gray, "From Eclecticism to Doubt" (1929), in Constant, *Eileen Gray*, 239.
16. Unknown author, *Art et décoration* (1923), original press clipping held in the Gray archive, Collins Barracks, National Museum of Ireland, Dublin, quoted in Constant, *Eileen Gray*, 52.
17. Unknown author, *Art et décoration* (1923), original press clipping held in the Gray archive, Collins Barracks, National Museum of Ireland, quoted in Constant, *Eileen Gray*, 52.
18. For an early description of Le Corbusier's "machine aesthetic," see Le Corbusier and Amadée Ozenfant, "Purism" (1920), in *Modern Artists on Art: Ten Unabridged Essays*, Robert Herbert, ed. (Englewood Cliffs, NJ: Prentice-Hall, Inc., 1964); and for more on these two competing styles in France in the 1920s, see Nancy J. Troy, *Modernism and the Decorative Arts in France: Art Nouveau to Le Corbusier* (New Haven and London: Yale University Press, 1991).
19. Unidentified, original press clipping held in the Gray archive, Collins Barracks, National Museum of Ireland, quoted in Constant, *Eileen Gray*, 52.
20. Unknown author in *L'amour de l'art* (1923), original press clipping held in the Gray archive, Collins Barracks, National Museum of Ireland, quoted in Constant, *Eileen Gray*, 52.

21. As I discuss in the Introduction, Reyner Banham argues that her work was "part of a personal style and philosophy of interior design which was ... too rich for the punditry of the time to take." See "Nostalgia for Style," *New Society* (February 1973), 249.
22. Jean Badovici, "L'art d'Eileen Gray", *Wendingen*, vol. 6, no. 6 (1924), 2 (special issue on Eileen Gray), transcribed in French in the Eileen Gray archive, Victoria and Albert Museum, London, England, my translation.
23. Adolf Loos, "Ornament and Crime" (1908), in *Crime and Ornament: The Arts and Popular Culture in the Shadow of Adolf Loos* (Toronto, Ontario: YYZ Books, 2002).
24. Le Corbusier and Ozenfant, "Purism," 60.
25. Le Corbusier, *Towards a New Architecture*, 7, 277.
26. Badovici, "L'art d'Eileen Gray," 4, 2.
27. Louis Vauxcelles: "elle suit, peut-être à son insu, une marche parallèle à celle de nos peintres logicians ... mystérieuse jusqu'à l'ésotérisme.... Et l'hymne à la geometrie est miraculeusement chanté" (undated manuscript, Eileen Gray archive, Victoria and Albert Museum).
28. Wils, quoted in the Dutch journal *Handelsblad* (undated French transcript, in the Eileen Gray archive, Victoria and Albert Museum).
29. Wils, quoted in the Dutch journal *Telegraf* (undated French transcript, in the Eileen Gray archive, Victoria and Albert Museum).
30. Ibid.
31. Wils: "puisées dans des richesses inéxprisables d'esprit et de désire de luxe" (quoted in the Dutch journal *Handelsblad*, undated French transcript, in the Eileen Gray archive, Victoria and Albert Museum).
32. Anonymous reviewer in the Dutch journal *Handelsblad* (undated French transcript, in the Eileen Gray archive, Victoria and Albert Museum).
33. Boeken, 1923, transcribed in the Eileen Gray archive, Victoria and Albert Museum, my translation from the French.
34. For more on cultural anxiety about gender, feminine fashion and French civilization, see Mary Louise Roberts, *Civilization without Sexes*.
35. Constant, *Eileen Gray*, 41.
36. Elaine Showalter, *Sexual Anarchy: Gender and Culture at the Fin de Siècle* (New York: Viking, 1990), 171.
37. Badovici, "L'art d'Eileen Gray," 4.
38. Leslie Topp, "An Architecture for Modern Nerves: Josef Hoffman's Purkersdorf Sanatorium," *The Journal of the Society of Architectural Historians*, vol. 56, no. 4 (December 1997), 414, quoting Le Corbusier, *The Radiant City* (1933).
39. Le Corbusier, *Towards a New Architecture*, 7.
40. Ibid., 16.
41. Colomina, "Medical Body," 60.
42. Ibid., 61.
43. Le Corbusier, *Towards a New Architecture*, 16.
44. Sylvia Lavin, "Open the Box: Richard Neutra and the Psychology of the Domestic Environment," *Assemblage*, no. 40 (1999), 6.
45. Debora L. Silverman, *Art Nouveau in Fin-de-Siècle France: Politics, Psychology and Style* (Berkeley: University of California Press, 1989).
46. Ibid., 85.
47. Mark S. Micale introduces his recent anthology on the formative connections between modern art and psychology by arguing that "the cultural affinities between aesthetic and psychological Modernism are in fact strikingly varied and detailed.... Both the arts and the sciences studied the unconscious, subconscious, and subliminal levels of mental life" (Micale, Introduction to

The Mind of Modernism: Medicine, Psychology, and the Cultural Arts in Europe and America, 1880–1940, Mark S. Micale, ed. (Stanford, CA: Stanford University Press, 2004), 2). Moreover, in his chapter on "Discourses of Hysteria in Fin-de-Siecle France," he explains that Charcot was particularly significant in this history of cross-over between psychological and aesthetic modernism: "To a degree surpassed by no other figure in the history of [new psychology], Charcot inspired paintings, novels, and plays as well as extensive commentary in the popular press" (Micale, *The Mind of Modernism*, 74).

48. Bernheim, quoted in Silverman, *Art Nouveau*, 87.
49. Silverman, *Art Nouveau*, 87.
50. Ibid., 87, 88.
51. Ibid., 81.
52. Ibid., 80.
53. Ibid., 77.
54. On *À rebours* as the first decadent novel, see Richard A. Long and Iva G. Jones, "Towards a Definition of the 'Decadent Novel,'" *College English*, vol. 1 (1961), 247.
55. Silverman, *Art Nouveau*, 78.
56. J.-K. Huysmans, *Against the Grain (À rebours)* (New York: Dover Publications, 1969), 15, 16.
57. Silverman, *Art Nouveau*, 77.
58. Ibid., 82.
59. Jason Edwards, "'The Generation of the Green Carnation': Sexual Degeneration, the Representation of Male Homosexuality, and the Limits of Yeats' Sympathy," in *Modernist Sexualities*, Hugh Stevens and Caroline Howlett, eds (Manchester and New York: Manchester University Press, 2000), 41.
60. And both Huysmans and Wilde based their main characters' aesthetic sensibilities on the works of Baudelaire, the literary forefather of European decadence. For more on Baudelaire's influence on Huysmans and Wilde, see Wolfdietrich Rasch, "Literary Decadence in Artistic Representations of Decay," *Journal of Contemporary History*, vol. 17, no. 1 (January 1982), 201–218.
61. Jane Caplan, "'Educating the Eye': The Tattooed Prostitute," in *Sexology in Culture: Labelling Bodies and Desires*, Lucy Bland and Laura Doan, eds (Chicago: University of Chicago Press, 1989), 106.
62. Richard von Krafft-Ebing, *Psychopathia sexualis* (1886, 12th edition 1903), reprinted in *Sexology Uncensored: The Documents of Sexual Science*, Lucy Bland and Laura Doan, eds (Chicago: University of Chicago Press, 1989), 45.
63. Laura Doan and Chris Waters, "Homosexualities: Introduction," in *Sexology Uncensored*, Bland and Doan, eds, 42.
64. Silverman, *Art Nouveau*, 83.
65. Ibid., 4.
66. Ibid., 5.
67. Loos, "Ornament and Crime," 102.
68. Ibid., 100.
69. Colomina, *Privacy and Publicity: Modern Architecture as Mass Media* (Cambridge, MA: The MIT Press, 1998), 38.
70. Mark Wigley, *White Walls, Designer Dresses: The Fashioning of Modern Architecture* (Cambridge, MA: The MIT Press, 1995), 10.
71. Le Corbusier, *Decorative Art*, 85.
72. Ibid., 90.
73. Ibid., 90.
74. Ibid., 96.
75. Ibid., 192.

76. Ibid., 192.
77. Colomina, "Medical Body," 61.
78. Ibid., 63.
79. David S. Barnes, *The Making of a Social Disease: Tuberculosis in Nineteenth-Century France* (Berkeley: University of California Press, 1995), 134.
80. For more on scientific racism in the regulation of sexuality and production of "homosexuality," see Siobhan Somerville, "Scientific Racism and the Emergence of the Homosexual Body," *Journal of the History of Sexuality*, vol. 5, no. 2 (October 1994), 243–266; and Somerville, *Queering the Color Line: Race and the Invention of Homosexuality in American Culture* (Durham, NC: Duke University Press, 2000).
81. Christina Cogdell, *Eugenic Design: Streamlining America in the 1930s* (Philadelphia: University of Pennsylvania Press, 2004), 4.
82. Le Corbusier, *Towards a New Architecture*, 4.
83. Ibid., 277.
84. Ibid., 14.
85. Ibid., 271.
86. Ibid., 14.
87. Ibid., 20.
88. Ibid., 14.
89. Ibid., 288.
90. Ibid., 277.
91. Ibid., 277.
92. Ibid., 14, 16.
93. Ibid., 14.
94. Ibid., 18–19.
95. Ibid., 284.
96. Wigley, *White Walls*, 302–303.
97. Ibid., xviii.
98. Ibid., 7.
99. Foucault, *History of Sexuality*.
100. Ibid., 108.
101. Colomina, "Medical Body," 61.
102. Foucault, *History of Sexuality*, 119.
103. Ibid., 119.
104. Christopher Reed, "Introduction," in *Not at Home: The Suppression of Domesticity in Modern Art and Architecture*, Christopher Reed, ed. (London: Thames and Hudson, Ltd. 1996), 15.
105. Ibid., 16.
106. Foucault, *History of Sexuality*, 108.
107. Gray, "From Eclecticism to Doubt" and "Description" (1929), in Constant, *Eileen Gray*, 240–241.
108. Le Corbusier published his "five points" for a new architecture in *L'architecture vivante*, where he included a sixth point ("suppression of the cornice"). See Le Corbusier, "Où en est l'architecture?," in *L'architecture vivante* (Fall 1927), 7–11.
109. Le Corbusier: "I am so happy to tell you how much those few days spent in your house have made me appreciate the rare spirit which dictates all the organisation inside and outside. A rare spirit

which has given the modern furniture and installations such a dignified, charming, and witty shape." From a postcard written by Le Corbusier to Eileen Gray in 1938, trans. in Adam, *Eileen Gray*, 309–310. The original postcard is held in the Eileen Gray archive, Collins Barracks, National Museum of Ireland.

110. Joseph Rykwert, "Eileen Gray: Pioneer of Design," *Architectural Review*, vol. 152, no. 910 (December 1972), 357.

111. Adam, *Eileen Gray*, 375, 147.

112. Constant, *Eileen Gray*, 120.

113. Chelsea Ray, "Decadent Heroines or Modernist Lovers: Natalie Clifford Barney's Unpublished *Feminine Lovers or the Third Woman*," *South Central Review*, vol. 22, no. 3 (Fall 2005), 34.

114. The two censored poems were "Lesbos" and "Condemned Women: Delphine and Hippolyta," a longer and less scurrilous version of the "Condemned Women" that was allowed to press. For more on the censorship trial, see Gretchen Schultz, "Baudelaire's Lesbian Connections," in *Approaches to Teaching Baudelaire's "Les fleurs du mal,"* Laurence Porter, ed. (New York: The Modern Languages Association of America, 2000), 130–138.

115. Ray, "Decadent Heroines," 33–34.

116. Constant, *Eileen Gray*, 7.

117. Baudelaire, "L'invitation au voyage" (1857), William Aggeler, trans., in *The Flowers of Evil* (Fresno, CA: Academic Library Guild, 1954), 178–179.

118. Baudelaire, "L'invitation au voyage" (1869), Francis Scarfe, trans., in *Baudelaire: The Complete Verse* (London: Anvil Poetry, 1986), 79.

119. Baudelaire, "L'invitation au voyage" (1857), 79.

120. Bridget Elliott, "Deconsecrating Modernism: Allegories of Regeneration in Brooks and Picasso," in *The Modern Woman Revisited: Paris between the Wars* (New Brunswick, NJ; and London: Rutgers University Press, 2003), 45. For more on the return to traditional gender roles in the interwar period in France, see Mary Louise Roberts, *Civilization without the Sexes* and Kenneth Silver, *Eprit de Corps: The Art of the Parisian Avant-Garde and the First World War, 1914–1925* (Princeton: Princeton University Press, 1989).

121. Elliott, "Deconsecrating Modernism," 45, citing Silver, *Esprit de Corps*.

122. Elliott, "Deconsecrating Modernism," 46.

123. Baudelaire, "L'invitation au voyage" (1857), 79.

124. Ibid., 81.

125. Ibid., 80.

126. "Much like the imaginary country that Charles Baudelaire conjured up in his prose poem 'L'invitation au voyage' (1869), an inspiration for Gray's mural in the E.1027 salon, one could say of her architecture: 'It is there we must go to breathe, to dream, and to prolong the hours in an infinity of sensations'" (Constant, *Eileen Gray*, 120).

127. Ray, "Decadent Heroines," 33.

128. Constant, *Eileen Gray*, 8.

129. Bridget Elliott and Jo-Anne Wallace, *Women Artists and Writers: Modernist (Im)positionings* (London and New York: Routledge, 1994), 39.

130. Ibid., 31.

131. Ray, "Decadent Heroines."

132. Laura Doan, *Fashioning Sapphism: The Origins of a Modern English Lesbian Culture* (New York: Columbia University Press, 2001), 63.

133. Elisabeth de Clermont-Tonnerre, "Les laques d'Eileen Gray," *Feuillets d'art*, no. 3 (March 1922), republished in English as "The Laquer [sic] Work of Miss Eileen Gray," *The Living Arts*, no. 3 (March 1922), 147.

134. Ibid., 148.

135. Ibid., 148.

136. Bridget Elliott, "Housing the Work: Women Artists, Modernism and the *maison d'artiste*: Eileen Gray, Romaine Brooks and Gluck," in *Women Artists and the Decorative Arts, 1880–1935 :Tthe Gender of Ornament*, Bridget Elliott and Janice Holland, eds (Aldershot, England, and Burlington, VT: Ashgate, 2002), 180.

137. Joseph Rykwert, "Eileen Gray: Two Houses and an Interior, 1926–1933," *Perspecta*, vol. 13, no. 14 (1972), 69.

138. Reyner Banham, "Nostalgia for Style," *New Society* (February 1973), 249.

139. Ibid., 249.

140. This idea of sapphic modernism has been taken up in recent feminist literature , but perhaps most productively by Laura Doan. Doan has focused on the role of clothing and photography in *Fashioning Sapphism*, and has edited, with Jane Garrity, the collection *Sapphic Modernities: Sexuality, Women and National Culture* (New York: Palgrave Macmillan, 2006). Doan's work expands the scope of sapphic modernism that Benstock introduced to consider the contested and not only literary cultures of sapphic modernities produced in the early twentieth century.

141. Shari Benstock, *Women of the Left Bank: Paris, 1900–1940* (Austin: University of Texas Press, 1986); and "Expatriate Sapphic Modernism: Entering Literary History," in *Lesbian Texts and Contexts: Radical Revisions*, Karla Jay and Joanne Glasgow, eds (New York: New York University Press, 1990).

142. Cassandra Laity, "H.D. and A.C. Swinburne: Decadence and Sapphic Modernism," in *Lesbian Texts and Contexts*, Jay and Glasgow, eds, 218.

143. Bridget Elliott, "Arabesque: Marie Laurencin, Decadence and Decorative Excess," in *Modernist Sexualities*, Hugh Stevens and Carline Howlett, eds (Manchester and New York: Manchester University Press, 2000), 94.

144. Ibid., 95.

145. Elliott, "Housing the Work," 177.

146. Ibid., 181.

147. Ibid., 184.

148. Ibid., 185.

149. Ibid., 195.

150. Ibid., 186.

151. Ibid., 188.

152. Foucault, *History of Sexuality*, 119.

2

Screening sexuality: Eileen Gray and Romaine Brooks

> One goes into the room—but the resources of the English language would be much put to the stretch, and whole flights of words would need to wing their way illegitimately into existence before a woman could say what happens when she goes into a room.... One has only to go into any room in any street for the whole of that extremely complex force of femininity to fly in one's face.
>
> Virginia Woolf[1]

The existing literature on Gray has tended to emphasize her relationship to major male modernist figures and the architectural and aesthetic movements that they have come to represent. Le Corbusier's Purism and machine aesthetic, Walter Gropius' Bauhaus functionalism and J.P.P. Oud's De Stijl abstract minimalism, the influences that are most commonly invoked, obviously informed her work and constituted an important context within which her architectural projects developed. However, this exclusive focus on Gray's place within canonical modern architectural history has failed to account for the critical differences constituted by Gray's work. Since the 1920s, critics have commented, with varying degrees of discomfort, on her mixed-genre aesthetics – the uneasy mingling of pre-modernist, nineteenth-century sensuality and luxury with distinctly early twentieth-century modernist abstraction and minimalism – but there has not yet been any significant consideration of what this unusual design aesthetic may have meant, to Gray or to her contemporaries. The architectural historian Caroline Constant has produced the most extensive work on Gray, arguing throughout that Gray's work needs to be understood as not simply or benignly different, but as posing a "significant challenge to modern movement tenets."[2] Moreover, Constant contends that Gray's challenge consists of her uniquely sensual aesthetic: "Gray's focus on the kinaesthetic, tactile, and sensual potential of architecture and furniture ... was unprecedented in Modern-Movement discourse."[3] If we continue, as Constant has done, to read Gray's work in relation to a modern movement narrowly defined by such figures as Le Corbusier, Gropius and Oud, we must conclude that her work was, indeed, "unprecedented."

As Lynne Walker has recently argued, however, this approach risks constructing Gray as an isolated and exceptional "great woman" artist, and leaving the structure by which we judge great modernist artists unchallenged. Celebrating Gray as "the feminists' heroine" par excellence[4] leaves many questions unanswered for feminist critics of architecture, aesthetics and modernism. Walker asks:

> Is Eileen Gray in danger of becoming that mythic beast for architecture, the enigmatic, but great woman who designed canonical modernist buildings? Moreover, are we simply adding Eileen Gray to architectural history without challenging architectural histories' categories or changing the rules of the game? ... At worst are we, those readers and writers of Eileen Gray's work, merely providing the defining opposite of male creativity? ... Can we find a positive, more productive reading of "Eileen Gray", the historical subject, in what Griselda Pollock has identified as "a gap ... that space of possibility": between gendered cultural prescriptions of femininity and difference which is outside "dominant masculine meanings" embodied in modernist history – a space for re-making history as its readers and writers, as well as for artistic production?[5]

I believe that shifting the historical focus, to include some of those figures and creative works that have fallen outside the scope of canonical modernist history, can begin to produce a more positive reading of Gray as a subject, designer and architect and can contribute to a more nuanced historical understanding of early twentieth-century artistic production generally. If Gray has been constructed as this great "mythic beast," the isolated exception to the still unchallenged rule, this is because she has been read only in relation to the modernism that she was criticizing and not the modernism from which her criticisms were generated. That is, Gray's critical emphasis on the tactile and sensual was far from unprecedented in the modernism constituted by Gray's female friends, lovers, colleagues and clients.[6] I will focus in this chapter on reading Gray's early lacquer works in relation to Romaine Brooks' first two nude paintings in order to explore some of the ways in which their emphases on sensuality and tactility can be understood as strategic recuperations of decadent aesthetics and engaged with early twentieth-century debates about domesticity, gender and sexuality.

In 1910, Brooks had her first solo exhibition at the Galerie Durand-Ruel in Paris. Among several other works, Brooks showed her first two female nudes, *White Azaleas* (1910) and *The Screen* (1910). *White Azaleas* depicts a languidly reclining woman, naked on a divan, her head and chest raised by a mound of plush cushions, her torso and hips angled towards the viewer, shrouded by shadow and surrounded by dark furnishings, save for the crowd of white flowers claiming the front right third of the canvas. The greenish grey of her skin tone and the horizontal stretch of her body are echoed in a wall mounted screen behind her, whose six panels depict three small ships floating in a hazy seascape. The woman's unsmiling face and distant gaze complicate the stark accessibility of her naked body, rendering her at once inviting and foreboding.

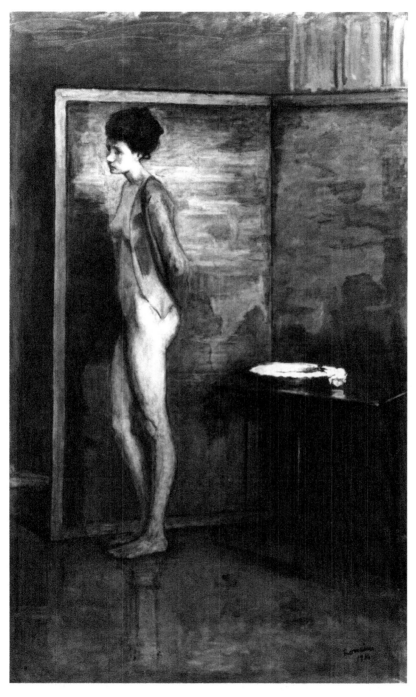

2.1 Romaine Brooks, *The Screen* (or *The Red Jacket*), 1910. Courtesy of the Smithsonian American Art Museum.

This same year, Brooks painted a similarly intimate and sombre scene in *The Screen* (Figure 2.1). A frail young woman stands before a tall free-standing bi-panelled screen, naked save for a short red jacket slung over one shoulder. Her similarly languid but angular frame elongated by the vertical lines of the screen, depicting another hazy scene, muted and indistinct, in browns, greys and black that again echo the woman's skin tone. A white hat lies waiting on a shining black lacquer table, and we realize that we have been invited into a scene as candid as that depicted in *White Azaleas*. The young woman is either dressing or undressing, and the screen that is meant to block her naked body from view is instead serving as a frame for our gaze. The young woman is shown in profile, looking away, relaxed, unhurried, unaware of or unconcerned by her viewer's presence. This screen as frame is a visual reminder of some transgression, a privileged or illicit look at some ambiguously intimate scene.

Between 1912 and 1915, Gray produced lacquered folding screens as well as door and wall panels that resembled Brooks' paintings in tone and style. *La voie lactée* (ca. 1912), made for her friend Florence Gardiner, is a four-panelled folding screen, depicting a slim nude figure striding overtop a mountainous landscape, its hair streaming behind to form the milky way across the four panels. The scene is cast in shades of dark blue, lit by silver highlights. The night sky is made of mother of pearl inlaid over midnight blue lacquer, and the body and landscape are a deeper blue, almost black, with silver outlines illuminated by the stars.[7] The figure has been read as female, but corresponds to an ethereal and androgynous femininity more characteristic of late nineteenth-century symbolism than the femininities figured by her cubist and orphist contemporaries. Her body, thin and stretched across the two left panels of the screen, recalls Brooks' two nudes, whose angular figures were similarly elongated by the screens that framed them.

In 1914, Gray produced another four-panelled lacquered folding screen, entitled *Le destin*. The figural side represents a drama of some kind, with three human figures, two of them youths, naked in blue, and one apparently aged, shrouded in grey, all three being sharpened by a thin silver outline (see Figure 2.2a). One figure anxious in the far right panel, his hand reaching into the second panel, strains towards the other blue figure in the third panel, who, separated by the hinged fold, burdened by the weight of the old body on his shoulder and with grey robes threatening to overwhelm him, walks off into the open space of the fourth panel. The verso shows swirling, thin silver arabesque lines opening to gashes of gold and black, set on the same burnt red background (see Figure 2.2b). Standing 199 cm and stretching 213 cm, with deep layers of luminescent and reflective lacquer and tall standing panels folding into a room – pleating the space, at once architectural, decorative and anthropomorphic – *Le destin* makes a striking imposition into domestic space.

SCREENING SEXUALITY: EILEEN GRAY AND ROMAINE BROOKS 65

2.2a Eileen Gray, *Le destin*, 1913.

The mystery of the drama enacted is never solved, either by the screen or by the critical literature that discusses it. Gray left no hint as to the meaning or the content of the story depicted, only this haunting and impressive image of striving, unsatisfied desire that she called "destiny" – the abstract searching and uneasy spin inward towards a centre that is not given, the naked human desire to contact, to touch another body who walks heavily away, loaded with an aged and indistinct burden. While Gray offered to domestic space this imposing presence of unresolved desire at the very outset of her career, no literature has seriously considered this or any of her pre-1924 interior design or, most importantly, what she might have been trying to contribute to understandings of domesticity and desire at the time.

2.2b Eileen Gray, *Le destin*, 1913.

In 2002, Bridget Elliott published the first investigation of the continuities between Gray's interior design work and that of her female contemporaries, Gluck and Brooks. As we saw in Chapter 1, Elliott argues that they were part of a generation of "women artists who were independently wealthy and who for most of their lives lived alone, even while entering into various lesbian and occasional heterosexual relationships …[and who] worked in and on their homes to advance aesthetic positions that laid claim to new possibilities for women."[8] While Gray was clearly less interested in representation than these two portrait artists, I think that by looking closely at her early, pre-1924 work, we can see that she was not only "denying and effacing the traces of gender" in domestic space.[9] Instead, I would like to argue that she was using the highly charged language of interior design to affirm precisely those traces of gender and sexuality that modern art and architecture were suppressing

at the start of the twentieth century. By comparing Brooks' first two nude paintings to Gray's first lacquer works – two folding screens, *Le destin* and *La voie lactée*, and a door panel entitled *Le magicien de la nuit* (1912) – we can see that both artists used their interior decoration, in combination with elements of decadent aesthetics, to imagine modern domestic space built to accommodate rather than expurgate new femininities and sexualities.

Domesticity, femininity and sexuality

During the nineteenth century, several factors, including the challenge of the *femme nouvelle*, increased urbanization, the rise of new communication technologies, discoveries in the new discipline of human psychology and developments in literary, visual and applied arts, contributed to the modern invention of "domestic space"." As Christopher Reed notes, "the idea of domesticity is an invention of the modern age. According to the cultural historian Walter Benjamin, it was in the early 1800s that, 'for the first time the living space became distinguished from the space of work.'"[10] Debora Silverman argues that by the end of the nineteenth century in France, domestic space was imbued with physical and psychological healing powers and was entrusted along with the combined forces of the decorative arts and new psychology with ensuring the health of the modern French citizen.[11] Similarly, Beatriz Colomina has argued that the history of modern architecture is inseparable from the history of tuberculosis – that modern architecture conceived of itself from the turn of the last century as not only a "machine-tool" but as a medical-machine-tool, committed to eliminating all modern pestilence for which tuberculosis and consumption became short-hand.[12] Moreover, as historians of sexuality have shown, during this same period, conceptions of health came to be entangled for the first time with ideas about sex. The healthy subject was defined in opposition to all varieties of sexual act, fantasy or desire which fell outside a newly identified and increasingly normative model of heterosexuality.[13] The modern invention of domesticity is so intimately involved with definitions of physical, psychological and sexual health that any representation of or commentary on domestic space needs to be understood as a contribution to debates about what constitutes healthy subjectivity.

In this context, it seems hardly surprising that Gray and Brooks, in many ways prototypical *femmes nouvelles*, living on handsome family inheritances as professional artists and pursuing intimate relationships with other women, would turn their attention to interior design at the very start of their independent lives. In 1906, Gray moved permanently away from her family to purchase and settle into her apartment, on 21 rue Bonaparte in Paris. From that time, her interest shifted from the painting

and sculpture taught in art school to carpet and furniture design, which she was introduced to in a workshop in London and continued to pursue with the collaboration of her female friend Evelyn Wyld and her lover Gabrielle Bloch. From 1910 to 1925, Gray was exclusively engaged in the design and production of carpets and furniture, which she generally sold individually, and used to redecorate one complete apartment for Madame Mathieu-Levy, owner of the fashion salon Suzanne Talbot (1919–24). As Constant notes, Gray carried out renovations on her own apartment, incorporating pieces of her own design, from the time she first bought it to the time of her death in 1976.[14]

While this early period is much less extensively studied than her few architectural projects, Gray dedicated the first 15 years of her career exclusively to interior design, and even when she turned her attention to architecture the problem of interior decoration would remain her central concern. In 1928, after having completed her first house, E.1027, she writes, "[e]xternal architecture seems to have absorbed avant-garde architects at the expense of the interior, as if a house should be conceived for the pleasure of the eye more than for the well-being of its occupants.... [Instead,] it should ensure calm and intimacy."[15] Gray's work was always dedicated to rethinking and redesigning the interior and organized around the need for sensual pleasure and intimacy. Years later she writes, "the poverty of architecture today results from the atrophy of sensuality."[16] Even after she turned her attention away from individual domestic projects and towards multi-dwelling apartment complexes and large-scale cultural and vacation centres (starting in the 1930s), her work continued to be motivated by what she saw as modern architecture's neglect of sensual domestic interiors.

Brooks also turned her attention to rethinking and redesigning domestic space from the time of purchasing her first large apartment in Paris, on avenue du Trocadéro, in 1908. From this time onwards, Brooks significantly redecorated each apartment and house she lived in while in Paris, New York and the south of France. In at least two of her apartments she moved beyond interior decoration to design major renovations, at her apartment on rue Raynouard in Paris, where she used two carpets and a *couvre-pieds* designed by Gray,[17] as and at the house near St. Tropez, shared and designed with her lover Natalie Barney, which they called "Villa Trait d'Union." All of her apartments and houses used the same stark style and signature tones of white, black and grey that she had first made famous in her Trocadéro apartment, and which would eventually prove to be Gray's favoured style and colour tones. In fact, at the time of her first solo show in Paris, in 1910, her interior decoration gained almost as much critical attention as her paintings, and many reviews commented on the aesthetic similarities between her personal fashion, her interior decoration and the artworks shown:

Mrs. Brooks is still a young woman possibly under the 30s. Of an exquisitely picturesque type, she reminds one of a beautiful old-fashioned picture. Her gowns, like her home, all have the individual touch. The soft velvet carpets on the stairs and the hall are plain light grey with a narrow black border made after her design. The brocaded hangings were made for her. The salon is in delicate light grey with accents of black, the only spots of colour being in the old masters' paintings on the wall and that of her own work.[18]

While Brooks never worked professionally in interior design, her decorative advice was sought by several of her friends, and the distinctive style of her own apartments was well known. Her decorative work at her Trocadéro apartment was so widely admired that both "the notorious aesthete Robert de Montesquiou"[19] and the "celebrated dandy" Henri Bernstein consulted her in hopes of emulating her distinct style.[20] She was a reluctant consultant, and designed only for her own living and working spaces. However, not only did the early paintings included in her first show resemble her domestic interiors stylistically, as critics remarked, with their shadowy, muted tones of grey, but they were also often set in and represent parts of her apartment's interior decoration.

Upon moving to Paris in the first decade of the twentieth century, embarking on the first steps of their artistic careers and identities, taking decisive steps away from familial obligations, pursuing what seem to be their first intimate relationships with women and acquainting themselves with Paris' burgeoning sexually dissident subculture, both Brooks and Gray took on the challenge of rethinking and redesigning domestic space. Elliott, citing Brooks' unpublished autobiography, writes that Brooks "recalled her enormous pleasure at realizing that she had both the means and the freedom to decorate the apartment as she liked. Rejecting the Victorian decoration she had grown up with, Brooks deliberately set out to create a décor that would reflect her own taste."[21] Along with so many artists and architects at the start of the twentieth century, Brooks and Gray recognized the importance of refashioning domestic space to accommodate their own needs and tastes, and Gray committed her life's work to designing domestic spaces for the needs and tastes of those she saw as neglected. As Peter McNeil has explained, interior decoration was, in some ways, understood as a natural extension of femininity, and indeed this assumption may have enabled the women who dominated the profession of interior decoration from the 1890s through to the 1940s:

The "lady decorator" dominated the popular image of the profession at a time when economic independence was socially unacceptable for such women. Rather than describing it as work, interior decoration was frequently characterised as an extension of women's natures, directly compared to the female compulsion to colour-blend complexion and costume.[22]

Moreover, many historians have argued that while the naturalized association of femininity, women and domesticity predates the nineteenth century,[23]

by the beginning of the twentieth century these terms were conceptually inseparable, with each always already referring to the other. Thus the collection of essays that Christopher Reed compiled to make up the book *Not at Home: The Suppression of Domesticity in Modern Art and Architecture*, addressing "the antagonism of twentieth-century art and architecture toward the values associated with domesticity," is also inevitably addressing "the enforcement of conventional divisions of masculinity and femininity (along with their compliment, heterosexuality)."[24] As Reed explains, "the home has been positioned as the antipode to high art. Ultimately, in the eyes of the avant-garde, being undomestic came to serve as a guarantee of being art."[25] Modernist art and architecture were defining themselves through a continual repudiation of domesticity, and its related concepts, which left women with limited opportunity to claim either their aesthetic work as serious art or their working identities as seriously artistic. That is, by the early twentieth century, the identities "woman" and "artist" were virtually mutually exclusive. Moreover, while women were naturally associated with domesticity, modern architecture was increasingly dedicated to purging interiors of their associations with anything domestic.

Rather than being always and inherently "home," modern women like Brooks and Gray seem to have considered themselves fundamentally and existentially homeless. Brooks identified as a "lapidée," or outcast, and her lover, Natalie Barney, writes that "Romaine Brooks n'appartient à aucun temps, à aucun pays, à aucun milieu."[26] Both chose to live as expatriates away from their "home" countries, Brooks from the United States and Gray from Ireland. While Brooks worked in London, Paris and (briefly) New York from 1900 to the 1960s, she took part in none of the artistic organizations, schools or movements related to these modernist meccas, and was notoriously reserved and removed from even the lesbian subcultural communities that she is generally associated with. Both women have been described as solitary and resistant to social or professional groups of any kind. Brooks is frequently quoted as having written unequivocally that "Hell is other people."[27] Adam quotes Gray as having considered socializing an "endless exercise in futility"[28] and writes that she preferred work to people:

Eileen ... recognised what she knew all her life, that the freedom she longed for had to be paid for with an enduring isolation and that only by immersing herself in her work was she able to escape the perils of the pattern of life other people were drawing around her.[29]

Though Adam fails to explore what some of these "perils" might have been, feminist historians of modernity have explained that they would surely have involved prevailing assumptions about gender and sexuality. As Whitney Chadwick and Tirza Latimer have recently pointed out, "for many women artists of the last century, the refusal to conform to categorical stereotypes or

be governed by social taboos – and, especially, the rejection of received ideas about what it meant to be a woman – was a fundamental condition of artistic identity and achievement."[30] Feeling out of place was a central part of what it meant to be a woman artist at the start of the twentieth century, and with this fundamental displacement women were compelled to reinvent the languages, images and spaces by which to understand, and to be, this new woman.

Chadwick and Latimer suggest that modern women artists were engaged in the process of reinventing a new subject, "a figure divorced from the contexts that previously structured the meaning of the word *woman*,"[31] and that this subject was produced out of the sense of homelessness or alienation that Brooks and Gray seem to have experienced. Expatriation, or being between countries, was not only a geographical, residential or even lifestyle choice that women like Brooks and Gray made, but a pressing social reality that they faced. "As Virginia Woolf recognized, national identity simply did not correspond with the realities of female experience; for all intents and purposes, Woolf argued, women, as a disenfranchised class of 'outsiders', had no country."[32] Women, moreover, who refused the conventions of heterosexuality conceived of themselves in a state of "perpetual, ontological expatriation."[33] Chadwick and Latimer explain that "[if] these women were at home anywhere, it was in the space of expatriation itself. This space was an imagined and imaginary territory that the 'women of the Left Bank' (and others) went to great lengths to cultivate."[34] These women were engaged in the production of a new definition of the word "woman" that revolved around not only the reality of being essentially outsiders, but the imagining of new or outside spaces. Women like Gray and Brooks recognized that modernist art and architecture were explicitly not accommodating their version of newness, and so they turned to creating rooms of their own.

Woolf speculates on the damage done to women's creative work as a result of having been denied their own spaces, or equal access to men's spaces, for so many centuries. "A room of one's own" is figured by Woolf as not only a physical space that women have been denied, but an imaginary and imagining space, linked to a community and history of women writers, which opens to a world of women's desires and identities. It is not simply that this room, this community, this history, these desires and identities, have not existed, Woolf contends, because they have. It is, instead, that we have lacked the structures, the language and the syntax to put them into words, to give them form:

One goes into the room – but the resources of the English language would be much put to the stretch, and whole flights of words would need to wing their way illegitimately into existence before a woman could say what happens when she goes into a room.... one has only to go into any room in any street for the whole of that extremely complex force of femininity to fly in one's face. How should it be otherwise? For women have sat indoors all these millions of years, so that by this time the very walls are permeated by their creative force,

which has, indeed, so overcharged the capacity of bricks and mortar that it must needs harness itself to pens and brushes and business and politics.[35]

Woolf is describing here not only the impossibility of describing a room, a regular room, saturated with women's "creative force," but more specifically a room where "Chloe liked Olivia"[36] – that is, a room where women's relationships to other women can be based on something other than their relationships to men. "All these relationships between women, I thought, rapidly recalling the splendid gallery of fictitious women, are too simple. So much has been left out, unattempted ... almost without exception they are shown in their relation to men."[37] The unwritten, perhaps unwritable, room is figured by Woolf as both the centre of women's surplussed, repressed creative energy and their suppressed, non-heterosexual relationships to each other. This non-heterosexual would not be called homosexual, not even lesbian, as these words, only recently invented, had not yet gained currency outside medical discourse, being wrapped more in the language of disorder than in that of desires or relationships to be repressed. With this conceptual connection between sexuality, femininity, domesticity and creativity in mind, it is perhaps not surprising that so many of the women who pursued non-heterosexual relationships with other women also chose to pursue the profession and practice of interior design.[38] Many women artists at the start of the last century recognized the need to realize such a room as Woolf could not quite describe, to wing into being a language and a space stretched to accommodate their as yet illegitimate existences: as Chadwick and Latimer explain, women such as Brooks and Gray were "[b]oth product and producer of this new syntax."[39]

"Smouldering sensuality": interior decoration and Brooks' first nudes

Joe Lucchesi has written the only critical analysis of Brooks' two 1910 nudes, and he focuses much more on *White Azaleas* than on *The Screen*. Lucchesi quotes Brooks as having declared *The Screen* "not at all erotic.... This was a poor girl who was cold."[40] While Lucchesi finds that reviewers at the time tended to concentrate on the frail, sickly, "consumptive" model and overall melancholic mood of the painting,[41] he suggests that their response "echoes fin-de-siècle and symbolist fantasies that linked female sexuality with disease."[42] Lucchesi argues, however, that it was with *White Azaleas* that Brooks made her most significant intervention into the "conventions associated with modern imagery of the female nude – conventions that produced images of sexually available odalisques, whose frank eroticism became increasingly associated with symbolist ideologies of danger and death."[43]

Writing in 1910, Brooks' friend and reviewer Robert de Montesquiou responds to the bold and unapologetic eroticism of *White Azaleas*, finding in the

supine figure "a little sister of *Olympia*" and locating Brooks in a controversial visual genealogy.[44] As Lucchesi points out, the scandal of Manet's *Olympia* (1863) was due as much to its representation of active, inviting and public female sexuality as to its implication of Manet's involvement in the spaces and economies of the nineteenth-century brothel. Brooks relocates this scene of public female sexuality to the private space of her apartment, using recognizable elements of her own interior decoration to create a decadent, darkly sensual tone, representing a female sexuality that is less destructive but equally challenging.

Shortly after her Galerie Durand-Ruel show, Brooks hosted a private exhibition in her apartment on avenue Trocadéro, where she again displayed *White Azaleas* and *The Screen*. Brooks had gained a reputation by this time for her distinctive black, white and grey interior design and for her lacquer furnishings and porcelain decorative accents. As Lucchesi points out, "[o]ne of her favourite motifs for these accents was a large black vase of white azaleas,"[45] and reviews of Brooks' avenue Trocadéro show note the prominently displayed "black enamel vase in which a snowy azalea flowers."[46] This telling decorative touch, Lucchesi argues, would have been an immediately recognizable element of Brooks' interior decoration for anyone who had visited her apartment.

Brooks uses this signature decorative element to locate the reclining female nude of her painting in the intimate interiors of her domestic space. While setting female figures in domestic surroundings was a well-established convention for female artists at the time, Lucchesi explains that Brooks

injected a smouldering sensuality into a scene that centered not on the
society ladies or solitary maidens who populated the scenes of other women
artists but on a languidly displayed odalisque borrowed from her male
colleagues. The domestic interior, clearly identifiable as Romaine's own
living space, personalised the relationship between artist and model, making
the image of a nude figure in a woman's salon even more jarring.[47]

By setting *White Azaleas* in her own clearly identifiable apartment, Brooks gives a frankly lesbian erotic charge to both the conventional female nude painting and the convention of female painters setting their subjects in domestic space. While Lucchesi focuses his argument on *White Azaleas*, Brooks similarly mobilized the jarring sensual potential of her interior décor in *The Screen*.

Much of her signature decoration can be seen in a publicity photo of Brooks at home, taken around the time of these two shows in 1910. She is shown seated at the piano, surrounded by simple black lacquered furnishings and a few white porcelain decorative objects, with a tall free-standing bi-panelled folding screen behind her. While a portion of a white vase of tulips is visible in the front right of the photo, the black vase of white azaleas is missing. This photo circulated in newspapers and art journals in Paris and London, which suggests that if the lacquered pot of flowers would have been recognizable

to anyone invited to Brooks' apartment, the folding screen would have been recognizable to an even wider audience.

Moreover, by 1910, folding screens, both in rooms and in paintings, carried highly sexualized connotations. *White Azaleas* was not alone in recalling the scandalous *Olympia*. As T.J. Clark notes,

> Olympia's face is framed, mostly, by the brown of a Japanese screen, and the neutrality of that background (what is shown is the back of the screen, the unpictured part) is one of the things that makes the address and conciseness of the face all that sharper. But the blankness is illusory: to the right of Olympia's head is a shock of red-brown hair, just sufficiently different from the screen's dull colour to be visible with effort.[48]

While the frank frontal nudity of Brooks' model in *White Azaleas* is a most overt reference to Olympia's pose, the presence of the folding screen and the relationship Brooks paints between it, the model and the viewer echoes the eroticism of Manet's intimate scene. Virginia Fabbri Butera argues that "the screen [in *Olympia*] symbolizes what we are not supposed to see. Olympia is behind the screen, hidden from men who would normally be entering the room on the painted side of the screen. The screen is a metaphor of transgression and disclosure in this painting."[49] Like Olympia, Brooks' model is posed against the undecorated or "unpictured" back of the screen, locating the viewer in a scene marked "private" and framing the body it is meant to conceal. The screen, publicized with Brooks in her private domestic space, makes a similarly intimate claim on the body of her female model to that figured in and by Brooks' *White Azaleas*, but also acts as a physical reminder of some intimate transgression.

Both of Brooks' first two nudes use elements of her interior decoration to represent an intimate relationship between female painter and female model. Interior decoration appears to have afforded her a language through which to suggest a relationship between the two women that was at that time literally incommunicable. Brooks uses her interior decoration here just as she uses clothing in her later and much more renowned portraits. During the 1920s, Brooks highlighted the masculinized clothing of her female sitters to present what are now read to be prototypically lesbian portraits. Recent work by feminist historians has warned, however, against reading these portraits as unproblematic or straightforward representations of lesbianism, as no such stable image or identity existed at the time. These masculinized outfits traded on the ambiguity of contemporary women's fashion: only the more discerning, or perhaps intended, viewer would detect the sexual implications behind the mannish New Woman's haute couture style. Brooks' artwork was part of a larger effort by women at the time to stretch the visual languages available to them into new forms. And, as feminist scholars have noted, they pushed the language of masculinized women's

fashion to exploit the homosexual connotations of feminized masculinity embodied by the fashionable nineteenth-century decadent dandy. As Elliott and Wallace explain, nineteenth-century decadence provided an aesthetic language through which women in the early twentieth century could fashion new gendered and sexual subjectivities.[50] While Brooks' portraits from the 1920s seem to have been engaged with visualizing lesbian identities from a combination of decadent aesthetics and fashionable clothing, I would like to suggest that these earlier paintings attempted to render visible a less tangible dissident desire by combining decadent aesthetics and fashionable interior decoration. This earlier combination of late nineteenth-century decadence and early twentieth-century fashion was less concerned with representing new gender and sexual subjectivities than with imagining a space for them.

When Manet staged Olympia on the back side of that screen, he helped continue the association between femininity, folding screens and sexuality that had characterized the medium for over a millennium already. Butera, in her Ph.D. dissertation, provides the only discussion of the history of uses and meanings of the folding screen in France. She provides a 1,300-year overview of Eastern (Chinese and Japanese) and Western (Spanish, French, British and American) folding screens, exploring representations of women and what she calls the theme of sexuality. She argues that while screens have historically been decorated by sexualized representations of women, by the end of the nineteenth century the folding screen, as both decorative and architectural object, had become conceptually conflated with women and sexuality, regardless of its figural content: "one of the most potent themes used on and *implied by* screens was the subject of sexuality.... From the outset, screens were viewed as sites for the exploration of feminine beauty, behaviour and symbolism."[51] By the end of the nineteenth century, the folding screen became a preferred medium for symbolist and decadent artists hoping to bridge the divide between decorative and fine arts, and a key element in the feminization of domestic space. Artists like Émile Bernard, Pierre Bonnard, Edouard Vuillard, Maurice Denis, Alfons Mucha, Armand Seguin and James McNeil Whistler each produced at least one folding screen, and several used prominently placed screens in their paintings.

Bonnard, for example, paints his *Man and Woman* (1900) with a tightly folded screen as the central figure. Its hinges more detailed than its decoration or design; it seems to divide the tight bedroom scene into two panels, so that the painting itself appears folded like a screen. The man and the woman are enclosed in one lush and sumptuous space, divided by the hinge but folded as two panels of the same screen. Butera argues that the bedroom is saturated in feminine and sexual imagery:

In Bonnard's painting ... the claustrophobic red room is a none-too-subtle allusion to the womb, with the folding screen serving as its

symbolic entrance ... the labialike edges of the closed screen underscore
the bedroom as a sexual metaphor for the female body.[52]

She takes the painting as a commentary on public gendered divisions being felt in private domestic space: the man separated, partly clothed, linking him to public world of activity and agency, and the woman seated, fully nude, genitals exposed, playing with cats, in her naturally sensual habitat, the bedroom, the symbol of sexuality and pleasure that sustains or nurtures his public life.[53] In this sense the screen acts as the fold between the two sexes, the two worlds, promising access to the feminized space of domesticity, intimacy and sexuality, the labial entrance to the domestic womb.

Like Manet before him, Bonnard uses a folding screen not only to demarcate a private space, but to symbolize the threshold to a particularly sexualized woman's private space. Very little has been written on the history of folding screens in France and why and where they were used, but Janet Adams finds that their popularity increased at the end of the eighteenth century, dwindled for the next 50 or 60 years and then peaked at the end of the nineteenth century.[54] As Butera notes, this roughly corresponds to French tastes for luxurious and explicitly feminized interior decoration, which surged with eighteenth-century rococo designs and enjoyed a renaissance with the late nineteenth-century art nouveau.[55] Their eighteenth-century rise to prominence also corresponds to the French invention of the boudoir, the architectural space dedicated to female privacy and the imaginative space dedicated to sexual intrigue. The boudoir is ubiquitous in late eighteenth-century literature as the setting for sexual scandal – perhaps most famously as the Marquis de Sade's setting for the sexual education of a young girl in *Philosophie dans la boudoir* (1795), and the vehicle for an unfaithful seduction in Jean-François de Bastide's *La petite maison* (1779). The folding screen became an important element of a fashionable interior décor at about the same time as did the boudoir, and the two would remain linked, with screens showing up in clichéd boudoir seduction scenes in the eighteenth century and later in model bourgeois boudoirs at the 1900 Paris World Exhibition.[56]

Sigfried Bing's pavilion at this 1900 Paris Exhibition, the Pavillon Art Nouveau Bing, made up of the decorative art and interior designs of Edward Colonna, Jose Maria Sert, Eugène Gaillard and Georges de Feure, was generally regarded as the quintessence of refined nineteenth-century French modernism.[57] Among the widely admired rooms that made up the Bing pavilion, none was more highly praised than the boudoir by de Feure. As the critic Gabriel Mourey opines,

M. de Feure ... designed the boudoir itself, which, I have no hesitation
in saying, is the thing that pleases me most; and, without disparagement
of M. de Feure's collaborators, I should declare this to be the pick of the
entire building. Here, to my mind, is expressed absolutely in its perfection

the fanciful, novel, independent, graceful spirit which pervades the whole exhibition.... the Boudoir de l'Art Nouveau Bing constitutes one of the first examples of *style* produced by the renaissance of decorative art in France.[58]

Another 1900 reviewer elaborates on what characterizes this "fanciful" and "graceful" new style:

de Feure cultivated flower ornaments with an effeminate feeling for their tenderness. Taken on the whole this accomplished, decadent artist has a fascinating grace of line and a sweetness in his coloring which seems to be inspired by over-refined and capricious women.... If one stepped from [the other rooms in the pavilion] into de Feure's boudoir one had the same impression of dear, anemic womanliness. The light enters subdued by a large gently colored glass window. The walls are covered with heavy silk on which pale rose branches have been appliquéd. The ... almost trembling furniture pierced by an iris motif was ... cut in wood and covered with pure gold leaf by a gilder. And the small upholstered areas at the side and the back of the chair and the couch were covered with silk embroidery in faded and tinted colors. The floor cover is like deep moss. The color is a mute, light-grey, as only cigarette ash can be, with a sprinkling of light red like fallen rose petals....But throughout there is the same composition of exaggerated slenderness and seductive exuberance, which is the charm of de Feure's furniture style. Over all of it shines an anemic beauty and a whiff of over-refined sensuousness, which is the essence of the decadent coloring of his interiors.[59]

Late nineteenth-century French modernity was characterized not only by decorative, domestic femininity, as Silverman has argued, but by a particularly decadent conception of femininity, by an "over refined sensuousness," a "seductive" but "anemic" femininity. This description of the boudoir, characterized by an excessive, spoiled, over-ripe femininity, resembles both Bonnard's and Manet's representations of female sexuality and feminized space; and so perhaps we should not be surprised that de Feure also uses a folding screen to accomplish this model of French domestic modernity. After praising its "deliciously feminine" gilded furniture, embroidered silk upholstery, brocaded walls, divan and silk carpets, Mourey concludes breathlessly that the "absolute perfection" of de Feure's boudoir culminates with "in one corner ... a screen, a perfect gem of art."[60] Mourey does not describe this "gem," and while his article reproduces a photograph of the screen alone, I can find no other accounts of the screen itself, only rapturous praise of the sensuous and decadent womanliness of the boudoir in full, to which we can only assume the screen contributed. As we see in Bonnard's *Man and Woman*, or Manet's *Olympia* or Brooks' *The Screen*, the design of de Feure's screen was apparently less significant to viewers than its creation of a certain overall interior effect: in de Feure's case, the screen's decoration was somewhat disingenuously literal, depicting two of the very "exaggeratedly slender," "over-refined," "anemic" ladies, that is, the very decadent femininity that his boudoir was meant to invoke.[61]

The screen in Brooks' 1910 painting by the same name, and perhaps the wall-mounted panels in *White Azaleas*, constituted a crucial part of the decadence of the scenes that Lucchesi mentions. Brooks puts a twentieth-century lesbian spin on fin-de-siècle rhetoric, casting herself into the "smouldering sensuality"[62] of the decadent domestic space figured at the turn of the last century by anaemic womanliness or sickly seductive women's bodies. *The Screen* just as potently as *White Azaleas* invokes the destructive female sexuality of *Olympia* and puts Brooks, the active female artist, in the place of the standing figure in *Man and Woman*. Perhaps Brooks recalled Manet's *Olympia* and Bonnard's *Man and Woman*, and attempted what Woolf notes has gone unattempted in that "splendid gallery of fictitious women": to represent women's relationships outside their relationship to men and to suggest the complexity of their non-heterosexual intimacy. Moreover, judging by Brooks' lifelong investment in interior decoration, and the role that it plays in these first two paintings, the possibility of attempting these relationships seems to have depended, as Woolf suggests, on re-imagining and recreating domestic space.

Screening sexuality: Gray's first lacquer works

Considering the history of folding screens, it seems surprising that the existing literature on Gray neglects to explore the fact that Gray had chosen the folding screen as her first medium, and that even when she was no longer physically capable of working with lacquer she continued to design and produce screens for the rest of her life.[63] Given Adam's suggestion that Gray's visit to the decorative arts pavilions at the 1900 Paris World Exposition influenced her decision to move to Paris and work on interior design, we can assume that, perhaps even more than Brooks, Gray was aware of the folding screen's feminized, sexualized and recently decadent connotations.[64] We can see in Gray's first two screens, as in much of her earliest work, that she chooses to emphasize these connotations by using imagery reminiscent of decadent artists.

The slim body stretched across the four panels in *La voie lactée* recalls not only Brooks' two nudes, elongated by the panels that frame them, but also Gustav Klimt's stretched and ethereal women. The flat unearthly body and voluminous hair as luminous decoration are standard devices in Klimt's paintings, and while his women are generally immobile, still and standing, his various paintings of women in water make the exception. While *Water Snakes I* (1904–07) and *Water Snakes II* (1904–07) represent women in motion; they appear listless, dead or asleep, propelled by a momentum outside their control, carried by or passive embodiments of wind or water currents. These paintings are based on Klimt's erotic sketches of lesbians, which formed part of a series of studies of women masturbating or embracing other women,

representations of female sexuality ostensibly independent of a relationship to men if we accept the illusive absence of the painter himself. However, while the sketched studies for both *Water Snakes* paintings suggest a self-propelled femininity, women whose sexual momentum is generated by themselves or with each other, women transported by an erotic pleasure that neither depends on nor responds to men, in their final painted versions Klimt refuses his women this kind of agency. *Water Snakes II* is a variation of *Water Snakes I*, alternately entitled *Girlfriends*,[65] which in turn is based on his sketches of two nude women embracing, one on her knees and buried in the torso of the other standing, her arm contorted, eyes closed and mouth open in a picture of complete and climactic sexual pleasure. The absorbed erotic intensity of this embrace is diffused in the first painted version, where Klimt is unable to resist including the presence of an observer, the large fish eye in the lower right corner, which is often read as a kind of self-portrait.[66] By the second painted version the women are separated with their backs to each other; the only suggestion of their original relationship that remains consists of the two disembodied and dismembered heads cramped together on the right edge, and the scene is once again observed by a watchful eye looking down from the top of the canvas. Their transport is the effect of a force beyond them, a current they ride, and the charge of their sexual pleasure is either neutralized as absolute passivity or pathologized as fatal, the women ambiguously represented as sleeping or dead. Their bodies, moreover, are equated with the dangerous sexual temptations of Eve and the serpent, seducing the hovering male observer to his downfall. The frail body on Gray's first screen is propelled, streaming its luminescent hair across space in a manner reminiscent of Klimt's *Water Snakes II*, but unlike in Klimt, its momentum remains self-generated and outside the scope of a watchful eye.

The equation of female sexuality, danger and death, the prototypical *femme fatale* for which Klimt and other fin-de-siècle decadent artists were famous, was both profoundly misogynist and homophobic, as many feminist historians have argued.[67] However, this actively seductive figure appears to have appealed to several women artists seeking to imagine a female sexuality outside of a heterosexual paradigm. Before Brooks appropriated much of this anaemic, diseased, dangerous, decadent female imagery for her first two nudes, it had already been appropriated and famously performed by lesbian icons such as Sarah Bernhardt and Ida Rubinstein, who both starred as the quintessential *femme fatale* in Oscar Wilde's play *Salomé* (Bernhardt in 1892 and Rubinstein in 1909). Wilde wrote his French version of *Salomé* in 1891, and it was translated into English and accompanied by Aubrey Beardsley's naughty illustrations in 1894. The play was banned from production in London but Beardsley's work became more widely known through his illustrations and cover designs for the decadent literary journal *The Yellow Book*, which he worked for between 1894 and 1896. However, Beardsley remained firmly

associated with Wilde in the English imagination and was fired from *The Yellow Book* at the time of Wilde's 1895 sodomy trial for fear of the journal's being tainted with a reputation for sexual deviance, despite its never having published Wilde's work.[68] As Mary Beth McGrath and Mark Lasner explain, "[t]hough *Salomé* was not used against Wilde as evidence of perversity, and Beardsley's name not mentioned during the trials, their names were linked enough in the mind of the public to associate Beardsley with all of Wilde's crimes."[69] Elliott writes that by the end of the nineteenth century, Wilde and Beardsley were widely recognized as the most scandalous and least desirable decadent artists in England:

Condemned as obscene, vulgar, pornographic and virtually any other term of abuse the critics could dream up, [Beardsley's] images were labelled as conspicuous examples of the "Undesirable". With the exception of Oscar Wilde's writings, more ink was spent denouncing Beardsley's pictures than almost any other aspect of late-nineteenth-century English culture.[70]

Feminist scholars have argued that several women artists at the start of the twentieth century strategically appropriated the decadent aesthetics represented by artists and writers like Beardsley and Wilde. However, Gray's use of these styles has not yet been a subject of sustained analysis.

Joseph Rykwert writes that Gray "was at first influenced by the linear qualities of Beardsley,"[71] and while Rykwert neglects to mention any of the early work to which he refers, the comparison brings several pieces to mind. In *Le destin*, the slumped grey figure might recall Beardsley's cloaked and hunching bodies, while the figure strained with its burden, his tightly curled hair, dimpled face, resolutely furrowed brow and slightly downcast eyes might bring the complex expressions of many of Beardsley's line drawings to mind (Figure 2.3). We might recall Beardsley again in the door panel Gray designed in 1912, entitled *Le magicien de la nuit*, depicting three ambiguously gendered bodies, two robed in classical gowns at either end and one nude, save for a pointed cap, and carrying a lotus flower (Figure 2.4). The figure on the right looks out towards the viewer, but languorously pulls the cloak from the now naked lotus-bearing middle figure offering the flower to the third, who gazes over at the first. The relationship between the classically dressed figures is enacted by the nude body, perhaps the night magician, moving with a blossoming symbol of female sexuality towards the third waiting, watching body, which demurely pulls down the front of its robe in anticipation. The scene might be a modernized version of Salomé's desire to touch Iokaanan, the desire whose troubling gender and sexual implications underwrote much of the play's scandal as well as its appeal to gay and lesbian audiences, and which Beardsley captured in *The Peacock Skirt* of 1893 (Figure 2.3).

For late nineteenth- and early twentieth-century audiences of Wilde's play, Salomé was masculinized by her active desire for Iokanaan, whom she in turn

2.3 Aubrey Beardsley, *The Peacock Skirt*, 1893.

2.4 Eileen Gray, *Le magicien de la nuit*, 1912.

feminizes, describing him as "a thin ivory statue.... I am sure he is chaste, as the moon is."[72] She pursues him, declaring, "I am amorous of thy body, Iokanaan! Thy body is white, like the lilies of a field.... Suffer me to touch thy body" (21–22). She then adds, "[i]t is of thy hair that I am enamoured, Iokanaan. Thy hair is like clusters of grapes, like the clusters of black grapes" (23). Finally, she concludes, "It is thy mouth that I desire, Iokanaan.... There is nothing in the world so red as thy mouth.... Suffer me to kiss thy mouth" (23–24). Salomé's ultimately fatal desire is cast as the longing to touch an ambiguously gendered body, characterized by its unearthly white, black and redness, in a scene cast against the blue night sky, a colour scheme that Gray echoes in this lacquer panel. The figure on the right, with Salomé's feathered tiara, touches the night magician led by its swayed hip and sexualized offering towards the waiting figure, enacting through this highly symbolic imagery Salomé's illicit desire to touch that androgynous and virginal body with its black coiling hair. In both these early works, *Le destin* and *Le magicien de la nuit*, Gray may have been using Beardsley's decadent "linear qualities," and perhaps even referring to his *Peacock Skirt*, to cast a scene and sensation of unrequited, illicit and (homo)sexualized desire.

In their 1994 book, Elliott and Wallace offer a way of understanding modern women artists' use of such decadent and symbolist aesthetics. They address their book to

the question of why so many early modernist women resurrected the literary and visual styles of the decadents, symbolists and aesthetes of the late nineteenth century.... [W]hile this "borrowing" or "echoing" of earlier styles has led to a critical devaluation of their work as derivative and second-rate, its strategic importance can only be understood within the context of an emerging discourse surrounding feminine, and especially lesbian, sexuality.[73]

They argue that rather than understanding these women's work as simply old-fashioned or derivative, as less innovative than that of their male modernist contemporaries, we need to recognize that modernist women artists used these decadent styles to render visible a new lesbian subject, whom Chadwick and Latimer describe as "a figure divorced from the contexts that previously structured the meaning of the word *woman*."[74] The critical literature on Gray has tended to neglect her early lacquer work or, when mentioning it at all, to relegate it to an immature or derivative phase on the way to her more formally innovative and properly modernist architectural work. Rykwert's 1972 article is typical of the early critical literature on Gray, where, after a brief half-paragraph description of her lacquer work, he asserts that she was "working away from" this Beardsley-esque design towards "more abstract and more generalised forms," going on to focus exclusively on her post-1924 architectural work inspired by De Stijl.[75] Reyner Banham concludes in his 1973 review that her work was tainted by "tinges" of late nineteenth-century style,[76] and Adam insists that Gray "was trying to free herself from the influence of the organic forms of Art Nouveau."[77] Caroline Constant has noted the tendency in literature on Gray to read her early design work as lacking properly modernist originality, or "a propensity among certain historians preoccupied with the heroic aspects of the period to evaluate her work as derivative."[78] The assumption that Gray was not working with or strategically appropriating these decadent styles but struggling to get away from them seems to reflect these critics' own limited vision of modernism and modernist design objectives less that it does Gray's.

These readings of Gray's work, however, have not been significantly revised since the 1970s despite the many and sometimes feminist perspectives that have been published since then. While Beatriz Colomina's highly influential article introduces the gender and sexual implications of Le Corbusier's "occupation" of Gray's E.1027, her focus is on his work, not hers, and we are left to wonder what there was, specifically, about Gray's work that elicited such an obsessive and violent reaction from Le Corbusier. Constant's work suggests that Le Corbusier reacted to E.1027's "significant challenge to modern movement tenets,"[79] arguing that we need to "see Gray's architecture not simply as an 'other' approach to the Modern Movement, but as an extensive commentary on the Movement itself."[80] Constant locates Gray's challenge in her career-long insistence on the sensuality of architecture and design, a concern for the sensual body that Constant attributes to Gray's early appreciation of symbolist

aesthetics, especially as they were popularized in the 1910 production of Diaghilev's *Schehérazade* by the Ballets Russes.[81] Constant, however, ignores the history of these symbolist aesthetics and overlooks entirely any personal or aesthetic relationships between Gray and the other women who were creatively working with the same symbolist inspiration. Constant briefly mentions Gray's "acquaintance" with Natalie Barney's salon and the Parisian sexual subculture associated with it, but quickly dismisses the significance of these relationships to her work, reasoning that Gray "carr[ied] out her personal life with extreme discretion."[82] With this seemingly casual dismissal, Constant can safely pursue her thesis that "Gray's focus on the kinaesthetic, tactile, and sensual potential of architecture and furniture ... was unprecedented in Modern-Movement discourse."[83] And if we continue to focus, as Constant does, on a modern movement defined by figures like Le Corbusier and organizations like De Stijl and the early Bauhaus, Gray's symbolist-inspired emphasis on the "sensual potential of architecture and furniture" was indeed unprecedented. Constant goes some way in reconsidering the role of these non-heroic tendencies in Gray's work, focusing on Gray's lifelong commitment to sensuality in design, but she strips this sensuality of both its decadent history and its lesbian present, rendering Gray's work a highly personal, idiosyncratic and depoliticized aesthetic exercise.

Domesticating the "specular" lesbian

While Constant chooses not to pursue them, she suggests elements of Gray's work that disrupt her own depoliticized thesis. Constant notes, for example, that Gray had been so impressed by the 1910 production of *Schehérazade* that she purchased copies of Leon Bakst's costume and set designs, whose influence can be seen in much of her early work. Constant explains that Bakst's designs created a particularly apt reflection of the reconfigurations of gender and sexuality in the play itself:

Consistent with [the] visual union of stage sets with figures and drapery
in motion was a blurring of gender distinctions; as interpreted by Nijinsky,
the hero's liberated body represented an erotic blending of masculine and
feminine traits. Diaghilev devised the production's androgynous sensuality to
exploit the audience's sexual fantasies, regardless of sexual preference.[84]

Perhaps, indeed, "regardless of sexual preference," but Constant fails to note that Diaghilev chose to cast in the lead roles two of the early twentieth century's most renowned queer icons: Vaslav Nijinsky as the feminized and sexually submissive Golden Slave to Ida Rubinstein's powerful *femme fatale* adulteress, Zobeida. As Michael Moon explains,

[t]he astonishing success of Scheherazade no doubt had more than a little to do with the extraordinary energy with which is found terms for specularizing – rendering both visible and spectacular – the "scandals" of the sexualities of its two stars and of their respective ways of revealing and concealing these in performances.[85]

The play was, Michael Moon writes, "one of the most famous premiers in an age of opening-night *coups de théâtre*," and made a profound and lasting impact on Parisian culture.[86] Much of this impact has been understood in Constant's terms as purely aesthetic, with Bakst's lush, decadent, richly coloured and exotic set and costume designs influencing fashions in painting, jewellery, interior decoration and clothing for years following. However, as Moon explains, the play's aesthetic influence depended not only on the more or less open secret of its two leads' homosexuality but also on its propagation of orientalist sexual fantasies that involved

inhabiting environments of extreme opulence in which the members of "master races" could enact with impunity "forbidden" sexual impulses on the dominated bodies of others ... [where] sexuality imaginarily escaped the constraints of bourgeois domestic life and took on a "savage" and many-hued intensity.[87]

The orientalist sexual fantasies that spread as aesthetic traces through Parisian culture depended not only on Bakst's opulently designed space but also on the forbidden and unconstrained sexualities embodied by the two famous leads.

By 1910, Rubinstein was notorious as the "[s]elf-styled high priestess of decadent performance in the early years of this century,"[88] and operated as a powerful symbol of gender and sexual conflict and upheaval. While Rubinstein was

in some ways compatible with contemporary male-identified fantasies of both extreme (phallic) feminine potency and no less extreme feminine passivity, the self-assertive and exhibitionistic aspects of her work also permitted her to present herself, at least liminally, as both a subject and an object of lesbian desire rendered visible to an extraordinary degree.[89]

Rubinstein used her performances of such theatrical *femme fatale* classics as Cleopatra in the 1909 Ballets Russes production, Wilde's Salomé, Diaghilev's Zobeida and eventually as Gabriele d'Annunzio's feminized male Saint Sebastian (in *The Martyrdom of Saint Sebastian*, 1911) to fashion herself into a potent public symbol of illicit early twentieth-century gender and sexuality.

Some time after Brooks' show in 1910, she and Rubinstein met, and the two remained lovers until about 1916. During that time, Brooks expanded the homoerotic implications of the symbolist imagery she first used in *The Screen* and *White Azaleas* and explored the transgressive representational possibilities of Rubinstein's body in a series of paintings and photographs. Lucchesi explains that:

[Brooks'] nudes rely on the aesthetic conventions of her symbolist contemporaries, whose largely misogynist underpinnings visualised female sexuality as dangerous, devouring, or deadly. Her paintings of Ida Rubinstein's body consider these visual problematics, and her photographs both assert her own erotic investments in Rubinstein's form and consider the attenuated legibility of that claim.[90]

Brooks capitalized on the same liminally homoerotic specularization that Rubinstein cultivated in her public persona to both stake a claim on her lover's body and problematize the visual possibilities of representing such a lesbian erotic investment. Lucchesi suggests that Brooks' 1911 painting of Rubinstein, *The Crossing*, was inspired by their private photo session from around the same time. In the series of photographs, Rubinstein performs for Brooks' camera, enacting an erotic undressing until she stretches nude, save for a triangular headband and high lace-up boots, on Brooks' divan in a pose that recalls both Manet's *Olympia* and *White Azaleas*. With *The Crossing*, Brooks refers to her earlier nude, but uses both Rubinstein's publicly symbolic body and Brooks' privately intimate relationship with it to imbue the painting with traces of what Lucchesi calls "an intensely private and elaborately choreographed erotic exchange between the two women."[91] The success of the Ballets Russes' *Schehérazade* had, as Moon explains, more than a little to do with the titillatingly ambiguous performance of its two stars' scandalous sexualities, but in Brooks' hands the homoerotic potentiality of Rubinstein's body had slipped past the confines of the stage.

The fact that Gray's emphasis on "sensuality ... [was] inspired in large measure by early productions of Ballets Russes"[92] deserves more attention than it has been given. The fact that Gray had been inspired to design her first full apartment for an unmarried haute couture shop owner, known only as Madame Mathieu-Lévy, by "thinking of the languorous attitude the dancer Ida Rubenstein [sic] struck in the Ballets-Russes *Schehérazade*"[93] has, I think, the potential to change the trajectory of Eileen Gray scholarship permanently. By the time when Gray was designing domestic spaces inspired by Rubinstein's body, Brooks had already been teasing out its female homoerotic implications for years – and the "languorous attitude" that Gray's designs recalled might just as easily have come from Brooks' intimate 1911 painting of Rubinstein in *The Crossing* than from her public performance in *Schehérazade*. The fact that we have neglected to consider influences on Gray's work that would extend beyond the boundary of canonical modernism strikes me as an obvious and damaging oversight – limiting our understanding of the possible meanings and aspirations of Gray's work, as well as those of her modernist contemporaries.

Just a subtle shift in our historical focus allows us to see that Gray was not alone in her appropriation of decadent and symbolist aesthetics and styles, and to recognize that this appropriation may have constituted something

more than an immature and imitative stage in her work. Gray and Brooks, like many modern women artists, seem to have been using elements of these outdated aesthetics to imagine a place for themselves that was being denied by their male modernist artistic and architectural contemporaries – and these women recognized that imagining room for new femininities in modernist art and architectural discourse involved re-imagining and re-designing domestic space. This appears to have registered as a particularly pressing reality for those women attempting to live lives divorced from the traditional obligations of heterosexuality: the challenge of fashioning new gender and sexual identities was for many women fundamentally related to the challenge of refashioning domestic spaces to accommodate them.

At a time when architecture was increasingly being defined in terms of exteriority, transparency and publicity, women who sought to live and work outside the bonds of heterosexuality were particularly invested in cultivating private, domestic space. The importance of privacy and a degree of invisibility can not be underestimated for these women. Historians of sexuality have found that the formulation of lesbian communities and identities took place largely outside the scope of public space and discourse. The increased medical and legal scrutiny of male homosexuality in the late 1890s corresponded with and contributed to the emergence of "highly visible communities of self-identified male homosexuals in the major European capitals."[94] The general ignorance, and denial, of female sexuality as well as women's lack of legal status and limited access to public space made lesbianism subject to much less public visibility and regulation at the start of the twentieth century. As Chadwick and Latimer explain,

Community formation (and, therefore, identity formation) among lesbians transpired, as a result, less in the sphere of public (legal, scientific, political) discourse than in the imaginary sphere of artistic and literary production and the semiprivate sphere of the literary and artistic salon.[95]

I have argued in this chapter that Gray and Brooks used elements of decadent aesthetics and interior design to imagine, image and create such a private, domestic sphere. In the next chapter I will discuss Radclyffe Hall's novel *The Well of Loneliness* (1928) and Gray's house first house, E.1027, built in the same year. The novel is a plea for understanding the nature of the "invert" and revolves around the heroine's need for shelter, for a refuge from unforgiving and intolerant public life, for a home that will accommodate and protect her private desires, gender and sexual dissidence. I will argue that Gray's E.1027 is an example of the sort of living space that Hall's heroine spends her life in search of. Gray's desire to create living spaces based on the anti-modernist principles of domesticity, sensuality, intimacy and privacy was represented by Hall as the fundamental desire and existential condition of the non-heterosexual female artist.

Notes

1. Virginia Woolf, *A Room of One's Own* (1928) (London: HarperCollins Publishers, 1994), 94.

2. Caroline Constant, "E.1027: The Nonheroic Modernism of Eileen Gray," *The Journal of the Society of Architectural Historians*, vol. 53, no. 3 (September 1994), 279.

3. Caroline Constant, *Eileen Gray* (London: Phaidon Press Limited, 2000), 7.

4. Lynne Walker, "Architecture and Reputation: Eileen Gray, Gender, and Modernism," in *Women's Places: Architecture and Design 1860–1960*, Brenda Martin and Penny Sparke, eds (London and New York: Routledge, Taylor & Francis Group, 2003), 88.

5. Ibid., 89, quoting Griselda Pollock, *Differencing the Canon: Feminist Desire and the Writing of Art's Histories* (London: Routledge, 1999), 115.

6. Women such as Natalie Barney, Romaine Brooks, Gabrielle Bloch, Loie Fuller, Evelyn Wyld, Elizabeth Eyre de Lanux, Louise Damien (Damia), Djuna Barnes and Gertrude Stein, among others.

7. This screen seems to have disappeared during Gray's lifetime. Peter Adam quotes her as having remembered that "the screen was shipped to England and later ended up in Canada or Australia" (Adam, *Eileen Gray, Architect, Designer: a Biography* (New York: Harry N. Abrams, Inc., 2000), 73). Its whereabouts are still unknown and its only surviving record is from a photo reproduced in a 1917 *Vogue* article. The design on its verso is also unknown. My description relies on this image, the vague *Vogue* article and Adam's brief discussion.

8. Bridget Elliott, "Housing the Work: Women Artists, Modernism and the *maison d'artiste*: Eileen Gray, Romaine Brooks and Gluck," in *Women Artists and the Decorative Arts, 1880–1935: The Gender of Ornament*, Bridget Elliott and Janice Helland, eds (Aldershot, England, and Burlington, VT: Ashgate, 2002), 188.

9. Ibid.

10. Christopher Reed, "Introduction to *Not at Home: The Suppression of Domesticity in Modern Art and Architecture*, Christopher Reed, ed. (London: Thames and Hudson, Ltd., 1996), 7.

11. Debora Silverman, *Art Nouveau in Fin-de-Siècle France: Politics, Psychology and Style* (Berkeley: University of California Press, 1989).

12. Beatriz Colomina, "The Medical Body in Modern Architecture," *Daidalos: Architektur, Kunst, Kultur*, vol. 64 (1997), 60–71.

13. See Jeffery Weeks, *Sex, Politics, and Society: The Regulation of Sexuality since 1800* (New York and London: Longman Press, 1981); and Michel Foucault, *The History of Sexuality*, vol. I: *An Introduction* (1978) (New York: Vintage Books, 1990).

14. Constant, *Eileen Gray*, 214.

15. Eileen Gray, "De l'éclecticisme au doute" ("From Eclecticism to Doubt") and "Description," in "Maison en bord de mer," *L'architecture vivante* (Winter 1929), 17–35, in Constant, *Eileen Gray*, 240.

16. Gray: "pauvreté de l'architecture d'aujourd'hui résultat de l'atrophie de la sensualité." Undated notes in the Eileen Gray archive, National Museum of Ireland, Dublin, my translation.

17. See Jean Désert receipts, "Ventes au comptant année 1923" and "Année 1924" in the Eileen Gray archive at the Victoria and Albert Museum, London, England.

18. Unidentified review, quoted in Elliott, "Housing the Work," 185.

19. Elliott, "Housing the Work," 185.

20. Meryle Secrest, *Between Me and Life: A Biography of Romaine Brooks* (New York: Doubleday & Company, Inc., 1974), 206.

21. Elliott, "Housing the Work," 184.

22. Peter McNeil, "Designing Women: Gender, Sexuality and the Interior Decorator, c.1890–1940," *Art History*, vol. 17, no. 4 (1994), 631.

23. See for example Mark Wigley, "Untitled: Housing Gender," in *Sexuality & Space*, Beatriz Colomina and Jennifer Bloomer, eds (New York; Princeton Architectual Press, 1992), 327–389.

24. Reed, *Not at Home*, 7, 16.
25. Ibid., 7.
26. "Romaine Brooks belongs to no time, no country, no milieu." Natalie Barney, *Aventures de l'esprit* (Paris: Éditions Émile-Paul Frères, 1929), 245.
27. Brooks, quoted in Secrest, *Between Me and Life*, 204.
28. Adam, *Eileen Gray*, 257.
29. Ibid., 117.
30. Whitney Chadwick and Tirza True Latimer, Introduction to *The Modern Woman Revisited: Paris between the Wars*, Whitney Chadwick and Tirza True Latimer, eds (New Brunswick, NJ; and London: Rutgers University Press, 2003), xx.
31. Whitney Chadwick and Tirza True Latimer, "Becoming Modern: Gender and Sexual Identity after World War I," in *The Modern Woman Revisited*, Chadwick and Latimer, eds, 14.
32. Ibid.
33. Sandra M. Gilbert and Susan Gubar, "'She Meant What I Said': Lesbian Double Talk," in *No-Man's Land: The Place of the Woman Writer in the Twentieth Century*, Sandra M. Gilbert and Susan Gubar, eds (New Haven and London: Yale University Press, 1989), as quoted in Chadwick and Latimer, "Becoming Modern," 14.
34. Chadwick and Latimer, "Becoming Modern," 14.
35. Woolf, *A Room*, 94–95.
36. Ibid., 89.
37. Ibid.
38. Women such as Elsie de Wolfe, Constance Spry, Elizabeth Eyre de Lanux, Evelyn Wyld and Hannah Gluckstein [Gluck]; for more on these women's interior design work, see Isabelle Anscombe, "Expatriates in Paris: Eileen Gray, Evelyn Wyld and Eyre de Lanux." *Apollo*, vol. 115, no. 240 (February 1982), 117–118; Isabelle Anscombe, *A Woman's Touch: Women in Design from 1860 to the Present Day* (New York: Viking Penguin 1984); McNeil, "Designing Women"; and Elliott, "Housing the Work."
39. Chadwick and Latimer, "Becoming Modern," 14.
40. From an interview conducted late in Brooks' life, quoted in Joe Lucchesi, "'An Apparition in a Black Flowing Cloak': Romaine Brooks' Portraits of Ida Rubinstein," in *Amazons in the Drawing Room: The Art of Romaine Brooks*, Whitney Chadwick, ed. (Berkeley: University of California Press, Chameleon Books, Inc., 2000), 75.
41. Lucchesi, "An Apparition," 179.
42. Ibid., 75.
43. Ibid., 77. For an overview of late nineteenth-century representations of femininity, see Bram Dijkstra, *Idols of Perversity: Fantasies of Feminine Evil in Fin-de-Siècle Culture* (New York: Oxford University Press, 1986), particularly 25–36 on "the cult of invalidism" and 51–63 on women and death.
44. Count Robert de Montesquiou in *Figaro*, 1910, quoted in Lucchesi, "An Apparition," 76.
45. Lucchesi, "An Apparition," 78.
46. Unidentified press clipping, quoted in ibid., 78.
47. Lucchesi, "An Apparition," 78.
48. T.J. Clark, "Olympia's Choice," in *The Painting of Modern Life: Paris in the Art of Manet and his Followers* (New York: Alfred A. Knopf, 1985), 136–137.
49. Virginia Fabbri Butera, *The Folding Screen as Sexual Metaphor in Twentieth Century Western Art: An Analysis of Screens by Eileen Gray, Man Ray, and Bruce Conner*, Ph.D. dissertation, City University of New York; Ann Arbor: UMI Dissertation Publishing, 2002), 3.
50. Bridget Elliott and Jo-Ann Wallace, *Women Artists and Writers: Modernist (Im)positionings* (London and New York: Routledge, 1994), 39.

51. Butera, *The Folding Screen*, xiii, 50, my emphasis.

52. Ibid., 3–4.

53. Ibid., 4.

54. Janet Adams, *Decorative Folding Screens: 400 Years in the Western World* (New York: Viking Press, 1982).

55. Butera, *The Folding Screen*, 51. For more on the resurgence of feminized decorative arts at the end of the nineteenth century, see Silverman, *Art Nouveau*; Nancy J. Troy, *Modernism and the Decorative Arts in France: Art Nouveau to Le Corbusier* (New Haven and London: Yale University Press, 1991).

56. For more on history of the boudoir, see Ed Lilley, "The Name of the Boudoir," *The Journal of the Society of Architectural Historians*, vol. 53, no. 2 (June 1994), 193–198.

57. See Silverman, *Art Nouveau*, and Troy, *Modernism*.

58. Gabriel Mourey, "Round the Exhibition: The House of the 'Art Nouveau Bing,'" *Studio*, vol. 20 (1900), 177–180.

59. This is quoted in Gabriel Weisberg, *Art Nouveau Bing: Paris Style 1900* (New York: Harry N. Abrams, Inc., 1986), 183–185.

60. Mourey, "Round the Exhibition," 170, 177.

61. De Feure had painted the façade of the pavilion as well, with the Parisienne muses of art nouveau, women very similar to those depicted on his screen: the "spirit" of these Parisiennes was understood, by at least Thiis, to permeate the whole pavilion. Not just de Feure's feminized boudoir but his actual representations of femininity were taken to symbolize French modernity at the turn of the last century. See Weisburg, *Art Nouveau Bing*, 180–185.

62. Lucchesi, "An Apparition," 186.

63. She developed a skin allergy to lacquer in the early 1920s, but until a year before her death she was working on new designs for folding block screens made of cork. Adam *Eileen Gray*, 376.

64. Ibid., 25–26.

65. Both *Water Snakes I* and *II* are based on erotic nude sketches of women together, sometimes entitled "Embracing Lesbians" or "Lesbian Lovers." For examples of these studies and these titles, see Susanna Partsch, *Gustav Klimt: Painter of Women* (Munich and New York: Prestel Press, 1994), 38–41; and Colin B. Bailey, ed., *Gustav Klimt: Modernism in the Making* (New York: Harry N. Abrams, Inc., 2001), 182–184.

66. See, for example, Neda Bei: "The artist-master-voyeur has painted himself as a mute and blind fish, as a creature of another kind, floating with them in the river of longing for lost happiness and for an unattainable mother." Bei, "The Two-Fold Woman (Water-Snakes)," in *Klimt's Women*, Tobias G. Natter and Gerbert Frodl, eds (New Haven and London: Yale University Press, 2000), 238.

67. See for example Elaine Showalter, *Sexual Anarchy: Gender and Culture at the Fin de Siècle* (New York: Viking, 1990), 169–187.

68. Mary Beth McGrath and Mark Lasner write, "So strong was the perceived link between Beardsley, Wilde, and *The Yellow Book* that Beardsley was dismissed in April 1895 from his post as art editor following Wilde's arrest, even though Wilde had in fact never contributed to the magazine." "The Life of Aubrey Beardsley," on *The Victorian Web*, http://www.victorianweb.org (1991), accessed 2007.

69. Ibid.

70. Bridget Elliott, "Covent Garden Follies: Beardsley's Masquerade Images of Posers and Voyeurs," *Oxford Art Journal* (1986), 45.

71. Joseph Rykwert, "Eileen Gray: Pioneer of Design," *Architectural Review*, vol. 152, no. 910 (December 1972), 357.

72. Oscar Wilde, *Salomé* (London and Boston: Elkin Mathews & John Lane, 1894), 19, University of Virginia Library Electronic Text Center, http://etext.lib.virginia.edu/modeng, accessed 2007. All further references to this work come from this edition.

73. Elliott and Wallace, *Women Artists and Writers*, 34.

74. Chadwick and Latimer, "Becoming Modern," 14.
75. Rykwert, "Pioneer of Design," 357.
76. Reyner Banham, "Nostalgia for Style," *New Society* (February 1973), 249.
77. Adam, *Eileen Gray*, 63.
78. Constant, *Eileen Gray*, 8.
79. Constant, "Nonheroic Modernism," 279.
80. Constant, *Eileen Gray*, 8.
81. Ibid., 15–18.
82. Ibid., 9–11.
83. Ibid., 7.
84. Ibid., 18.
85. Michael Moon, "Flaming Closets," *October*, vol. 51 (Winter 1989), 20, 28.
86. Ibid., 20.
87. Ibid., 22.
88. Ibid., 23.
89. Ibid., 25.
90. Joe Lucchesi, *Romaine Brooks' Portraits and the Performance of Lesbian Identity*, Ph.D. dissertation, Chapel Hill University (Ann Arbor: UMI Publishing, 2000), 190.
91. Lucchesi, "An Apparition," 81.
92. Constant, *Eileen Gray*, 18.
93. Adam, *Eileen Gray*, 99.
94. Chadwick and Latimer, "Becoming Modern," 10.
95. Ibid., 11.

3

Accommodating ambiguity: Eileen Gray and Radclyffe Hall

If the house is all white, the outline of things stands out from it without any possibility of transgression.... Put on it anything dishonest or in bad taste – it hits you in the eye. It is rather like an X-ray of beauty ... It is the eye of truth.

Le Corbusier.[1]

Their desire for strict precision has made them neglect the beauty inherent to all forms.

Eileen Gray[2]

The same roof mustn't shelter us both any more.

Radclyffe Hall[3]

Eileen Gray's work tends to be represented as a progression away from decorative art and towards architecture, with her first built house, E.1027 (Figure I.1), standing as her most decisive break from the old to the new. In 1972, Joseph Rykwert wrote two major reviews of her work which stressed this distinction. As I discuss in the last chapter, he finds that "much of her early work was highly individual, particularly the lacquer screens.... Although she was at first influenced by the linear qualities of Beardsley, she was working away from figuration to more abstract and generalised forms."[4] In another more detailed article that year, Rykwert uses E.1027 as the first example of this more abstract and generalized form that Gray was working towards: "in this house at Roquebrune Eileen Gray's previous work is eclipsed and transformed, purged of any Art Deco velleities."[5] When Reyner Banham reviews Gray's 1973 show, he insinuates that her work had never achieved a complete purge of these "tinges of [Art Deco] fashion."[6] He argues that her work was forever mired in her "too rich ... personal style and philosophy of interior design"[7] – that it never managed to transcend the individual and achieve the abstract and general that Rykwert praises. He suggests that her work's brief moment of transcendence was gallantly offered to her by Jean Badovici, in the form of a special issue of his journal dedicated to E.1027,[8] and by Le Corbusier, in the form of murals, his "graffiti," on her walls.[9] In 1986, Adam's biography echoes

the logic of these reviews, which were more than ten years old. Adam writes that by the time Gray started working on E.1027, around 1926, she had entirely abandoned her earlier decorative artworks – they were reminders of a life she had left far behind, "the sins of her youth" – and had begun to concentrate on "pure architecture."[10] The shift away from the decadent, decorative sins that I discuss in the previous chapter he attributes to her infatuation with the good-looking Jean Badovici. His biography loosely aligns her aesthetically and sexually experimental youth with her decorative art, and her serious, mature career with "pure architecture" and an intimate relationship to Badovici. This impulse to cast her life and career as a progression from decadent decorative arts and relationships with women towards abstract, functionalist architecture and relationships with men continues the critical tradition, which we see in Rykwert and Banham, of denigrating and feminizing interior decoration in the service of heroizing modernist abstraction and avant-garde architecture, and betrays the heteronormative framework through which Gray's involvement in modernist art and architecture has been understood. A closer look at her work and her life shows this to be more of an easy fictional narrative than an accurate biographical or critical sketch. Gray abandoned neither her sinful female friends nor her sinful interior designs when she began collaborating with Badovici on architectural projects. The domestic space that she designed at E.1027 involved neither a purging of rich, personal intimacies nor an absolute investment in pure architecture of generalized forms.

E.1027 was constructed between 1926 and 1929, a crucial period in the history and formation of modernist architecture. Gray had begun seriously studying architecture around 1924, at the age of 46, after having built a career and international reputation as an architecturally inclined interior designer. She began her study under the tutelage of Badovici, apparently using the earliest editions of his journal, *L'architecture vivante*, as her textbooks, and the modernist projects and theoretical essays featured there, by architects like Adolf Loos, Gropius, Theo van Doesburg and Le Corbusier.[11] Badovici dedicated seven full volumes of *L'architecture vivante* to Le Corbusier, and the impact of his architectural theories and projects on Badovici and Gray was immense.

Indeed, understanding Le Corbusier's impact on Gray's architecture and design, and on E.1027 particularly, seems fundamental to understanding all of Gray's work and its eventual elision from the history of modern architecture and design. When Le Corbusier painted eight large murals on the walls of Gray's first built house (1938) – a house which she had funded and intricately and intimately designed, the product of nearly three years living and working on site with the local craftsmen and builders between 1926 and 1929 – he made a mark on her work that would not be erased (Figure I.2). My own research on Gray has been motivated by the question of what there was in her architecture and design that compelled Le Corbusier's obsessive, invasive and sexualized

violence. And to what extent has Le Corbusier's initial heteronormative violence marked and continued to structure critical perspectives on Gray's work? This chapter attempts to address these questions by offering an alternate perspective on E.1027, one which is guided by Gray's own efforts there to develop other ways of looking. While Colomina suggests that Le Corbusier's violence was related in some way to the fact that Gray was "openly gay,"[12] alternate or non-heterosexual female sexualities in the 1920s had not yet accrued into such a stable cultural or social identity. Gray's sexuality, despite her reputed intimate relationships with women or with Badovici, would not have looked like anything we recognize as lesbian, bisexual or heterosexual. Instead of reading a contemporary sexual identity back onto Gray, I would like to suggest with Walker that "[i]t seems less important what [Gray's] sexual activities were than to try to explain the role that sexuality played in her creative life."[13] Women like Gray, who lived outside the bounds of conventional heterosexuality in the 1920s, were not yet clearly or unambiguously recognizable or identifiable, which historians like Bridget Elliott, Tirza Latimer, Whitney Chadwick, Joe Lucchesi and Laura Doan, whom I have discussed in the previous chapters,[14] have suggested played a role in their representational strategies, or their efforts to create alternate ways of looking – of both appearing and seeing. Moreover, with the risks of social and cultural persecution and legal prosecution, non-heterosexual women's other ways of looking were fundamentally and necessarily ambiguous, straddling the volatile line between revealing and concealing what was seen as a culturally deviant, medically degenerate, and, increasingly, legally criminal desire. These were some of the concerns for women in the 1920s that would have structured what Annamarie Jagose has described as "the ambivalent relationship between the lesbian and the field of vision,"[15] and that I hope to show influenced the critical visual strategies that Gray used at E.1027.

I hope to suggest in this chapter that Gray's sexuality played a role in the critical alternative she offered with E.1027 to the dynamics and erotics of vision, of total exposure, exteriority and the pleasure of visual mastery, that Le Corbusier had defined and influentially promoted throughout the 1920s. I will argue that Gray's architecture and design at E.1027 was invested in an alternate erotics of visual ambiguity, which secures for the inhabitant the power of privacy and invisibility and which encourages the pleasures of partial views, glimpses and suggestion. Gray scholars, critics and reviewers have long been compelled, and often confused and disturbed, by the marked sensuality of Gray's ambiguous aesthetics (by her combinations of too rich, decadent-inspired, personal aesthetics and abstract, purist, generalized forms).[16] I hope to show that to understand better these sensually and erotically ambiguous visual dynamics, so critically different than Le Corbusier's and those that would come to define modern architecture in the 1920s, we need to account for the influences on Gray's work that fall outside this narrow scope of

canonical modern architecture and design, and to recognize that Gray's work may have been inspired by and conceived for other aesthetics and subjects. The literature on Gray has indicated for years that Gray's architecture and design were different, but it has not accounted for why they were different. That is, who were these differences intended for? What were her critical differences inspired by? What or whom were they trying to enable? And why did Le Corbusier react to them with this "well-known dominance gesture"?[17]

I will show that Gray conceived of E.1027 for the kind of sexually dissident female subjects who Radclyffe Hall argued, in her novel *The Well of Loneliness* (1928), were being exiled and denied appropriate living space in the 1920s, and that Gray's critically different visual dynamics are related to the erotics of visual ambiguity that non-heterosexual women cultivated through their masculinized self-fashionings in the 1920s – a visibility based, like Gray's designs, on ambivalence, suggestion, partial views and glimpses, as much on concealing as on revealing. I will argue that Radclyffe Hall is significant to understandings of E.1027, first because her novel dramatizes non-heterosexual women's need for living spaces like those that Gray designed, and second because just as Le Corbusier is central to understanding the visual dynamics and the primacy of vision in modern architecture, Hall is central to understanding the sartorial visual dynamics cultivated by female sexual dissidents in the 1920s, and the eventual reduction of these ambiguous dynamics to a fixed and circumscribed image of lesbian identity.

E.1027: The privilege of privacy

External architecture seems to have absorbed avant-garde architects
at the expense of the interior, as if a house should be conceived for the
pleasure of the eye more than for the well-being of its inhabitants.

Eileen Gray[18]

Gray built E.1027 on a secluded plot along the French Mediterranean coastline east of Monte Carlo, between the town of Roquebrune and Cap-Martin. This small, two-level house was constructed into the sloping land below the coastal railway and perched above the rocky seaside cliffs, and accessible only by a winding footpath, by which all of the building materials were carted down. Adam explains that she had chosen the land for her first house because of its isolation: "She had heard of land which was cut off so that one could not drive to it ... inaccessible and not overlooked from anywhere."[19] Inaccessibility, isolation and the dynamics of looking or seeing would prove to be among the central concerns in Gray's meticulously designed and first built architectural project. Despite its small size, Gray envisioned the house for socializing and hosting friends.[20] On an exhibition placard (probably for

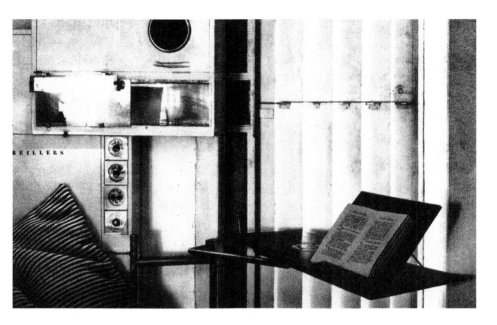

3.1 E.1027, alcove divan headboard with electrical outlets and built-in pivoting bedside table. Reproduced with the kind permission of the National Museum of Ireland.

the first Union des Artistes Modernes show in 1930), Gray announced her objectives at E.1027: "House envisaged from a social point of view: minimum of space, maximum of comfort."[21] Each room was designed for this comfort, ensured by multi-purpose, functional and sensually engaging furnishings as well as the possibility of privacy and independence.

The house consists of two bedrooms and a large central living room adjoined by a small alcove. Each of the spaces is intended to serve as a separate sleeping area.[22] All of the rooms, including the alcove, are equipped with a bed or divan, a bedside table or wall-mounted storage unit, a reading lamp and electrical outlets for a kettle and "bed-warmer" and shuttered windows for light and ventilation. In Gray's photographs of the house, published in a special issue of *L'architecture vivante* dedicated to E.1027 in 1929, the beds and divans are piled with throw cushions and tousled wool or fur blankets; the built-in beside table props up an open book on its reading stand; the guest-room writing desk is shown concealed in its wall-mounted cabinet and then opened with a pen atop papers askew, a martini-shaker, glass and ashtray; the soft leather, suede, velvet and chrome chairs are reclined for relaxing on soft, multi-level, multi-form, overlapping textured rugs; the shelves contain open books; and the tables carry drinks, cigarettes and ashtrays (Figures 1.1 and 3.1). Gray pictured her rooms in mid-use, conceived for both luxuriating and working. She also pictured them in isolation, despite their very close proximity.

That is, Gray's photographs of E.1027 emphasize the independence of every area, even when they provide glimpses through to adjoining rooms. The photograph of the main living room, for example, shows a darkly shadowed area sunk into the wall at the back (see the photo's top left corner in Figure 1.1). While we can see that this area, the sleeping alcove, is not structurally separate from the main room, Gray created the impression of separation by closing the shutters on both windows that would have lit the area, both the window above the alcove's divan and the one on its door to the side deck. She photographs the alcove itself separately, with a close-up image of the divan's wall-mounted headrest with electrical outlets, reading lights and bedside table, the open book and comfortably compressed, creased cushion emphasizing the privacy and intimacy that she hoped to secure in even this relatively exposed niche (Figure 3.1).

The independence of the rooms is secured in the rest of the house with built-in screening devices, the architectural integration of the earlier freestanding, folding screens discussed in the previous chapter, which are used at the entry to each room. The view of the main room is obstructed by the extendable storage partition in the entrance (Figure 3.2: designed for coats, hats, umbrellas, a gramophone and records), which also partly blocks views from the living room to the dining area and bar, an area that in one photograph is further screened by a tall, moveable storage unit. The privacy of each of the bedrooms is also protected through sunken doors that open into the room – so that when one enters, one's view of the room is blocked by both the open door and the wall into which it is sunk, and in the main bedroom, access to the room is further prolonged by another screening storage unit (see the floor plan, Figure 3.3, for the main bedroom and guest bedroom).

This provocative strategy of obstruction extends from these architectural screening devices to her furniture designs, where the full function and multiple guises of the objects are both suggested and obscured by their appearance. Everything in this small house, from the architectural floor plan to the concealed cupboards, drawers and lighting to the multi-textured rugs, to the adjustable tables, to the extendable divans, to the screening storage devices, defies easy visual comprehension, demands a physical engagement, conceals something (another function, another angle) even in the act of revealing.

In Gray's written description of the house, published along with her photographs in the 1929 special issue of *L'architecture vivante*, she outlines the four "essential issues" that the house addresses:

1. The problem of the windows...
2. The problem, often neglected and thus very important, of shutters: a window without shutters is an *eye without eyelids*...
3. The problem of independence of the rooms: everyone, even in a house of restricted dimensions, must be able to remain free and independent....
4. The problem of the kitchen, which should be easily accessible yet sufficiently isolated. (241)

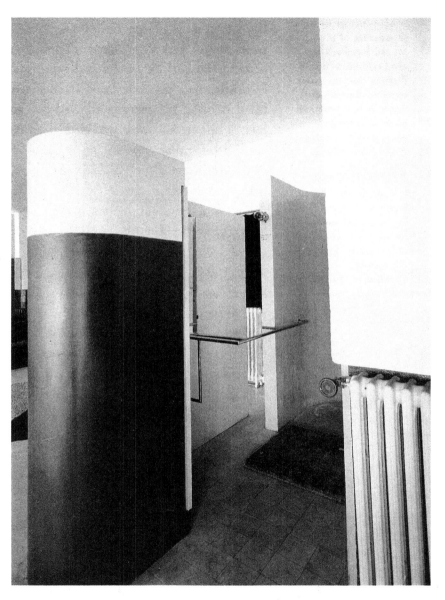

3.2 E.1027, entryway partition, with partial views through to living room. Reproduced with the kind permission of the National Museum of Ireland.

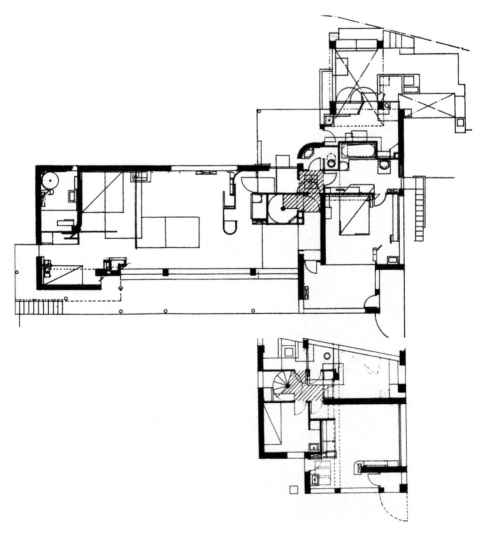

3.3 E.1027, main and lower floor plan. Reproduced with the kind permission of the National Museum of Ireland.

Each of these revolves around the issue of seeing or being seen – windows, the eyes of the house, which need shutters, or eyelids that can be closed; rooms where the inhabitants will remain independent or out of sight; the kitchen which must be accessible but unseen – which Gray emphasizes by framing her list of four essential points with a discussion of entrances.

She introduces the list explaining that "[o]ne avoids making a door when one fears that is may open at any moment, evoking the possibility of an inopportune visit" (241), and she concludes the list with a description of

"The Entry – This is a large covered space: a sort of atrium; it is large, accommodating ... Ahead is a large blank wall, suggesting the idea of resistance, but clear and distinct ... The door to the right leads to the main room: a partition screen obstructs views that might penetrate from the exterior to the interior when the door is open" (241). Despite the incorporation of Le Corbusier's "free plan," which he advocated in a 1927 issue of *L'architecture vivante* for its capacity to open domestic space before the spectator as a vista, a total view, Gray designs several strategies to deliberately obstruct the absolute visibility promised by this free plan.[23] To create the essential *"impression* of being alone, and if desired, entirely alone ... [Gray decided] to position the walls so that the doors remain out of sight" (241). Moreover, to ensure that each inhabitant "remain free and independent" (241) every room includes a private exit to the garden or deck. Each room, then, has a hidden door to the interior and a private door to the exterior. Every room in the house is designed to address the four "essential issues," which are in turn framed by the problem of the door, or the problem of obstructing views and ensuring the impression of total privacy or being entirely alone.

The only architectural precedent for this kind of entirely independent room is the study, which was historically the exclusive domain of the master of the house. The fundamental feature of the study, as Victoria Rosner explains, is its power to preserve the masculinized privilege of privacy: "More than just another room in the house, the study participates in the construction of gender roles through the allocation of privacy. Masculine spaces afforded privacy; feminine spaces were subject to interruption."[24] In upper-class English houses in the nineteenth century, of the sort that Gray was raised in,[25] the study was normally located near the garden entrance, or provided with its own, "allowing the occupant to come and go unobserved."[26] E.1027 incorporates this essential issue of privacy into each of its rooms, turning them all into potential studies. Every bed or divan is equipped with not only a reading light and storage space for books, but also with adjustable, at times built-in and pivoting, bedside tables for reading and writing (see Figure 3.1).[27] In addition to the bedside reading/writing table, the main bedroom includes an area for a desk and work space, which she called her "boudoir/studio," "merging," as Caroline Constant has noted, "the historically gendered spaces of boudoir and study into a single entity."[28] Gray's elimination, or merging, of gendered domestic space was indeed unprecedented in the work of her avant-garde contemporaries,[29] and in 1928 a woman's claim to the traditionally masculine privilege of privacy, to be out of sight and uninterrupted in domestic space, was indeed a radical statement. This was, of course, the year in which Virginia Woolf made the daring and controversial assertion that the possibility of doing creative work was predicated on this exclusively male privilege to a room of one's own, or "that a lock on the door means the power to think for oneself."[30] In a letter

written years later, Gray seems to agree with Woolf. Gray advises her niece, the painter Prunella Clough,

Don't bother to write, as you say even now, you are not really having the quiet you need. Personally I am brainless when in contact with people its [sic] only when one feels one can count on being alone, when one can let one's brain free-wheel, that one has moments of lucidity getting underneath things.
 I was looking forward to going up to Paris for a month, its [sic] quite impossible to work at anything here ... the living room a sort of passage for people bursting in unexpectedly.[31]

Gray clearly built E.1027 so that its inhabitants "can count on being alone," but the importance of this claim to the privilege of domestic privacy has not been explored.

E.1027 was also completed the same year as Radclyffe Hall published what is widely considered the first lesbian novel, *The Well of Loneliness* (1928), where the quest for appropriate domestic space is at the centre of the problem of sexually dissident survival.[32] Stephen Gordon, Hall's semi-autobiographical heroine in *The Well*, is exiled from her aristocratic family home, Morton House, and spends the rest of the novel in search of a shelter for her sexual identity and relationships. Everything she does, from the time of exile, is in the service of creating domestic space appropriate to homosexual desire and subjectivity – and she doggedly pursues a writing career as a "refuge" for herself and her lover. Through Stephen, Hall proposes a model of sexually dissident subjectivity whose only chance for survival is to create appropriate domestic space – and whose aesthetic work is conceived as primarily architectural. Those elements that Gray argues are missing from modern architecture turn out to be the very same ones as those for which Stephen is searching. Comparing E.1027 with *The Well of Loneliness* suggests the extent to which architecture and interior design were understood to be implicated in constitutions of female sexual dissidence in the 1920s and, moreover, that Gray was invested in building homes for sexual exiles like Stephen.

In *The Well of Loneliness*, Stephen's claim to the privacy of the study is fundamentally linked to the realization of her masculinity, or her gender inversion. When her "unnatural" (203) desire is discovered by her mother and she is exiled from Morton House, she retreats first to her father's study. In the moment when Stephen most needs to "claim an understanding" of her unnatural and unwanted self, she is naturally drawn "by some natal instinct" to the house's most potent architectural symbol of masculinity, to the locked secrets of her father's study.[33] But instead of the familiarity and comfort that it once offered, her father's study renders her alienation more acute as she recognizes that the protection the study secures is for the masculinity to which she has no natural right. Inside the locked bookcase in her father's private study, Stephen finds the answer to "the riddle of her unwanted being" (206)

in the work of Richard von Krafft-Ebing, the first sexologist to name and study "sexual inversion," the term for homosexuality at the time. The study turns out to be the room where the secret of her masculinity and unnatural desire is locked up as well as where it is revealed. Stephen goes on in the novel to build two more studies, sheltering these books and the more or less open secret of her masculinity. Rosner argues that in *The Well*, and other novels at the time, "[m]asculinity hinges on privacy to such a marked extent that when women in these texts acquire their own private spaces, they become masculine ... the possession of culturally masculine attributes [like a private study] is often understood as the possession of hidden biological ones."[34] These dynamics of hiding and "coming out," of concealing and revealing a sexual secret, are symbolized in the *The Well* by the study or private domestic space, and turn out to be the same dynamics and architectural spaces that E.1027 addresses. A woman's claim to the masculine privilege of private space, to the uninterrupted freedom to think for oneself, was a potentially alienating challenge to the sex/gender order of the time, and Gray's E.1027 needs to be understood in this historical context. While Gray's challenge to this order is never explicit, with her emphases on privacy, sensuality and intimacy, on the dynamics of revealing and concealing, she was inscribing her architecture with a kind of eroticized visual ambiguity that would have accommodated the vexing gender and sexual ambiguity that had Stephen exiled from Morton.

E.1027 as "critical commentary"

The fact that Le Corbusier has become central to the story of E.1027, to the story of Gray's elision from the history books, the neglect of her work and her recent rediscovery becomes particularly compelling when we consider that Gray conceived of E.1027 as an engaged critique of Le Corbusier's architectural and design principles. While the architectural plan was officially a collaborative project with Badovici, which Gray reflected in the name E.1027 (E = Eileen, 10 = J, 2 = B, 7 = G), historians have agreed that Badovici's input on the project was minimal, including the suggestion that the main level of the house be raised on pilotis and that the central spiral staircase extend to the roof.[35] The architecture and design were primarily Gray's responsibility, and reflect the engagement with Le Corbusier's ideas that had informed her earliest architectural studies.[36] Gray's architectural work seems to have been motivated from its inception by a critical engagement with Le Corbusier, and by the time she began E.1027 she was able "to build upon her nascent critique of Corbusian principles, evident in her House for an Engineer."[37] Indeed, as Constant argues, we need "to see Gray's architecture not simply as an 'other' approach to the Modern Movement, but as an extensive commentary on the Movement itself"[38] and E.1027 as a critical commentary on Corbusian principles particularly.

The house was one of the first to incorporate Le Corbusier's "five points of a new architecture," which Gray would have read about in a 1927 issue of L'architecture vivante: "pilotis; roof garden; free plan; strip windows; free façade."[39] She would also design several pieces of light and mobile furniture in the "camping style" popularized by Le Corbusier in 1925 in *The Decorative Art of Today*. While Gray makes use of these new ideas for architecture and interior design, she argues against the application of standardized or formulaic architecture: "Formulas are nothing, life is everything" (239). Gray reacts strongly against the desire for standardization that drives Le Corbusier's quest for a type-house. For her, architecture's first task is to build *"dwellings for people"* (240), and the building's design must follow from "interpreting the desires, passions and tastes of the individual" (239). In stark contrast, Le Corbusier argues that the problem of the house demands "a close search for a standard, that is for a type."[40] This search will lead, of course, to "the 'House-Machine', the mass-production house, healthy (and morally so too)."[41] Gray, however, succinctly concludes: "A house is not a machine to live in."[42] For her, the house "is not just the expression of abstract relationships; it must also encapsulate the most tangible relations, the most intimate needs of subjective life" (239). And these relations and intimate needs cannot, for Gray, be reduced to one standard or all-encompassing type. She explains that

> For the avant-garde, architectural creation must be self-sufficient, with no consideration for the atmosphere that the inner life calls for.... [Instead,] only the human being should be considered.... How can we achieve such a result if we build without the least concern for the inhabitants' well-being and personal comfort, and if we don't take into account their human need to discover in the places where they live certain characteristics that express their individual personalities and their own tastes? (239, 240)

While questions of gender and sexuality are never explicitly addressed by Gray, she is careful to avoid the use of the supposedly gender-neutral term "man," the standard in modernist architectural theory of the time, replacing it wherever she can with "individual," "inhabitant" or "human being." In contrast to modernist architecture's standardized "man of today," Gray posits the particular, sentient, private, inner life of the "human being" at the centre of her architectural project. While Gray's human being was not necessarily a woman, her architecture included considerably more space for women than did Le Corbusier's architecture for man.

Gray begins her description of E.1027 by criticizing the avant-garde's neglect of interiority, both personal and architectural: "External architecture seems to have absorbed avant-garde architects at the expense of the interior, as if a house should be conceived for the pleasure of the eye more than for the well-being of its inhabitants" (240). Le Corbusier is central to the creation of an identifiable, avant-garde modern architectural movement preoccupied with the external and visual pleasure. The whiteness that would become the

definitive look of modern architecture by 1927 was first defined and promoted by Le Corbusier in *The Decorative Art of Today* (1925). It was two years later at the Weissenhofsiedlung in Austria (1927) that architects and designers from across Europe first agreed on the colour white, and it was through what Mark Wigley explains as an "unprecedented ... level of agreement about white"[43] that modern architecture first came to be: "The exhibition ... facilitated the reduction of the diverse tendencies and contradictions of the avant-garde into a recognisable 'look' that turns around the white wall."[44] Early twentieth-century architecture and design became a modern movement and international style in the moment at which it agreed on one unifying and reductive look.

Importantly, however, "[m]odern architecture was never simply white. The image of white walls is a very particular fantasy. It is the mark of a certain desire."[45] Nearly all of the iconic modern architectural buildings were coated with coloured paint; their famed and fabled whiteness is the product of black and white photography and a shared fantasy of what that look would stand for. As I discussed in Chapter 1, the white look stood for health and the fantasy of constructing not just new buildings but new bodies and subjects, purged of all symptoms of degeneration and their unhealthy, perverse, decadent tastes. It also stood for a particular visual fantasy, a desire for not just healthy bodies but visible bodies, stripped of degenerate ornamentation and exposed to view. Le Corbusier's writings are driven by visual fantasy, by the desire for total exposure. In 1923, he puts it perhaps most succinctly when he declares that modernist architecture is fundamentally about "REWARDING THE DESIRE OF OUR EYES."[46]

In marked contrast to Le Corbusier's desire for visual pleasure, modern architecture's definitive desire, Gray writes that "the interior should respond to human needs and the exigencies of individual life, and it should ensure calm and intimacy.... It is not only a matter of constructing beautiful arrangements of lines, but above all *dwellings for people*" (240). Rather than building a standard type that will reward the desire of the eye, Gray aims at building houses that "express the psychological reality of an era" (240), and this reality cannot be determined from the purely abstract point of view that Le Corbusier advocates. Instead, the psychological reality that houses must express can be determined only "by interpreting the desires, passions and tastes of the individual" (239). The highly individual intimate desires, passions and tastes of Gray's human dweller are apparently significantly different from those that Le Corbusier imagines for his desiring viewer.

Other accommodations: E.1027 and *The Well*

Gray's argument that certain human beings, with private tastes and pleasures, are being neglected by what she calls the avant-garde reveals the limits of

modern art and architecture's "one spirit," its universal, standard type, and suggests that she was building for those people who were left out of modern architecture's vision. Radclyffe Hall's novel is written from the perspective of one of these people. When Stephen Gordon's sexual desire for another woman is exposed to her mother's "terrible eyes, pitiless and deeply accusing" (202), She is exiled from her traditional family home at Morton House. Her mother explains:

> this thing that you are is a sin against creation. Above all is this thing a sin against the father who bred you, the father whom you dare to resemble. You dare to look like your father, and your face is a living insult to his memory, Stephen. I shall never be able to look at you now without thinking of the deadly insult of your face and your body to the memory of the father who bred you ... I would rather see you dead at my feet than standing before me with this thing upon you. (203)

This thing that her mother cannot bear to name and cannot stand to see is the inescapably physical and visual evidence of Stephen's sexual inversion. Her mother concludes that Morton House can not shelter the deadly insult of this inverted visibility: "we two cannot live together at Morton.... The same roof mustn't shelter us both any more" (205). From this first expulsion, Stephen goes on to live the life of an exile, in London and then in Paris, joining others who had like her been "launched upon the stream that flows silent and deep through all great cities, gliding on between precipitous borders, away and away into no-man's land ... They were exiles. She turned the word over in her mind – exiles; it sounded unwanted, lonely. But why had Stephen become an exile?" (360, 339–340). And even when she had made a home for herself and her lover, Mary, on the rue Jacob, steps from Eileen Gray's apartment on the Left Bank in Paris, this question would always lead Stephen back to Morton: "Morton that was surely Stephen's real home, and in that real home there was no place for Mary" (340). Stephen realized that no home, no country, no city would provide a place for her and Mary, and so she took on the challenge of building that place for them.

Stephen is a writer who conceives of her literary work in architectural terms that resonate with Gray's. When Mary worries over Stephen's long and taxing hours of writing, Stephen reasons, "I'm trying to build you a shelter" (346), and goes back to her work. As Victoria Rosner argues, Stephen longs to build a shelter unlike the architecture she knew – unlike that architecture which operated "as a regimented theatre of control in which women are typically confined to interior spaces, heterosexual desire alone is granted shelter, and exteriority is privileged over interiority."[47] Like Gray, Stephen hopes to build a home that will shelter her private tastes, intimacies and desires – a house that will respond to her individual psychological reality and not the "terrible, pitiless and deeply accusing eyes" that had banished her.

Stephen hears of the house on the rue Jacob from Valérie Seymour, a character that Hall based on Natalie Barney, Romaine Brooks' lover who hosted famous weekly salons from her house on rue Jacob. When Stephen renovates the house, she is careful to hire an architect who would build to her specifications: "she found a young architect who seemed anxious to carry out all her instructions. He was one of those very rare architects who refrain from thrusting their views on their clients" (252). While her Empire aesthetics differ from Gray's, Stephen shares her taste for muted colours and emphasis on individualized rather than standardized homes. Stephen seems to recognize that the abstractly determined solution to the problem of the house that architects were eager to thrust upon their clients was a type that did not accommodate women like her. Stephen, like Gray, understands that building according to the views of the architect would not grant shelter to her particular passions, desires and individual tastes.

While entirely unlike Stephen's in tone, the only other domestic space where she feels comfortable is at Valérie Seymour's house. "The first thing that struck Stephen about Valérie's flat was its large and rather splendid disorder. There was something blissfully unkempt about it … Nothing was quite where it ought to have been, and much was where it ought not to have been, while over the whole lay a faint layer of dust" (246). This "splendid disorder," modelled on Barney's house, was the heart of lesbian high culture and community in pre-war and interwar Paris, in both Hall's novel and her life. To the stream of exiles that flowed into Paris, "the shipwrecked, the drowning … poor spluttering victims" (356), Valérie/Barney offered "the freedom" and "the protection … of her salon" (356). "For Valérie, placid and self-assured, created an atmosphere of courage; everyone felt very normal and brave when they gathered together at Valérie Seymour's" (356). As Rosner explains, "Valérie's rooms offer a fully developed alternative to the domesticity of Morton … a gorgeous mess that permits gender categories to blend and blur, a place where such blurring seems the rule rather than the taboo exception."[48] The dust and disorder provide an alternative not only to Morton, but also to the fantasy of total hygiene propagated by modern architecture at the time.

As I discussed in Chapter 1, modernist architecture conceived of itself primarily as "a kind of medical equipment," securing both hygienic domestic spaces and hygienic bodies.[49] To combat what Le Corbusier deemed the "sickening" "perversion" of decoration and "useless disparate objects," modernist architecture proposed the clarity and purity of the white wall. By 1927, this white wall would become the defining feature (and fantasy) of twentieth-century architecture, and Le Corbusier imagines its legal prescription, "the Law of Ripolin," where

His home is made clean. There are no more dirty, dark corners. *Everything is shown as it is.* When you are surrounded with shadows and dark

corners you are at home only as far as the hazy edges of the darkness
your eyes cannot penetrate. You are not master in your own house.[50]

Modernist architecture was medical equipment geared to purge the dusty disorder, the blurred boundaries and hazy edges that makes exiles like Stephen feel brave and protected. Beatriz Colomina argues that the modern "house is first and foremost a machine for health, a form of therapy,"[51] but the first sign of health for Le Corbusier was *"to love purity!"*[52] This conception of architectural-therapeutic purity provided literally no room for figures like Stephen, who were understood according to the medical logic at the time as fundamentally mixed: as Krafft-Ebing put it, "[t]he masculine soul, heaving in the female bosom"[53] or, as Hall puts it, "mid-way between the sexes" (81). Modernist architecture's health and hygiene campaign was aimed specifically at "blissfully unkempt" houses like Valérie's and may have registered as a threat to those who personified the disorder it was meant to treat. "Yes!" Gray writes, "We will be killed by hygiene."[54] While it is perhaps lacking in dust, we can see among the tousled throw cushions and blankets, overlapping wool carpets and toppled pile of magazines in Gray's photograph of E.1027's living room the sort of blissfully unkempt or splendid disarray that Hall appreciated (see Figure 1.1). Gray is less interested in clarifying those hazy or blurred edges that threaten the master of the house than in recognizing and accommodating them, or creating, as Valérie has, "a place where such blurring seems the rule rather than the taboo exception."[55]

Fashion, vision, architecture

Gray's resistance to hygiene, precision, clarity, vision and visibility, her emphasis on interiority, privacy, sensuality and intimacy, suggests that she shared with Hall a sensitivity to modernity's gendered and sexualized politics of vision. Modernity, since the mid-nineteenth century, has been characterized by shifting modes of vision and a new emphasis on visuality generally. And vision, perhaps more than anything else, was at the heart of Le Corbusier's modernist project. Colomina explains that "[s]eeing, for Le Corbusier, is the primordial activity of the house. The house is a device to see the world, a mechanism for viewing."[56] As Wigley puts it, his houses are "[n]ot machines for looking at but machines for looking."[57] Le Corbusier's privileging of the look is well known. However, as Wigley notes, "the nature of that look and that privilege is not examined."[58] In his creation of "machines for looking," Le Corbusier posits the white wall as the guarantor of clear visibility. The possibility of vision comes from securing the freedom of all surfaces from decoration, and whitewash, or a coat of white paint, emerges as the liberator. In their freedom, Le Corbusier writes, things appear truthful: "[Whitewash]

is the eye of truth."[59] Modernist architecture presented whitewash as a form of uncovering, of stripping off the dishonest, ornamental garb to reveal the essential truth, showing "everything as it is." However, the effect of this naked architecture can be achieved only by putting on a new coat of white paint. That is, our "perception of a building becomes the perception of its accessories, its layer of cladding."[60] It turns out that the problem is less with clothing, per se, than with dishonest outfits – claddings which obscure or haze the truth.

Beatriz Colomina explains that to enter Le Corbusier's architecture is to enter the space of a camera – a mechanism that changes men to disembodied viewers, to look-outs: "we will get the feeling of being look-outs dominating a world in order."[61] Unsurprisingly, if modern man is a sort of camera, modern woman is a picture. Her innovations have been in dress. Her modern achievement consists of new ways of presenting her body:

woman cut her hair and her skirts and her sleeves. She goes out bareheaded, barearmed, with her legs free.... And she is beautiful; she seduces us with the charm of her graces.... The courage, the liveliness, the spirit of invention with which woman has revolutionized her dress are a miracle of modern times. Thank you![62]

Woman is modern insofar as she presents her body to view. Her modern revolutions are new visual technologies of seductive exposure. Le Corbusier reports the seductions of women's dresses as lessons in modernity:

The women are beautiful to behold, beautifully coiffured even in the harsh light and all decked out in exquisite dresses. To us they are not like strangers whose costumes alone would create a barrier ... all these things urged us to notice and admire them.[63]

Modern women's dress is no longer a barrier; it is an invitation to men's notice and admiration. Men's dress, by contrast, erases the male body: "It had *neutralized* us.... The dominant sign is no longer ostrich feathers in the hat, it is in the gaze. That's enough."[64] Le Corbusier's houses are "machines for looking," but it becomes clear that the viewing dynamics are inextricably gendered. Perhaps the most prevalent modern stereotype of femininity was her too close association with materiality, to the trickery of surfaces, the illusions of appearance. In Le Corbusier's work, we find that the job of the modernist artist and architect was to order, discipline, control by rendering clearly and absolutely visible this dishonest and dissimulating force. Women's short hair, free legs, bare heads and arms are signs of honesty, truthfulness to the "neutralized" men who gaze at them in appreciation. Women's bodies, like white walls, stripped of decorative feminine accoutrements, would eliminate those hazy edges that evade the penetration of the eye and threaten the master of the house.

Constant has argued that Gray designed E.1027 as a critique of the visual agenda built into Le Corbusier's houses in the 1920s. Le Corbusier

organized his houses according to the *promenade architecturale*, a strategy by which the spaces unfold as a series of tableaux. He describes the desired effect first in his Maison Le Roche (1924): "One enters. The architectural spectacle presents itself in succession to the eye; one follows an itinerary and the perspectives unfold with great variety."[65] Gray designed E.1027 not to promote but to obstruct the transformation of domestic space into a sphere of spectacle and visual pleasure. As Constant explains, "Intertwining the visible with what is out of sight, she manipulated vision to different ends.... Gray sought to transcend the reductive nature of the total view."[66] Despite Constant's indication that E.1027 was intended as a critique of the reductive visual agenda that Le Corbusier promoted, the implications for gender and sexuality of Gray's efforts to subvert "the pleasure of the eye" have never been explored.

Gray's assertion that the pleasure of private intimacies should trump the pleasure of the eye would have resonated beyond the confines of architectural debate and into the wider domain of social debates about fashion, gender and sexuality which, as Wigley and Colomina argue, sustains these architectural rhetorics of vision. In Gray's private papers we can find rough notes that suggest she was highly sensitive to the dynamics of desire and vision and designed to challenge the reductive tendencies of visual pleasure. She writes, for example, "la chicane sans donner une impression de résistance arrive le désir de pénétrer. donne la transition. garde le mystère. les objets à voir tiens en haleine le plaisir."[67] Gray admits of the desire of the eye, but is less interested in its satisfaction than in its obstruction or deflection. The various screening devices that Gray designed for E.1027, the sunken doors, hidden by partial walls, extended by storage partitions, obstruct the reductive pleasure of total visibility. Even the furnishings incorporate this impression of resistance, concealing even as they reveal their multiple forms, functions and sensations. Gray's photograph of the entryway partition suggests the effect that this obstructive visual strategy would have had (Figure 3.2) – prolonging one's physical access to the room and breaking up the visual field into partial glimpses, both revealing and concealing, separating while still suggesting the porosity and connectivity of the spaces, provoking, as she explains, a desire for the sight to be seen. That is, she is interested in objects that remain just tantalizingly out of view, that keep their mystery, that withhold the satisfaction of total visibility or complete exposure and prolong the pleasure of desire itself. As Constant has noted, Le Corbusier's suggestion that Badovici remove this partition indicates the significant differences in Gray's visual agenda, and the extent to which it may have disrupted Le Corbusier's.[68] On the same page of notes, she writes that "the poverty of architecture today results from the atrophy of sensuality."[69] Judging from the lines just preceding this intriguing criticism, it seems that sensuality for Gray was constituted by the play between exposure and concealment, between seeing and the desire to see.

The pleasure of Gray's design and architecture takes place on the cusp between the visible and the invisible. In another page of notes on "Interior Architecture" ("Architecture intérieure"), she writes of

La tristesse des 2 voyageurs entrant dans la salle à manger
de l'hôtel aux 200 couverts éternellement mis.
La femme éternellement parée.
Le monde extérieur – les gens – l'Art – ne valent que par leur pouvoir de suggérer.[70]

This is the only explicit reference to woman that I have ever seen in Gray's writing. And the term "parée" can be taken several ways. It can be "dressed up," "prepared," "ready to go" or simply "ready,"[71] and its meaning depends on the phrases it follows and precedes. Gray imagines the sadness of travellers greeted by tables eternally set, by a room that loses its power to suggest the pleasures of a meal, of respite, rest, satiation or satisfaction by its eagerness to expose itself fully. As though to reveal her point, to clarify, Gray uses the example of this woman who is ambiguously dressed up, ready, or ready to go. We can assume that this woman, like the dining room, has lost her power to suggest some kind of pleasure through over-exposure. All the same, Gray's point remains unclear. But by looking through her personal and published writings, as well as her designs at E.1027, we find that this lack of clarity appears to *be* the point. She builds emphatically against the clarity that modern architecture most values, and towards the power of suggestion that the woman could embody if not for her total exposure. The eternally ready woman serves to illustrate the importance of ambiguity, of keeping something back, of not "showing everything as it is" according to Le Corbusier's fantasies.

These notes make it into Gray's published writing. In "De l'éclectisme au doute" she insists that "[e]very work of art is symbolic. It conveys, it suggests the essential more than representing it" (238). However, when Gray speaks of "the essential" she means something quite different than Le Corbusier's abstractly determined standard. Gray's essential is less universal than it is particular and contingent. It is an expression of "individual pleasures" which are determined by "the conditions of existence, of human tastes and aspirations, passions and needs" (238). The essential elements that structure Gray's architecture would be ruined by the total exposure that Le Corbusier advocates. Gray builds to suggest these individualized pleasures, passions and needs, not to show them. Wigley insists that modern architecture is everywhere "haunted by the spectre of fashion,"[72] and indeed if we are in search of a source for Gray's fundamentally ambiguous look, built into the furnishings and architecture of E.1027 and signalled in Gray's notes by the woman whose power of suggestion rests on her remaining on the cusp between the visible and the invisible, we can find it in new women's fashion in the 1920s.

Other fashions, visions, architectures

The limited evidence of Gray's own fashion choices and the extensive information about the very similar fashion choices of other women at the time suggest that Gray's architecture follows the logic of fashion no less, but quite differently, than Le Corbusier's. Whereas Le Corbusier's notion of fashion, in architecture and dress, depended on stripping and exposure, Gray's seems to have depended on disguise and concealment. Gray appears to have taken part in those female fashion reforms that Le Corbusier praised, just as she took part in those architectural reforms, but rather than celebrating their power to show and reveal, she seems to have capitalized on their potential to do the opposite, to obstruct and evoke.

The only photographs of Gray from the late 1920s which have survived were taken by Berenice Abbott in 1926 (Figures I.3 and 3.4).[73] Adam indicates that Gray approached Abbott after having seen her portrait exhibition in 1926.[74] Although no record of their correspondence remains, it may have been just as likely that Abbott, chronicler of the Parisian avant-garde in the mid-1920s, would have approached Gray. As Laura Cottingham notes, Abbott's early photography was importantly invested in documenting the high-profile lesbian figures of the Left Bank – an investment which has been largely overlooked: the foreword to the most recently published book of Abbott photographs

> takes pains to call the reader's attention to Abbott's portraits of James Joyce, Andre Gide, and Jacques Cocteau but fails to reveal the fact that Abbott photographed high culture's Left Bank lesbian set of the 1920s, and that Abbott's charmed lesbian circle is featured one-by-one in the portraits of Jane Heap, Sylvia Beach, Princess Eugene Murat, Janet Flanner, Djuna Barnes, Edna St. Vincent Millay and – from their countenances and appearances – many of the other women featured in the book. Not to acknowledge Abbott's lesbianism is not to understand her art or her subjects.[75]

Gray's portraits are not included in this collection, but the "countenances and appearances" that Cottingham refers to resemble those that Gray had assumed at the time. While Cottingham shares with many commentators of the period the assumption that this masculinized appearance was a tell-tale sign of lesbian identity, recent historians of modernity have argued convincingly that this look was not so straightforwardly revealing. "Fashion," Tirza Latimer reminds us, "is by nature an ambivalent form of discourse."[76] As Laura Doan explains, the multiple signifying possibilities of masculinized women's fashion in the 1920s have tended to be lost on historians reading a fixed image of lesbian identity back onto subjects and sartorial styles that precluded such stability.[77]

Gray's masculinized look in 1926–27 would have straddled the line between outré New Woman fashion and upper-class mannish lesbian.

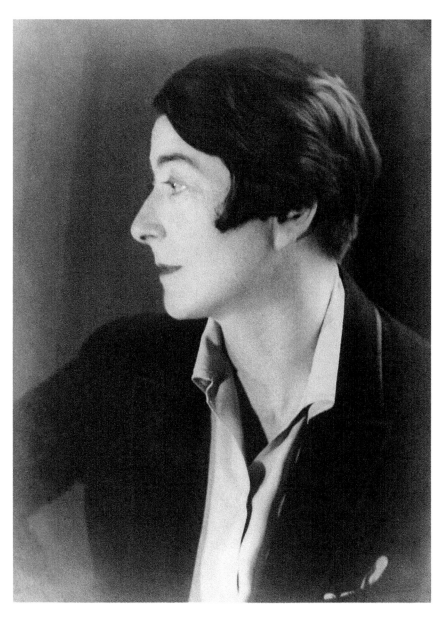

3.4 Eileen Gray, photograph by Berenice Abbott, 1926. Reproduced with the kind permission of the National Museum of Ireland.

Paris in the 1920s saw an explosion of simplified, gender-blurring *mode à la garçonne*, popularized famously by designers like Coco Chanel and Paul Poiret and hairstylists like René Rambaud; and at the same time, London witnessed the rising popularity of the "boyette" or the "masculine note" in female fashions.[78] Journalists, politicians, doctors, architects and all forms of social and cultural commentators in both London and Paris were preoccupied by women's changing fashion in the 1920s. As Roberts explains, "[f]ashion bore the symbolic weight of a whole set of social anxieties concerning ... gender relations: the blurring or reversal of gender boundaries and the crisis of domesticity."[79] Reactions to women's tendency to "disguise themselves as men" ranged from laudatory to humorous to invective:

Postwar critics spoke of a certain absence or lack of definition, which characterized both the new female body and "womanhood" itself. They interpreted the fashions that the modern woman wore as reproducing her inability to be defined within the boundaries of traditional concepts of womanhood.[80]

And Roberts points out, not incidentally, that this anxiety was informed by scientific discourse on sexual inversion "inspired by the translation of Havelock Ellis into French. 'The species feels itself endangered by a growing inversion,' the literary critic Pierre Lièvre argued in 1927, 'no more hips, no more breasts, no more hair.'"[81] The discourse of dangerous inversion would have resonated by the 1920s with sexological descriptions of female homosexuality. Krafft-Ebing writes, for example, that "[female inversion] may nearly always be suspected in females wearing their hair short, or who dress in the fashion of men, or pursue the sports and pastimes of their male acquaintances"; such women exhibit "masculine features ... manly gait ... [and] small breasts."[82] Havelock Ellis focused less on physical characteristics than on taste: the female invert can be detected in "traits of masculine simplicity ... [and] frequently a pronounced taste for smoking cigarettes ... also a decided taste and toleration for cigars."[83] Female homosexuality, they argued, could be either indicated or created by taking on the mannerisms, professions, hobbies, fashions or desires of men. Masculinized fashions, critics feared, were masculinizing women, which according to the scientifically informed logic of the time resulted in lesbianism.

However, not all critics, and not all women, would have read these new masculinized fashions as straightforward indications of female sexual inversion. In her study of early twentieth-century British lesbian culture, Doan looks at

the pervasive phenomenon of masculine fashion for women, with its concomitant openness and fluidity, to explore the ways in which some women, primarily of the upper middle and upper classes, exploit the ambiguity that tolerated, even encouraged, the crossing over of fixed labels and assigned categories such as female boy, woman of fashion in the masculine mode, lesbian boy, mannish lesbian, and female cross-dresser.[84]

The visual codes of masculinized femininity were not yet fixed in the 1920s, and while some would recognize its implications of female sexual inversion (the mannish lesbian), this was not its only or necessarily primary meaning. Doan focuses on readings of Hall's notoriously masculine fashions to show that while she tends to be read by today's viewers as typifying lesbian style, "it is important to remember that [she] appeared quite differently to the press and public in the 1920s."[85] Hall was a major figure in the upper classes of artistic London nightlife in the 1920s, and rather than being taken as the visual epitome of a sexually deviant subculture, she was invariably read as the vanguard of chic modern style. For example, after she received the prestigious Femina Prize for her 1926 novel *Adam's Breed*, photos of Hall were featured in newspapers throughout England praising her for being "in the front rank of ... modern fashions in dress."[86] As the widely circulated 1927 photograph of Hall and her partner Lady Una Troubridge posing in their London home suggests, while certain viewers were undoubtedly familiar with the inverted sexual implications of her mannish look, upper-middle-class and upper-class artistic women like Hall were able to enjoy the ambiguity of such masculinized female fashions to reveal and conceal their lesbianism simultaneously.

In the 1920s, Hall and Gray's preferred look, like Gray's architecture and design, eschewed the absolute visibility and clear intelligibility that Le Corbusier praised. When Le Corbusier celebrated the visual pleasures of new women's fashion in the 1920s, he may have been referring to the same look that women like Hall and Gray favoured. When Le Corbusier admires women's short hair, bare head and free legs, he praises their fashion innovations according to the architectural logic of simplification, stripping the dissimulating ornament and revealing the truth of women's bodies – their luring charm for the pleasure of men's eyes. These innovations were embraced, however, by women like Gray and Hall less for their ability to reveal than for their power to suggest. Latimer explains that

[in] the process of formulating image-making strategies capable of both communicating and dissimulating same-sex desires, lesbians of the early twentieth century confronted a number of interrelated dilemmas bearing on what Annamarie Jagose has described as "the ambivalent relationship between the lesbian and the field of vision."[87]

With the threat of social, cultural and, in England, legal persecution, lesbians in the early twentieth century were compelled to cultivate what Latimer terms a "visible invisibility": they could, of course, be seen, but only by those who knew how (and where) to look.[88] Marjory Garber explains that "vestimentary codes" are a complex "system of signification":

[They] speak in a number of registers: class, gender, sexuality, erotic style. Part of the problem – and part of the pleasure and danger of decoding –

is in determining which set of referents is in play in each scenario. For decoding itself is an erotics – in fact, one of the most powerful we know.[89]

This elaborate process of decoding, of learning how to look, constituted the pleasure (and danger) of lesbian visibility at the time – obviously and necessarily a very different erotics of vision than that which was promoted by Le Corbusier and modern architecture in the 1920s. But it was significantly very similar to Gray's architectural investment in obstructing views to produce desire, or to her assertion that "the objects to be seen keep pleasure in suspense."[90] Gray's writings indicate that her work was based on the pleasure and power of suggestion, on objects and domestic spaces that conceal their mystery or secure their privacy, on designing for the pleasure of decoding or wanting to see that which will only be partially shown and never totally revealed. This might be seen as a sort of visual philosophy that derived, as much as the rest of modernist architecture's, from the logic of fashion, but instead of their philosophy of uncovering, stripping, revealing and exposing, she worked with covering, protecting, obstructing and evoking.

Doan explains that through such sartorial codes lesbians in the 1920s entered into a uniquely ambivalent field of visibility, such that "one woman's risk was another woman's opportunity, for *within* a discreet, perhaps minuscule, subculture, lesbians passed as stylishly recognizable lesbians as well as women of fashion."[91] However, the flexibility of these codes, Doan argues, was abruptly fixed at the time of Hall's obscenity trials in 1928. Within weeks of Hall's publication of the first "long and very serious novel entirely upon the subject of sexual inversion,"[92] the *Sunday Express* published a sensational attack on the book, which spearheaded the legal campaign against it. Most scholars have read these obscenity trials as a demonstration that "the very suggestion of lesbian sexuality was enough to unleash remarkable animosity,"[93] or as examples of "hostility towards lesbianism."[94] However, Doan shows that in the years, and even days, preceding the article and the legal battle, lesbianism was not yet a stable point of reference against which the press, the public or the courts could reasonably rail. Instead, the proliferation of photographs of Hall in the daily papers, and the legal campaign associating her with "a particular hideous aspect of life as it exists among us today"[95] from August to December of 1928, effectively created a lesbian identity modelled on Hall's previously stylish modern image. After 1928, "[t]he very fashions that facilitated 'passing' in an earlier era would thus thrust some lesbians out into the open."[96] The photograph of Hall and Troubridge at home, for example, was carefully cropped for newspaper publications during the obscenity trials: it was cut just above Hall's knees, converting her stylish skirt to transgressive trousers and removing Troubridge altogether, transforming the image of Hall from chic, fashionably skirt-suited new woman to the picture of deviant and criminal mannish lesbian. After the trials, Hall's and so Gray's masculinized

look had lost much of its ambiguity, and the dangers of being unequivocally "out in the open" were vividly pronounced in the press.

Conclusions

While the effects of Hall's trials in France have not been so carefully studied, fashion historians have noted that by 1929 feminine styles were being firmly reasserted in France as well as England.[97] We might assume that for those French critics who had expressed anxiety about the sexual inversion produced by masculinized female fashions, the news of Hall's legal battles and her mannish style could only have confirmed their worst fears. Perhaps in the context of the sensational outing of lesbianism achieved by Hall's obscenity trials we can better understand Gray's choice not to use her portraits for her publication in 1929 or for any subsequent shows and her decision to continue wearing masculinized styles into the 1930s, as well as her renowned shyness. By the 1930s, when she was remembered for her pant-suits and bow-ties, women's mannish fashions had lost the multiple, suggestive signifying possibilities that they had enjoyed before Hall's trials.[98] Gray showed her work in 1929 and 1931 at the Paris exhibitions of the Union des Artistes Modernes (UAM)[99] and in 1937 at Le Corbusier's Pavillon des Temps Nouveaux, and, after painstakingly arranging her displays, chose to attend none of their openings. Gray's reluctance to attend her openings or publicize her work tends to be attributed to her shyness[100] but may be better understood in the context of her writings on vision, and her emphases on privacy and the pleasure and power of suggestion. That is, her reticence about such public and publicized events may be understood as a reluctance to submit herself and her work to the reductive politics of vision and identity following Hall's influential trials in 1928.

Considering Gray's only published statements about her work in light of the trials that had just six months before found Hall's novel obscene – a novel which is essentially a plea for the creation of private, domestic space that would shelter a-typical, non-heterosexual intimacies and desires – allows us to recognize some of the wider implications of Gray's criticisms of exteriority, "the pleasure of the eye" and type-houses. The story of E.1027, like that of all of Gray's work, has until very recently followed strictly heteronormative narrative lines: as a turning point in her maturation from decadent, figurative and excessively personal decorative arts, conceived in early experimental relationships with women, to "pure" modernist, generalized, abstract architecture conceived in serious personal and professional relationships with modern masters. Caroline Constant was the first to explore the critical edge to Gray's sensually engaging design and architecture, and Beatriz Colomina suggests that this critical sensuality was related to Gray's sexuality,

which was in turn related to the sustained and sexualized disciplinary action by Le Corbusier, in the form of vandalism, occupation and the eventual effacement of Gray's name and work. Colomina claims that "Gray was openly gay,"[101] but just how open Gray's gayness was is not so clear. Save for this one unequivocal assertion, Gray's non-heterosexuality seems to have operated as a sort of open secret, as an erotics of visible invisibility in her work, in her life and in the literature that has struggled to make sense of her unaccountably critical sensuality. Indeed, Le Corbusier's visual philosophy of exposure would suggest that he hoped to reveal something that Gray had kept deliberately concealed. And his three-part theory of muralling – to purify, to penetrate or enter, and to "violently destroy"[102] – suggests a desire to clarify the blurred and indefinite visibility that Gray cultivated, to insert himself forcibly into and so to destroy an erotic dynamic that excluded or threatened him.

Colomina's version of the story of E.1027 suggests that the effacement of Gray's name and work from the history of modern architecture results from the systemic continuation of this first act of homophobic violence. We may think of Le Corbusier's effacement as a more successful censorship of homoerotic aesthetics than the one attempted by the London courts. The 1928 obscenity trials intruded on the privacy that Hall's ambiguous visibility had afforded her and reduced the erotically suggestive power of her image to an unambiguously identifiable and unacceptable "look," but ultimately boosted the international sales of her novel and secured her a place in the history books, whereas Le Corbusier's invasion of the privacy that Gray hoped to achieve with her erotically ambiguous visibility succeeded in concealing her work from view entirely for nearly 40 years, so that by the time it was rediscovered, the sexually suggestive critical edge of her work was reduced to what the literature on her continues to consider a nearly unintelligible sensual engagement. Allowing Hall into the story of E.1027 lets us consider the relationship between Gray's critical emphases on suggestion, interiority, intimacy, individualized pleasures and privacy, the contemporaneous creation of recognizable lesbian identities and the heteronormative theoretical framework that has been sustained by editing these relationships out.

Notes

1. Le Corbusier, *The Decorative Art of Today* (1925) (Cambridge, MA: The MIT Press, 1987), 189.
2. Eileen Gray, "De l'éclecticisme au doute" ("From Eclecticism to Doubt"), in "Maison en bord de mer," *L'architecture vivante* (Winter 1929), trans. in Caroline Constant, *Eileen Gray* (London: Phaidon Press Limited, 2000), 239.
3. Radclyffe Hall, *The Well of Loneliness* (1928) (London: Virago Press Limited, 1982), 205.
4. Joseph Rykwert, "Eileen Gray: Pioneer of Design", *Architectural Review*, vol. 152, no. 910 (December 1972), 357.
5. Joseph Rykwert, "Eileen Gray: Two Houses and an Interior, 1926–1933," *Perspecta*, vol. 13, no. 14 (1972), 68.

6. Reyner Banham, "Nostalgia for Style," *New Society* (February 1973), 249.

7. Ibid.

8. "Maison en bord de mer," *L'architecture vivante* (Winter 1929).

9. Le Corbusier refers to his mural at E.1027 as "Graffiti at Cap Martin" in *My Work*, James Palmes, trans. (London: The Architectural Press, 1960), 50. I will return to these murals shortly.

10. Peter Adam, *Eileen Gray, Architect, Designer: A Biography* (New York: Harry N. Abrams, Inc., 2000), 375, 147.

11. Caroline Constant, *Eileen Gray* (London: Phaidon Press Limited, 2000), 67–68; Adam, *Eileen Gray*, 150.

12. Beatriz Colomina, "Battle Lines: E.1027," in *The Sex of Architecture*, Diana Agrest, Patricia Conway and Leslie Kanes Weisman, eds (New York: Harry N. Abrams, Inc., 1996), 171.

13. Lynne Walker, "Architecture and Reputation: Eileen Gray, Gender, and Modernism," in *Women's Places: Architecture and Design 1860–1960*, Brenda Martin and Penny Sparke, eds (London and New York: Routledge, Taylor & Francis Group, 2003), 104.

14. Joe Lucchesi, "'The Dandy in Me': Romaine Brooks's 1923 Portraits," in *Dandies: Fashion and Finesse in Art and Culture*, Susan Fillin-Yeh, ed. (New York and London: New York University Press, 2001), 153–184; Bridget Elliott, "Performing the Picture or Painting the Other: Romaine Brooks, Gluck and the Question of Decadence in 1923," in *Women Artists and Modernism*, Katy Deepwell, ed. (Manchester and New York: Manchester University Press, 1998), 70–82; Bridget Elliott and Jo-Ann Wallace, *Women Artists and Writers: Modernist (Im)positionings* (London and New York: Routledge, 1994); Laura Doan, *Fashioning Sapphism:The Origins of a Modern English Lesbian Culture* (New York: Columbia University Press, 2001); Tirza True Latimer, *Looking Like a Lesbian: The Sexual Politics of Portraiture in Paris between the Wars*, Ph.D. dissertation, Stanford University (Ann Arbor: UMI Dissertation Publishing, 2002); Whitney Chadwick and Tirza True Latimer, "Introduction" and "Becoming Modern: Gender and Sexual Identity after World War I," in *The Modern Woman Revisited: Paris between the Wars*, Chadwick and Latimer, eds (New Brunswick, NJ, and London: Rutgers University Press, 2003), xiii–xxiv, 3–19.

15. Annamarie Jagose, *Inconsequence: Lesbian Representation and the Logic of Sequence* (Ithaca: Cornell University Press, 2002), 2.

16. Scholars like Caroline Constant and those included in her collection *Eileen Gray: An Architecture for All Senses* (1996) have been compelled by Gray's "non-heroic" sensual architecture and design. Reviewers and critics such as Banham, Rykwert and Adam, as well as her contemporaries in the 1920s, have been more confused and disturbed.

17. Walker, "Architecture and Reputation," 102.

18. Eileen Gray, "Description," in "Maison en bord de mer," *L'architecture vivante* (Winter 1929), trans. in Constant, *Eileen Gray*, 240. Unless otherwise noted, all further references to Gray's published writings come from Constant, *Eileen Gray*, 238–245.

19. Adam, *Eileen Gray*, 174.

20. The house measured 1,600 square feet on the upper level, 1,200 on the lower.

21. Gray, quoted in Constant, *Eileen Gray*, 94.

22. The third room on the lower floor is the maid's room, "the *smallest habitable cell* … where one seeks only essential comfort" (244). This room is exceptionally smaller than any other in the house, and its essential comforts included only a bed and a washbasin, with one small window that is entirely blocked by an external piloti, or cement pillar. Gray writes that "this room could serve as an example of all rooms for children and servants" (244) and would indeed set the tone for her servant's room in the next two houses she built, reflecting a profoundly classist attitude to the maid, Louise Dany, with whom she would spend nearly 50 years of her life (1927–76). Judging by Gray's letters, however, her relationship to Louise was more intimate and conflicted than her strictly separate architecture suggests.

23. Le Corbusier, "Où en est l'architecture?," *L'architecture vivante* (Fall 1927), 7–11.

24. Victoria Rosner, *Housing Modernism: Architecture, Gender and the Culture of Space in Modern British Literature*, Ph.D. dissertation, Columbia University (Ann Arbor: UMI Dissertation Publishing, 1999), 159, quoting Geoffrey Beard (1990).

25. Gray's childhood was spent between her family's Victorian townhouse in Kensington, London, and an Edwardian English manor house, Brownswood, in Enniscorthy (County Wexford, Ireland).

26. Rosner, *Housing Modernism*, 153.

27. The divan in the alcove off the living room, for example, has "a flexible table with two pivots [which] allows for reading while lying down" (242). This flexible table, built into the headrest with electrical sockets and reading lights on dimmer switches, was also used for Gray's bedroom in Paris.

28. Constant, *Eileen Gray*, 107.

29. For example, Le Corbusier's model house at the Pavillon de L'Esprit Nouveau (1925), Marcel Breuer's contribution to the Werkbund in Paris (1930) and Loos' Muller House in Prague (1930) all included separate rooms designated for the man and the woman of the house. As Bridget Elliott explains, unlike the avant-garde architecture upon which much of this first house was based, "Gray's solitary spaces were geared towards work and study [and I would add relaxing and luxuriating] and not associated with either sex." Elliott, "Housing the Work: Women Artists, Modernism and the *maison d'artiste*: Eileen Gray, Romaine Brooks and Gluck," in *Women Artists and the Decorative Arts, 1880–1935: The Gender of Ornament*, Bridget Elliott and Janice Helland, eds (Aldershot, England, and Burlington, VT: Ashgate, 2002), 182.

30. Virginia Woolf, *A Room of One's Own* (1928) (London: HarperCollins Publishers, 1994): 115.

31. Gray, letters in the Eileen Gray archive at the National Museum of Ireland, Dublin. This is one of the many undated letters in the archive, but it was sent from Lou Perou, Gray's final architectural project in the south of France, which suggests it was written in the 1950s.

32. While *The Well* has long been read as the first and prototypical literary representation of lesbianism – the cover of my edition dubs it "a classic story of lesbian love" (Virago Press Limited, 1994) – recent scholarship has shown that the term "lesbian" can be only retrospectively and at best uneasily applied to the main character and subject of the novel, Stephen Gordon. Jay Prosser argues that Hall's description of Stephen's extreme gender dysphoria needs to be understood as the first narrative of transsexuality, before such a category existed (Prosser, *Second Skins: The Body Narratives of Transsexuality* (New York: Colombia University Press, 1998)), and Laura Doan argues that the lesbian identity which has so persistently been read back into Hall's story is an *effect* of the novel, its obscenity trials and the photographic images of Hall that they became conflated with at the time (Doan, *Fashioning Sapphism*). Indeed, the word "lesbian" is conspicuously absent from the novel, which relies instead on the sexologists' terminology of "inversion." Throughout this chapter, I have tried to use the term "invert" when discussing the novel, "non-heterosexual" or "homosexual" when discussing its implications for Gray's work and female subjectivities at the time, and "lesbian" as a post-1928 identity and theoretical perspective. All further references to Hall's *The Well of Loneliness* will come from the Virago Press edition of 1994.

33. "As though drawn there by some natal instinct, Stephen went straight to her father's study; and she sat in the old arm-chair that had survived him.... All the loneliness that had gone before was as nothing to this new loneliness of spirit. An immense desolation swept down upon her, an immense need to cry out and claim understanding for herself, an immense need to find an answer to the riddle of her unwanted being. All around her were grey and crumbling ruins, and under those ruins her love lay bleeding.... Getting up, she wandered about the room, touching its kind and familiar objects; stroking the desk, examining a pen... then she opened a little drawer in the desk and took out the key of her father's locked book-case" (205–206).

34. Rosner, *Housing Modernism*, 183–184.

35. Constant, *Eileen Gray*, 94; Adam, *Eileen Gray*, 191.

36. Constant has published the only discussion of Gray's first two hypothetical projects, explaining that the first was based on Loos' Villa Moissi (1923) and reworked "into a form more indebted to Le Corbusier" (Constant, *Eileen Gray*, 68); but for her second, a "House for an Engineer" (1926), "Gray pursued a more independent route. Adapting selected aspects of Le Corbusier's theoretical precepts to her experiential objectives ... [but] reject[ing] the volumetric purity of Le Corbusier's early purist villas" (Ibid., 68).

37. Ibid., 94.

38. Ibid., 8.

39. Le Corbusier, *L'architecture vivante* (Fall 1927), 12. Le Corbusier published "Où en est l'architecture?' in *L'architecture vivante* and this outlined his five points and included another, "suppression of the cornice." He would publish "Five Points of a New Architecture" in the

catalogue of his and Pierre Jeanneret's buildings for the Stuttgart Weissenhofsiedlung in the following year, 1928.

40. Le Corbusier, *Towards a New Architecture* (1923), F. Etchells, trans. (New York: Dover Publications, 1986), 264.

41. Ibid., 6–7.

42. Gray, quoted in Adam, *Eileen Gray*, 309.

43. Mark Wigley, *White Walls, Designer Dresses: The Fashioning of Modern Architecture* (Cambridge, MA: The MIT Press, 1995), 302–303.

44. Ibid., 303.

45. Ibid., xv.

46. Le Corbusier, *Towards a New Architecture*, 16.

47. Rosner, *Housing Modernism*, 29.

48. Victoria Rosner, "Once More unto the Breach: The Well of Loneliness and the Spaces of Inversion," in *Palatable Poison: Critical Perspectives on The Well of Loneliness*, Laura Doan and Jay Prosser, eds (New York: Colombia University Press, 2001), 324.

49. Beatriz Colomina, "The Medical Body in Modern Architecture," *Daidalos: Architektur, Kunst, Kultur*, vol. 64 (1997), 61.

50. Le Corbusier, *The Decorative Art*, 188, emphasis in original.

51. Colomina, "Medical Body," 64.

52. Le Corbusier, *The Decorative Art*, 188, italics in original.

53. Richard von Krafft-Ebing, *Psychopathia sexualis* (1886, 12th edition 1903), reprinted in *Sexology Uncensored: The Documents of Sexual Science*, Lucy Bland and Laura Doan, eds (Chicago: University of Chicago Press, 1989), 47.

54. Gray, trans. in Caroline Constant, ed., *Eileen Gray: An Architecture for All Senses* (Wasmuth: Harvard University Graduate School of Design, 2003), 70. In the original, Gray writes: "De l'hygiène à en mourir!" This 1996 translation seems more accurate than the 2000 one, which reads: "Hygiene to bore us to death!" (239).

55. Rosner, "Once More unto the Breach," 324.

56. Beatriz Colomina, *Privacy and Publicity: Modern Architecture as Mass Media* (Cambridge, MA: The MIT Press, 1998), 7.

57. Wigley, *White Walls*, 8.

58. Ibid., 4.

59. Le Corbusier, *The Decorative Art*, 188.

60. Ibid., 10.

61. Le Corbusier, quoted in Beatriz Colomina, "The Split Wall: Domestic Voyeurism," in *Sexuality & Space*, Beatriz Colomina and Jennifer Bloomer, eds (New York: Princeton Architectural Press, 1992), 112.

62. Le Corbusier, quoted in Colomina, *Privacy and Publicity*, 333–334.

63. Le Corbusier, quoted in Wigley, *White Walls*, 277.

64. Le Corbusier, quoted in Colomina, *Privacy and Publicity*, 127.

65. Le Corbusier, *Oeuvre complète 1910–1929* (Zürich: Éditions d'Architecture, 1964), 60.

66. Constant, *Eileen Gray*, 116, 117.

67. "the deflector/divider without giving the impression of resistance brings the desire to penetrate. give the transition. keep the mystery. the objects to be seen keep pleasure in suspense." Notes in the Eileen Gray archive, National Museum of Ireland, my translation.

68. Constant cites a letter held in the Fondation Le Corbusier (Paris) from Le Corbusier to Badovici, 1949, in *Eileen Gray*, 117.

69. "pauvreté de l'architecture d'aujourd'hui résultat de l'atrophie de la sensualité." Notes in the Eileen Gray archive, National Museum of Ireland, my translation.
70. "The sadness of two travelers entering the dining room of a hotel to 200 table settings eternally put out./ The woman eternally ready./ The exterior world – people – Art – are valuable only by their power to suggest." Gray, "Architecture intérieure," Eileen Gray archive, National Museum of Ireland.
71. *Collins Robert: Paperback French Dictionary* (Glasgow: HarperCollins Publishers, 1984).
72. Wigley, *White Walls*, 52.
73. Adam writes that Gray was photographed by Abbott again in 1927, but it remains unclear to me whether any of these photographs have survived (Adam, *Eileen Gray*, 185). In the Eileen Gray archive at the National Museum of Ireland, the photograph in figure 32 has "26" noted below it. And while there is no date on figure 33 in the archive, Adam has dated it from 1926. It is possible that some of these photographs were taken in 1927, but this would mean that Gray had kept precisely the same hairstyle and length, and had donned the same outfit, down to the white handkerchief in her front jacket pocket. If this is the case, it seems that Gray's carefully managed self-styling is all the more significant. However, it may be that the 1927 photographs are simply missing from Gray's available archives.
74. Adam, *Eileen Gray*, 184–185. Abbott's first solo exhibition, "Portraits photographiques," was held in Paris at the gallery Au Sacre du Printemps in 1926.
75. Laura Cottingham, "Notes on Lesbian," *Art Journal*, vol. 55, no. 4 (Winter 1996), 74, referring to Muriel Rukeyser in *Berenice Abbott/Photographs* (1990).
76. Latimer, *Looking Like a Lesbian*, 50.
77. "Before public exposure, for the better part of a decade, masculine-style clothing for women held diverse spectatorial effects, with few signifiers giving the game away, and readings (whether of clothing, visual images, or stories about women living with other women in 'close companionship') varied accordingly among those who knew, those who knew nothing, and those who wished they didn't know" (Doan, *Fashioning Sapphism*, xiv).
78. On the political implications of boyish styles in France in the 1920s, see Mary Louise Roberts, "Samson and Delilah Revisited: The Politics of Fashion in 1920s France," in *The Modern Woman Revisited*, Chadwick and Latimer, eds, 67–71. On the relationship between 1920s fashion and the creation of lesbian identities in England, see Doan, *Fashioning Sapphism*, particularly on the popularity of mannish female fashions, 102–117.
79. Roberts, "Samson and Delilah," 67–68.
80. Ibid., 74.
81. Ibid., 74.
82. Krafft-Ebing, *Psychopathia sexualis* (1886), reprinted in *Sexology Uncensored*, Bland and Doan, eds, 46.
83. Havelock Ellis, *Sexual Inversion* (1897), quoted in Doan, *Fashioning Sapphism*, 101.
84. Doan, *Fashioning Sapphism*, 99.
85. Ibid., 111.
86. From *Eve: The Lady's Pictorial*, July 13, 1927, quoted in Doan, *Fashioning Sapphism*, 110.
87. Tirza True Latimer, *Women Together/Women Apart* (New Brunswick, NJ: Rutgers University Press, 2005), 12, quoting Jagose, *Inconsequence*.
88. Latimer, *Women Together*, 12.
89. Marjory Garber, *Vested Interests: Cross-Dressing and Cultural Anxiety* (New York: Routledge, 1992), 161.
90. Gray, notes in the Eileen Gray archive, Collins Barracks, National Museum of Ireland.
91. Doan, *Fashioning Sapphism*, 120.
92. Hall, quoted in Doan, *Fashioning Sapphism*, 1.
93. Joseph Bristow, 1997, quoted in Doan, *Fashioning Sapphism*, 4.
94. Deirdre Beddoe, 1989, quoted by Doan, *Fashioning Sapphism*, 4.

95. James Douglas, 1928, quoted in Doan, *Fashioning Sapphism*, 18.

96. Ibid., 122.

97. Mary Louise Roberts, *Civilization without Sexes: Reconstructing Gender in Postwar France, 1917–1927* (Chicago and London: University of Chicago Press, 1994), 9–10; Roberts, "Samson and Delilah," 84; Doan, *Fashioning Sapphism*, 95–125.

98. Adam quotes Gray's craftsmen at Tempe à Pailla, built between 1932 and 1934, remembering her "driving around in a little MG, wearing a trouser suit with a neat bow tie, fussing over everything" (Adam, *Eileen Gray*, 267–268).

99. The UAM was organized to offer a progressive, international and modern alternative to the staid, traditionally French Société des Artistes Décorateurs, and was co-founded by Gray with Sonia Delaunay, Pierre Chareau, Jean and Joel Martel, Le Corbusier, René Herbst, Gustav Miklos and Jean Prouve, under its first president Robert Mallet-Stevens. For a detailed history of the UAM, see Nancy Troy, *Modernism and the Decorative Arts in France: Art Nouveau to Le Corbusier* (New Haven and London: Yale University Press, 1991).

100. Rykwert implies that her work had been neglected for so long because "[s]he was, and has remained, a very shy person" (Rykwert, "Pioneer of Design," 360). Adam asserts that by the 1930s, "Eileen needed help. If only her shy and modest nature had not prevented her from taking the first step" (Adam, *Eileen Gray*, 249).

101. Colomina, "Battle Lines," in *The Sex of Architecture*, 170.

102. Melony Ward explains that Le Corbusier understood his sketching and obsessive tracing and retracing an image as a process of eliminating the excess, the unnecessary, and purifying an idea to its most essential form: "Drawing for Le Corbusier is a process of purification." Ward, "Cleaning House: Purity, Presence and the New Spirit in Le Corbusier," in *Practice Practise Praxis: Serial Repetition, Organizational Behaviour, and Strategic Action in Architecture*, S. Sorli, ed. (Toronto: YYZ Books, 2000), 88. On entering, in *Creation is a Patient Search*, Le Corbusier writes, "By working with our hands, by drawing, we enter the house of a stranger" (Le Corbusier, *Creation is a Patient Search*, James Palmes, trans. (New York: Praeger, 1960), 203). Finally, Le Corbusier explains in 1932, "I admit the mural not to enhance the wall, but on the contrary, as a means to violently destroy the wall, to remove from it all sense of stability, weight, etc." (Le Corbusier, from a letter to Vladimir Nekrassov, quoted in Colomina, "Battle Lines," in *The Sex of Architecture*, 174).

4

Not communicating with Eileen Gray and Djuna Barnes

An explanatory model based on a dramatic "before" and "after" seems almost too seductive in its simplicity, but the simple – if, for some, lamentable – fact of the matter is that after the obscenity trials of *The Well* life changed utterly for all women who lived with other women, or all women drawn to masculine styles of dress, whether lesbian or not.

Laura Doan[1]

Roattino remembers Eileen driving around in a little MG, wearing a trouser suit with a neat bow tie, fussing over everything.

Peter Adam[2]

Gray's house at Castellar serves as a sanctuary from the vicissitudes of contemporary urban life…. It is more compact and introverted, tailored not only to Gray's small frame but also to her solitary way of life. It is less of a showpiece and more grounded in reality.

Caroline Constant[3]

Throughout the twentieth century, it has been communication technologies, perhaps more than anything else, that have come to differentiate mere buildings from architecture. Kester Rattenbury writes, "[t]here's a strong argument, probably even a historical one, that architecture – as distinct from building – is always that which is represented, and particularly that which is represented in the media aimed at architects."[4] And indeed, in *Privacy and Publicity: Modern Architecture as Mass Media*, Beatriz Colomina has convincingly and influentially made this strong historical argument, explaining that early twentieth-century construction became modern architecture not only through its representation in media aimed at architects, but through its engagement with new communication technologies generally:

It is actually the emerging systems of communication that came to define twentieth century culture – the mass media – that are the true site within which modern architecture is produced and with which it directly engages. In fact, one could argue (this is the main argument of [her] book) that modern architecture only becomes modern with its engagement with the media.[5]

In one sense, modern architecture came to constitute itself as such by relying on widely distributed photographic, filmic and written representations to publicize and popularize its ideas and aims. With the means for mass printing in place, the development of more user-friendly and mobile photographic technology and the ease of distribution facilitated by aeroplanes, motorized cars, steamships, electric trains and an expanding international network of railway lines and highways, a whole new industry of avant-garde and popular architectural journals emerged, and for the first time in history architecture and design came to be known through images, written descriptions and theoretical explications rather than individual experience or word of mouth.

However, in another importantly related sense, architecture became modern by fashioning itself after and according to these new means of communication. Colomina demonstrates the ways in which modern architecture not only used but modelled itself after communication technologies decades before architects like Rem Koolhaas, Robert Venturi and Denise Scott Brown began to fashion so-called post-modern architecture after and into popular media.[6] That is, these technologies produced not only new ways of seeing architecture, but new ways of designing and conceiving of architecture as a technology of representation. Indeed, during the early part of the twentieth century, the technologies and strategies by which buildings were represented were also those which came to transform buildings into modern architecture. As Colomina suggests, to understand the importance of new communication technologies in the development of modern architecture we need to concentrate less on considering architecture's relationship with media than on "thinking of architecture *as* media."[7]

Where Colomina contends that architecture only becomes modern through its engagement with media, Mark Wigley argues, as I discussed in the previous chapter, that early twentieth-century architecture becomes an intelligible and identifiable international modern movement at the Weissenhofsiedlung in 1927, "the moment in which sixteen architects and numerous interior designers from different countries collaborated on a single advertising image ... the reduction of the diverse tendencies and contradictions of the avant-garde into a recognisable 'look' that turns around the white wall."[8] Taken together, Wigley and Colomina show that early twentieth-century architecture and design became modern not only through an engagement with media but through a transformation into media, into an advertisement that sold both a reductive image of new architecture and a new architecture that promoted reductive ways of looking fashioned after advertising imagery. In both her work and her life, however, Gray seems to have resisted the reductive tendencies of any one look, capitalizing instead on the evocative sensuality of that which remains hidden in every appearance, those spaces, objects and intimacies that remain just tantalizingly out of view. As we saw in the previous chapter, modern architecture's investment in clarity, exposure, whiteness, the movement's instantiating advertising image, threatened to reduce the visual ambiguities

and sensual engagements that characterized Gray's interiors. Moreover, modern architecture's drive towards highly circulated, widely publicized representational clarity may have resonated for women like Gray, women who enjoyed an eroticized visual ambiguity or non-heterosexual invisible visibility in the 1920s, with the hazards of media exposure and representation so graphically illustrated through Radclyffe Hall's 1928 obscenity trials and the reduction of a certain gender and sexual ambiguity to a newly recognizable pathologized identity and clear lesbian look.

Throughout the 1910s and 1920s, Gray was relatively engaged with publicity and mass communication – cooperating if not collaborating on both popular and avant-garde publications of her lacquer works, interior decoration and furniture designs,[9] showing several major exhibitions in Paris and representing France for a furniture exhibition in Amsterdam,[10] publicizing her design shop, Jean Désert, anonymously co-writing at least two articles for L'architecture vivante with Jean Badovici[11] and finally preparing that journal's special issue on E.1027, "Maison en bord de mer," in 1929.[12] However, after 1929, Gray's involvement with publicity significantly decreased.[13] Removed from the communication systems that came to define modern architecture, her work went almost entirely unnoticed until the 1970s. Gray scholars have tended to hold Gray largely responsible for her work's lack of publicity, media representation and engagement, blaming her "shyness" or her lack of media-savvy: Adam, for example, declares casually, "Eileen had no talent for self-promotion."[14] I, too, would like to suggest that Gray was in some part responsible for distancing her work from communications, but that this was less the fault of her timidity and ineptitude than it was a careful cultivation of a sort of strategic incommunicability – of privacies, interiorities, sensualities and desires that were threatened by the media representations and investments defining modern architecture at the time. Indeed, it seems to me no simple coincidence that Gray's participation in mass communication would so dramatically decrease at the time when both the new architecture and the new woman were stripped of their ambiguities and reductively defined through their unprecedented engagement with media.

As the headquotes to this chapter suggest, I think we need to read Gray's introversion, her retreat from publicity and urban life, in the post-*Well* historical context where, Doan reminds us, life had changed for all women whose tastes for masculine styles (such as bow-ties, trouser suits and sports cars) and/or living with other women[15] aligned them with a reductive and increasingly recognizable lesbian identity. I will argue that Gray's strategy of resistance to publicity and a certain kind of communicative clarity, so central to modern architecture, are comparable to the narrative strategies of Djuna Barnes, a contemporary of Gray's whom she would have met at Natalie Barney's salon and in the Left Bank neighbourhood that they shared in the 1920s,[16] and whose life and aesthetic works were similarly resistant to reductive communicative clarity. I will begin

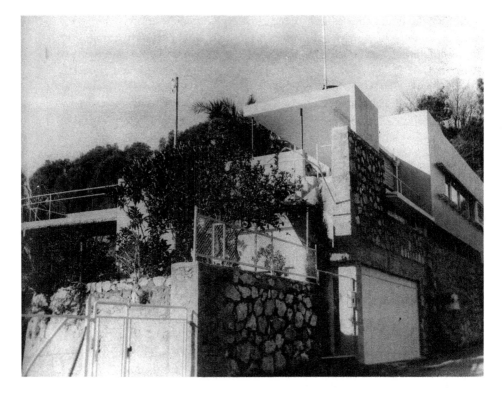

4.1 Tempe à Pailla, seen from the road, 1934. Reproduced with the kind permission of the National Museum of Ireland.

by discussing Barnes' and Gray's comparable retreat from communications in the immediate post-*Well* era of the 1930s, and I will conclude by focusing on the impenetrable and non-communicative works that they produced as a result. By concentrating on Gray's very private house, Tempe à Pailla (1932–34, Figure 4.1),[17] that she built for herself immediately after finishing E.1027, and Barnes' notoriously difficult novel *Nightwood*,[18] published in 1936 and known for its intensely anti-realist, anti-representational exploration of interiors, transgressive desires and erotics, I hope to show that Gray's resistance to clear communication was, like Barnes', related to the cultivation and preservation of subjects, desires and intimacies that would not be reduced to a fixed (modern architectural) image or (modern lesbian) identity.

Retreat from communications

Before discussing either the house or the novel, it is important to note that both Barnes and Gray had taken significant steps away from publicity and

communications by the early 1930s. From 1913 to 1931, Barnes earned her income as a journalist writing primarily for popular, mass-circulation magazines like *McCall's, Charm, Vanity Fair* and the *New Yorker* while living in New York's Greenwich Village and then on the Left Bank in Paris, where she moved in the early 1920s. Bridget Elliott and Jo-Ann Wallace argue that Barnes' long engagement with mass media contributed to both her extreme sensitivity to the ways in which she was represented, as a woman writer and public figure, and her decision in 1931 to "effectively g[i]ve up journalism" to work on *Nightwood* and a "serious" literary career.[19] Elliott and Wallace explain that modernist women artists and writers such as Barnes

were enormously self-conscious about not only their positioning specifically as *women* writers and artists during the modernist period, but also about the ways in which they were represented in the popular and, later, the academic press.... They were enormously aware of the degree to which their subjectivity could be manipulated through representation and performance, by others and by themselves.[20]

While carefully attending to their public and professional image was by no means unusual for artists and writers at the time, Elliott and Wallace suggest that for reasons of gender, sexuality and economic status Barnes was especially conscious of the ways in which she was represented in both popular and professional media. Barnes has been represented, both during the modernist period and in subsequent memoirs and histories of it, more often as a colourful "character" and public personality than as a modernist writer. Thus, in their analysis of Barnes and the British artist Nina Hamnett, Elliott and Wallace note, "Barnes and Hamnett may be more familiar to many of today's readers as bit players in the modernist pageant than as artists in their own right."[21] Barnes was aware that her public persona, constituted largely by her representations in and engagements with popular mass media, threatened her career as an avant-garde writer: "success as an avant-garde novelist was compromised as long as she continued to publish widely in the popular press."[22]

Retreating from the public eye and popular communications to concentrate on her serious literary career led to her becoming, in her own words, "the most famous unknown of the century."[23] It also led to her writing *Nightwood*, which, as Joseph Allen Boone observes, has "remained one of the 'most famous unknown[s]' of this century, despite the increasing critical attention it has garnered as a modernist classic."[24] That is, far from going critically unnoticed, following T.S. Eliot's introduction and endorsement of the novel in formalist New Critical terms, as "the great achievement of a style,"[25] *Nightwood* has been hailed as both classically modernist and, owing to the fact that, as early reviewers observed, "the centre of the [novel's] stage is taken over by the lesbians,"[26] it has also been celebrated among the "classics of lesbian imagination."[27] However, despite its fame, *Nightwood* is perhaps

most well known as a novel that resists any attempts to categorize, naturalize or "know" it.[28] Reviewers in the 1930s note, with varying degrees of consternation and admiration, that efforts to explain or describe the novel will inevitably fail – that ostensibly "it's about homosexuality"[29] but ultimately it is "non-representative ... immovably contained in and identical with the original phrasing of the author."[30] Since its first publication, literary scholars have struggled to make sense of this frustrating resistance to representation or knowability, its paradoxical narrative performance of the unsayable and non-communicative.[31] Elliott and Wallace explain that after nearly 20 years working as a journalist, Barnes had become "enormously aware" of the ways in which she could be represented and so decided to give up her career in communications to write a fundamentally non-communicative novel that concentrates on unrepresentable desires and subjects.

While Gray was never as financially dependent or professionally invested in communications as Barnes, she did have some involvement in popular and professional publishing and publicity from the late 1910s to 1929, and there is evidence to suggest that she was also highly aware of and sensitive to the ways in which she and her work were represented. For example, Gray's archive holds the draft of an article written by Louis Vauxcelles, undated but presumably from the late 1910s or early 1920s when she was working exclusively in lacquer, with a note asking for Gray's corrections before it went to press ("Bon à tirer après corrections. L. Vauxcelles").[32] After two spelling mistakes, the only correction that Gray made to the two-page, nearly 1,500-word article was to cross out the "Miss" that he used throughout and replace it with her proper name (she added "Eileen" in the margins beside each crossed-out "Miss"), and once with "cette artiste." Written in French, the use of this "Miss" throughout would have been not only a reference to her Englishness and gender, but a rather jarring and explicit indication of her unmarried status. The fact that Gray chose to replace it simply with her proper name, and not the French equivalent, *Mademoiselle* (which would have sounded uncomfortably young for Gray, who was by then in her late 30s or early 40s), or the more likely *Madame* (the heteronormative title of respect routinely used for a woman her age, even if unmarried), suggests that her resistance to the title had less to do with its connotations of English than with its insistence on gender and marital status. The article was apparently never published (or at least has never been located), so we cannot know whether Vauxcelles was willing to neutralize his overtly gendered representation of Gray, but from her revisions we can know that she was sensitive to the effects that her gender, and perhaps even her sexuality, could have on representations of her art, and herself as an artist.

Again, when it came to choosing a name for her furniture and interior design store, rather than choosing a woman's name, or a name that might suggest it to be the entirely woman-run operation that it was, Gray used

"Jean Désert," with an obviously if not stereotypically French man's first name, to publicize the business.[33] While the shop's vernissage, held in the spring of 1922, advertised "JEAN DÉSERT ouvre le 17 mai. MEUBLES LAQUES PARAVENTS TAPIS d'EILEEN GRAY" much of the publicity material she designed, for newspapers, journals and business cards, obscured her role in the business – either leaving her name out completely or, after the frequency with which she received correspondence addressed to Monsieur Désert, eventually including herself as Jean Désert's ambiguously gendered partner, "E. Gray." Gray's efforts to obfuscate gender in representations of her work continued (as we saw in the previous chapter) into her published explanation of E.1027, being written in as gender-neutral language as possible, where she emphasizes that her architecture is designed for the "human being" or "individual" in place of the "man" at the centre of architectural discourse at the time. Some insight into this non-gendered representational strategy is suggested in Gray's 1973 letter to Sheila de Bretteville. In response to the prospect of exhibiting her work at the 1973 Women's Building in Los Angeles, Gray explains her suspicion that such gender-marked publicity leads to a sort of reduction or marginalization of women's work: "I am sorry that the building in L.A. is called the Women's building. For what reason? It seems to mean that women are an inferior species. Otherwise, why is this building not for everyone?"[34] And certainly Gray's coming to media consciousness in the 1920s, in a newly media-saturated, highly male-dominated architectural culture, would have contributed to this suspicion.

As the only independent female architect affiliated (even as marginally as she was) with European architectural modernism at the time, Gray may have found it difficult enough to gain serious recognition or respect as an architect without drawing extra attention to her exceptional gender. Indeed, the only other female architects regularly participating in the European modern movement in the 1920s and 1930s were Charlotte Perriand and Lilly Reich, whose architectural works have been largely overlooked by both popular and avant-garde press and whose contributions were confined to interior design and decoration schemes subsumed in each case under the name and reputation of the man with whom she collaborated, Le Corbusier and Ludwig Mies van der Rohe respectively.[35] While Le Corbusier apparently admired Perriand's solo show at the 1927 Salon d'Automne, "Bar sous le toît," when she approached him about working in his architectural firm, he initially turned her away with the dismissal, "we don't embroider cushions in my studio."[36] Assumptions of women's incompatibility with the architectural profession would have been difficult to overcome, with Gropius as head of the Bauhaus actively barring women from the architectural courses and relegating them to textiles and weaving,[37] and Le Corbusier maintaining similar beliefs in the gender of architectural and interior design practice. Indeed, as Despina Stratigakos has recently argued, the association of masculinity with architecture was so strong that women entering the

practice were understood and represented as manly women, embodiments of sexology's "third sex" or female invert: "she necessarily became transgendered [and lesbian], for the woman who created like a man also developed his sexual desires."[38] Though both Perriand and Reich were trained architects, during the 1930s Perriand's (publicly represented) work was contained to the feminized realm of interior design for Le Corbusier's architecture and exhibitions, and Reich's primarily to exhibition display designs and furnishing the interiors of Mies van der Rohe's architecture. Reich's architectural and design work was, moreover, heavily gendered: her design for the Ground-Floor House, for example, exhibited in the 1931 exhibition "The Dwelling in our Time" ("Die Wohnung unserer Zeit"), maintained the architectural tradition of gendered domestic space, with her "room for a woman" decorated in pink and beige, in contrast to her "room for a man" in browns and black.[39] Gray, as the rare female architect, producing neither clearly gendered design nor architecture, unmarried and unattached (romantically or professionally) to men, perhaps already haunted by her attachments (romantic and professional) to female inverts and moreover sporting the look of increasingly visible female inversion, may well have been wary of the spectre of lesbianism that she provoked. Given the history of Gray's attention to her gendered professional representation, and the marginalization of her female architectural contemporaries that she witnessed at the time, it seems only reasonable to assume that Gray would have been highly conscious of the ways in which she and her work were represented by and related to the systems of communication that came to define modern architecture.

And indeed Gray was particularly careful about, and largely dissatisfied with, the ways in which her work was represented at exhibitions and in publications, and rarely made an appearance at an opening of her own show. She was unhappy with the inaccurate colour reproductions of her lacquer work in the 1917 *Vogue* publication, and again with the hand-coloured photos of E.1027 published in *L'architecture vivante* (1929); she was dissatisfied with her furniture display at the 1923 exhibition in Amsterdam; even after painstakingly preparing her stand at Le Corbusier's 1937 Pavillon des Temps Nouveaux, she was frustrated with the final display; and her disappointment with the spots her work was given at the UAM exhibitions in 1930 and 1931 led to her final resignation from the organization in 1934. Peter Adam dismisses Gray as unaccountably "critical and fussy,"[40] but Elliott notes that this heightened sensitivity to the ways her work was shown was shared by other women artists at the time, such as Romaine Brooks and Gluck: "All three women seem to have been more anxious than is usual about exhibiting their work. Each obsessively modified her exhibition space, issued countless instructions for displaying her work, and avidly collected press reviews."[41] For reasons of gender and sexuality, women like Brooks, Gluck, Barnes and Gray were wary of the increasingly popular systems of representation and

communication available to them, and Brooks, Gluck and Gray chose to re-design private, domestic spaces in which they would have greater control over how they and their works were shown. But by the end of the 1930s, Gray like Barnes had effectively given up on communications: she stopped showing altogether, published only a very few photos of her works and wrote nothing about them. Moreover, like that of Barnes, Gray's retreat from communications seems to have been related to her production of an overwhelmingly non-communicative work.

Architecture and communications

MODERN ARCHITECTURE

During the 1930s, modern architecture was increasingly invested in not only technologies but also concepts of clear communication. Walter Gropius explains that at the Bauhaus, "[w]e want to create a clear, organic architecture, whose inner logic will be radiant and naked, unencumbered with lying facades and trickeries."[42] And Le Corbusier explains that he can not tolerate the lying trickeries of "those futile objects which ... howl or murmur around [him],"[43] and so promotes "the suppression of the equivocal."[44] Echoing these sentiments, in 1930 Theo van Doesburg declares that in art and architecture, "Absolute clarity should be sought!"[45] In 1932, Philip Johnson and Henry-Russell Hitchcock explain that the fundamental unifying characteristic of "The International Style" of modern architecture is clarity of expression: "Style is character, style is expression; but even character must be displayed and expression may be conscious and clear, or muddled and deceptive. The architect who builds in the international style seeks to display the true character of his construction and to express clearly his provision for function."[46] By 1934, Gropius announces that "the outward forms of modern architecture ... correspon[d] to the technical civilization of the age we live in ... clearly manifest throughout Europe."[47] And Le Corbusier explains that "the technical civilisation" expressed in modern architecture is constituted by new "machines for abolishing time and space":[48] specifically, communication technologies like "the telegraph, the telephone, steamships, airplanes, the radio and now television. A word said in Paris is with you in a fraction of a second!"[49] By the 1930s, modern architects had embraced these communication technologies not only as means for publicity, but as a constitutive element of their architecture and logic for their architectural theory. Modern architecture promised the immediate intelligibility and unequivocal clarity of new technologies of communication.

In Sigfried Giedion's highly influential early history of modern architecture, *Bauen in Frankreich, Bauen in Eisen, Bauen in Eisenbeton* (*Building in France,*

Building in Iron, Building in Ferroconcrete), he explains that "[b]y their design, all buildings today are as open as possible. They blur their arbitrary boundaries. Seek connection and interpenetration."[50] New construction materials, most notably iron and reinforced concrete, enabled the elimination of thick load-bearing exterior walls, introducing the possibility of larger windows or window-walls and the development of the free plan, reducing the need for fixed, enclosed interior rooms. These constructional innovations were promoted for their openness, lightness and clarity, for their elimination of boundaries and for this sensation of interpenetration. Unlike the "fortresslike incarceration"[51] of old buildings, trapping you in your isolated interiors, new buildings located you in the exterior space of communications:

Fields overlap: walls no longer rigidly define streets. The street has been transformed into a stream of movement. Rail lines and trains, together with the railroad station, form a single whole.... The antenna has coalesced with the structure, just as the limbs of the towering steel frame enter into a relationship with city and harbour. Tall buildings are bisected by rail lines. The fluctuating element becomes a part of building.[52]

Communication technologies become important not only as transmitters of ideas and images of modern architecture, but as constitutive elements of new buildings. A building is modern insofar as the "arbitrary boundaries" between inside and outside, private and public, are blurred and the building is swept into the stream of communications.[53] Gray's architecture was invested in neither the logic nor the technologies of communication. As Caroline Constant explains, Tempe à Pailla needs to be understood as an extension of the "critique of Modern-Movement precepts" that had informed E.1027,[54] but whereas Gray's critical investments were suggested by E.1027's accompanying publication, Tempe à Pailla's critical content was even more private. As we will see, Tempe à Pailla's carefully designed strategies for ensuring this privacy work to suggest that Gray's critique revolved primarily around modern architecture's investment in communication technologies and communicability.

In the section that follows, I will describe some of these strategies by which Tempe à Pailla resisted the physical and conceptual communicative clarity to which modern architecture aspired: first, through its location, in the relatively isolated town of Castellar and the visually inaccessible section of its large plot of land; second, through the impression of impenetrability achieved by its façade and layers of exteriority; third, through its carefully designed interior obstructions, circumscriptions and separations, interrupting the clear communication between spaces that its free architectural plan promised; and fourth, through its insistence on embodiment, its defiance of detached visual access, each area's demand for physical presence, its inscription or inversion of the sensual body into each space. I hope to show that these four main

elements of Tempe à Pailla work to enhance and protect a complexly sensual way of dwelling, or living, which would be threatened by the communicative clarity promised by modern architecture.

TEMPE À PAILLA: NON-COMMUNICATIVE BY DESIGN

Shortly after completing E.1027, Gray began work on Tempe à Pailla, located in the small town of Castellar, further from the more populated coast and in the hills behind Roquebrune-Cap-Martin and Menton. Even more isolated than E.1027, which was framed by the coastal railway to its north and the sea traffic to its south, Tempe à Pailla was removed from major railways and motorways, the first indication of its resistance to the communication technologies so fundamental to modern architectural projects at the time. Le Corbusier's Villa Savoye (1929), for example, was set in a rural area outside Paris (Poissy) but was literally designed according to the logic of motor traffic and its seamless communication with Paris. In his *Oeuvre complète*, Le Corbusier introduces the main features of the house: it was linked to Paris by a 30 km drive, and "we go to the door of the house by car, and the minimum turning arc of a car provides the dimension of the house. The car enters under the pilotis, turns around the service quarters, arrives in the middle, at the vestibule door, enters into the garage or follows its route to return [to Paris]: such is the fundamental given."[55] The fundamental feature of the house, then, is its relationship to the car, to uninterrupted motor route communication with Paris. Indeed, with its wrap-around driveway, the house is situated like a sort of pit stop in the centre of a highway traffic circle. Moreover, the house is not only framed by car traffic, but literally defined by it – its dimensions being determined by the turning radius of Le Corbusier's own car, the 1929 model Voisin. Le Corbusier emphasizes the significance of the car to the modern house and lifestyle with all his villas at the time: he published a series of photographs of his Villa Stein (1927) with the car featured in the foreground, shown on approach to the house; his 1929 movie *L'architecture d'aujourd'hui* opens with an extended scene of him driving through the front gates and down the long driveway to the Villa Garches (before bounding athletically through the house, past the woman and children, up the spiral staircase to the roof garden view); and he agreed to have his 1927 Weissenhofsiedlung double-house used as backdrop for a new Mercedes-Benz advertisement. As Stanislaus von Moos observes, "[i]ndeed, it is often unclear in these images whether it is the car or the house that supplies the context for an advertisement of the contemporary good life."[56] In very stark contrast, Gray photographs Tempe à Pailla with a bicycle leaning against the surrounding stone wall, not even on the main road to the front gate, but along the footpath that traverses but does not enter the property (Figure 4.2). While Gray was remembered at the time of construction "driving around in a little MG, wearing a trouser suit with a neat bow tie,

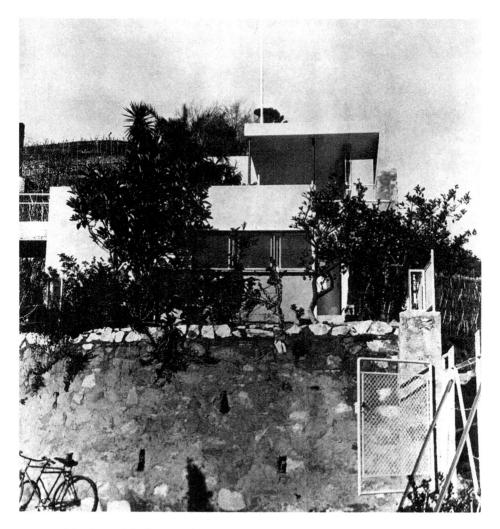

4.2 Tempe à Pailla, view from footpath, with bicycle. Reproduced with the kind permission of the National Museum of Ireland.

fussing over everything,"[57] this picture of masculinized modern mobility that she embodied was not one she wanted advertised or associated with Tempe à Pailla. Instead, this image, like all of Gray's photographs, emphasizes the privacy and isolation of the house – less advertisements for the modern "good life," with the promise of publicly engaged houses, domestic interiors seamlessly linked to the modern exterior world by new communication technologies, than obscured glimpses of a house in retreat.

As Caroline Constant explains, Gray "[r]einforc[ed] the site's natural isolation, [and] devised a dense system of architectural layers to insulate

herself against any potential intrusions on her privacy."[58] And it seems that Tempe à Pailla was conceived, well before it was designed, for privacy. In 1926, the year before Gray purchased the plot of land for E.1027, she bought three parcels of land on the outskirts of Castellar. In 1932 she bought a fourth (bringing the size of her property to 1.5 acres), so that despite the plots being intersected by a small road and a smaller footpath leading off it (towards a farmhouse on the other side of Gray's land), she had taken the first crucial steps to securing the privacy that Constant suggests is Tempe à Pailla's central design concept. Adam and Constant have both interpreted Gray's purchase of such a large quantity of land, which included unusable agricultural buildings, a lemon grove and three stone water cisterns, as a strategy to preserve her uninterrupted views of the mountains to the north and ocean to the south. However, given the guarded building that she eventually designed, it seems just as likely that she bought up the surrounding land to regulate inward views as to regulate outward ones.

As Gray's photos of Tempe à Pailla attest, and as Adam suggests, the house was situated within the property in such a way that clear and comprehensive views of the building were nearly impossible to gain. Adam shows a photo of the house's eastern, street-facing façade (Figure 4.3), explaining, "[t]he very steep and difficult terrain makes it hard to obtain a good view of the house. Only the street façade can be clearly seen."[59] As closer-up and awkwardly angled photos from the street in front show (Figure 4.1), the supposed clarity of the image taken from the steep lemon grove is questionable, being obstructed first by trees and foliage and then by the hill itself, rendering the garage and two gate entrances invisible. And while the gates, garage and thick stone retaining walls of the old cisterns (that she built into as well as around) are visible from the small road directly out front, the new plane white façade, covered terrace and thin strip of window on the upper level are obscured. Views are similarly difficult to gain from the footpath that runs along the tall stone wall and under Gray's bridge connecting the house to the garden on the other side of the path. And while the footpath passes close alongside the western façade, the main "public entry beside the footpath is relatively mute.... Gray made the entry façade visually impenetrable" (Figure 4.4).[60] Tempe à Pailla, even more than E.1027, is constructed towards privacy and visual ambiguity, so that any perspective or image of the house will always obstruct another, frustrating one's desire for a reductive total view – a desire so clearly satisfied by Le Corbusier's Villa Savoye, where all angles of the façade are studiously alike. Not only, then, is the house so far removed from major railway lines and highways, but it seems to have been positioned in the very worst spot, on this unusually large plot of land, from which to gain clear views or photos of it. If Gray had been interested in the kind of visual clarity and communicability that her contemporary modern architects celebrated, she could have built the house further back on the relatively level plot, providing ample viewing and

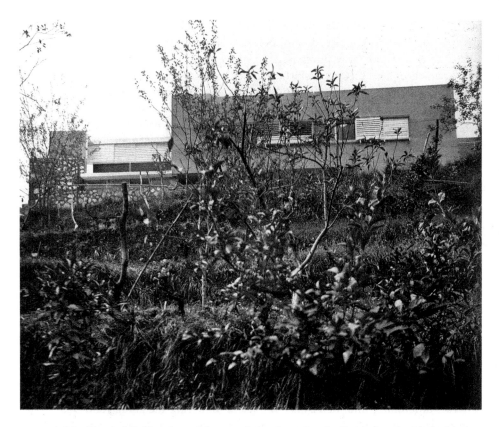

4.3 Tempe à Pailla, view of the east-facing front façade. Reproduced with the kind permission of the National Museum of Ireland.

photo opportunities, and perhaps including a driveway for at least a nod to modern architecture's enthusiasm for communication technologies.

Tempe à Pailla's exterior is not only visually but carefully physically obstructive. Rather than there being a straightforward drive to the front door, physical access to the house is as much postponed as visual access: from the gate beside the garage: a narrow zig-zag staircase rises to the guest room midway up and the covered terrace at the top (Figure 4.5). While the window-wall and sliding glass doors that frame the view from the terrace to the living room could provide the first (and most obvious) entrance to the house, Gray's plans indicate the main entrance as the small door hidden around the corner. The terrace led along a narrow passage between the western face of the house and the stone wall separating the footpath, to the main door to the house, which, like that at E.1027, was sunk quietly into the wall, contributing to the entry façade's impression of "mute impenetrability." These various strategies for deferring visual and physical access to the house – the partial and obstructed views from road, footpath or even adjoining property, the exterior staircase

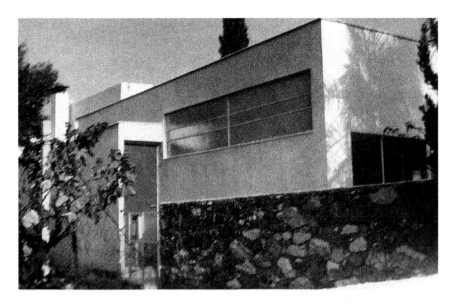

4.4 Tempe à Pailla, door to the main entrance. Reproduced with the kind permission of the National Museum of Ireland.

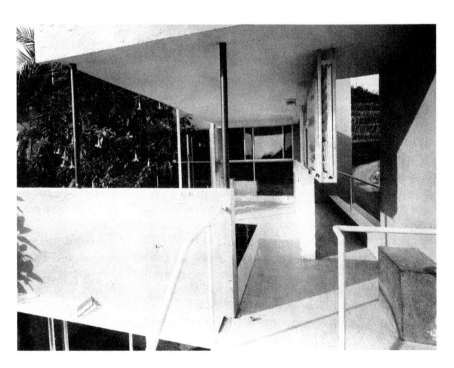

4.5 Tempe à Pailla, terrace towards study/living room windows. Reproduced with the kind permission of the National Museum of Ireland.

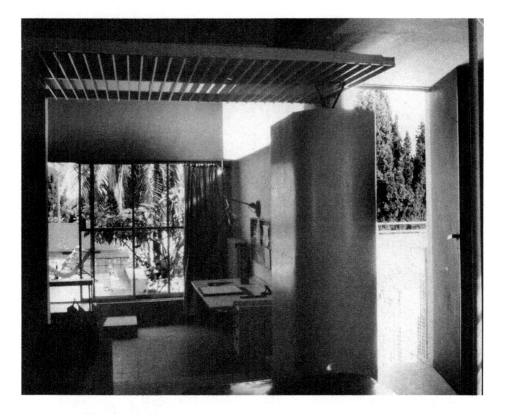

4.6 Tempe à Pailla, rounded storage screen in main entrance, dining room (foreground) and study/living room (background). Reproduced with the kind permission of the National Museum of Ireland.

to intermediary terrace introducing glass walls and door, a provocative invitation to the living room that might be closed, a desire to enter deferred around the corner and along the blank, unintelligible, non-communicative back façade to the main door shrouded in shadow by the protruding walls that protect it – recall Gray's notes on obstruction, discussed in the previous chapter: "la chicane sans donner une impression de résistance arrive le désir de pénétrer. donne la transition. garde le mystère. les objets à voir tiens en haleine le plaisir."[61] Gray's investment in privacy and the erotics of obstruction, already pronounced at E.1027, seems to have intensified with Tempe à Pailla, whose dense system of insulating and protecting architectural layers would have been seen by Gray's modernist architectural contemporaries as the sort of "fortresslike incarceration" they sought to overcome.[62]

For the interior, Gray made what Constant calls "selective references to the free plan."[63] As Hitchcock and Johnson explain, the free plan produced "interiors which open up into one another without definite circumscribing partitions," promising the clear views and unlimited communication between

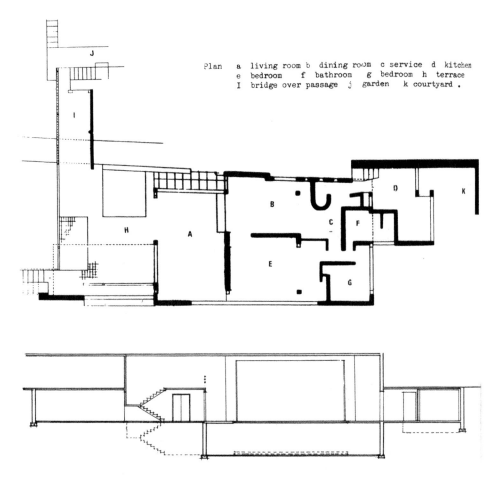

4.7 Tempe à Pailla floor plan. Reproduced with the kind permission of the National Museum of Ireland.

spaces that we see in something like Mies van der Rohe's Tugendhat House (1928–30).[64] However, Gray counteracted this openness through various strategies of interruptions, obstruction and circumscription, in both design and photography, "to qualify her body's presence and intensify her own consciousness of dwelling."[65] Once inside the clandestine principal entrance, the visitor is met by a similar screening storage device to the one Gray used at E.1027, working to shield views into the small dining room or large living room/study and further prolonging access to the interior (Figure 4.6). Similar obstructive devices are used throughout the house. This entrance foyer adjoins the dining room and is architecturally connected to the living room/study (see floor plan, Figure 4.7) – her free plan shows no formal separation between the living room (A) and dining room (B) – but Gray creates the impression

of separation by extending a section of the dining room wall, which juts out to help the entrance storage screen in blocking views between the dining and living room areas and creates a constricted and more intimate dining alcove (Figure 4.6). Moreover, this non-structural division is emphasized by a detached, wood slatted dropped ceiling, which was intended for storage space (where Gray kept her architectural plans and models), before the steps down to the study/living room. The partial wall, storage screen and dropped ceiling create an enclosed passageway, not unlike the enclosed entrance foyer, that would have increased the sensation of spaciousness found in the study/living room, with its south-facing glass wall to the terrace, lowered floor and west-facing strip window raised to the full-height ceiling. Constant explains that throughout the house,

> [Gray] enhanced haptic awareness of internal threshold conditions by varying floor levels and ceiling heights, taking advantage of the resulting sectional differences to accommodate storage and admit natural and/or artificial light ... the threshold between the entry foyer and the living room is marked overhead by a grill shielding fluorescent lights and reflected underfoot by a short flight of steps built over descending layers of shelves.[66]

She achieves a similar effect, the heightened haptic awareness of prolonged threshold spaces combined with ingenious storage devices, by creating a passage up two steps over concealed shelves from the living room to the raised terrace. These threshold passages enhanced the physicality or sensuality of the house, but also contributed to her emphasis on the separation between the various spaces. For example, while the living room/study is clearly visually connected to the terrace through the window-wall, rather than designing a seamless transition between outside and inside (as she had done between the living room and terrace at E.1027), Gray emphasized their distinction (Figure 4.8). Along with the two steps up, the visual communication between outside and inside is interrupted by the vertical line of the chimney and the block of the fireplace extended horizontally by cupboards and a banister/shelf – reinforcing the boundary between interior and exterior that the glass wall would seem to undermine.

In photographs as well, Gray seemed to mark not only this unexpected glass boundary, but also the distinct spaces of this characteristically dual-purpose interior study/living room (see Figures 4.9 and 4.10). Figure 4.9 focuses on the study as a seemingly separate space – with the wall-mounted desk top folded down to expose the cork bulletin board and the "rather splendid disorder" that Hall associates with non-heterosexual (invert) domestic space in *The Well of Loneliness*,[67] and which, we will see, also characterizes the invert interior spaces in *Nightwood* (as it had in Gray's interior photos of E.1027). While this photograph contains a section of the window to the terrace and a portion of the steps, it seems to bracket the space deliberately, suggesting neither the

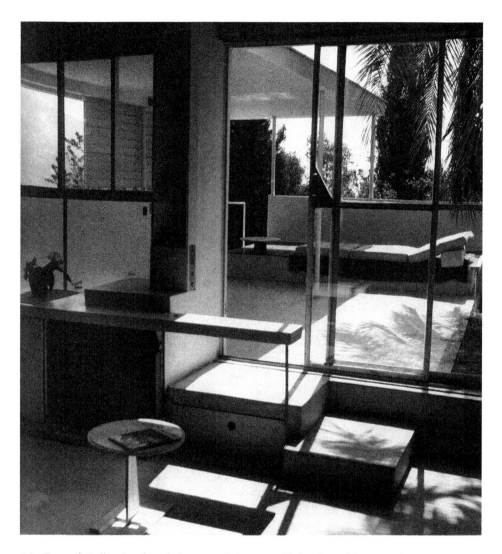

4.8 Tempe à Pailla, view from living room to terrace, with fireplace, chimney and extended shelf. Reproduced with the kind permission of the National Museum of Ireland.

wall of transparency to the left nor the proximity of the dining room to the right. The circumscribed photograph of the study seems even more deliberate when compared with the skewed panoramic view of the living room (Figure 4.10). This image contains a much larger area, including the majority of the glass wall, demonstrating both that the restricted view of the study was not the accidental result of the camera's technical limitations and that Gray imagined this one open room to have two separate functions, both independent of the living space outside. That is, despite the wide angle and the possibility of articulating the

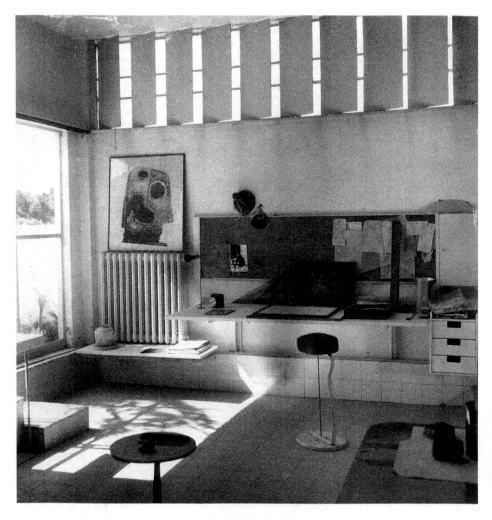

4.9 Tempe à Pailla, study. Reproduced with the kind permission of the National Museum of Ireland.

living room's communication with the outside, the study or the dining room, the terrace door is pictured shut (even the handle to suggest its potential opening is removed), the eastward road-facing windows above the again dishevelled daybed are covered (the dark panel can slide horizontally to reveal the last section of the strip window that runs along most of the east façade), the dark wall interjects at left to silence any suggestion of the dining room to which it leads, and the Transat chair on the right faces inwards to close the room where it would make contact with both the study and the terrace. Gray's photographs emphasize the separations and circumscription of her rooms, enhancing the disconnected or non-communicative sensuality of each space.

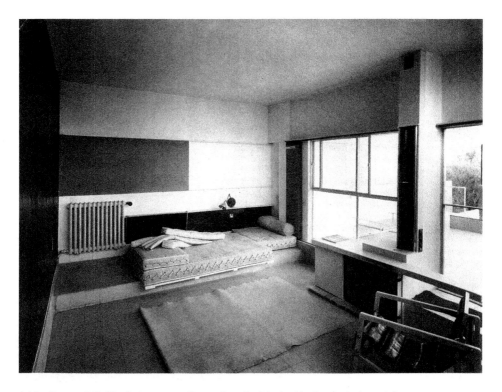

4.10 Tempe à Pailla, living room. Reproduced with the kind permission of the National Museum of Ireland.

In 1956, photographs of Tempe à Pailla were included in René Herbst's *25 années UAM*,[68] providing an opportunity for Gray to highlight her modernist architectural achievements, but the images she submitted for publication are unlike any of the other architecture or interior design photos included. Whereas the architectural photographs, of works by Le Corbusier, Robert Mallet-Stevens, and François Jourdain and André Louis conformed in format to the modernist convention of providing clear views of fully articulated façades, Gray's showed Tempe à Pailla's public face fragmented and obscured, with the actual living space concealed behind the old stone foundation and covered terrace (Figure 4.1). And the photos included in the book's "interior architecture" section suggest a consistent strategy of concealment. That is, rather than submitting photos that represent the intricately designed interiors, Gray used images of the terrace, a space ambiguously neither outside nor inside (Figure 4.11) – within the stone wall surrounding the property, but outside the house's interiors that she individuated in her photography and design. Indeed, these published photographs seem to accentuate the ambiguity of this not-quite-interior architecture, showing the view from behind the living room windows (not even the potentially open glass door), to the terrace designed

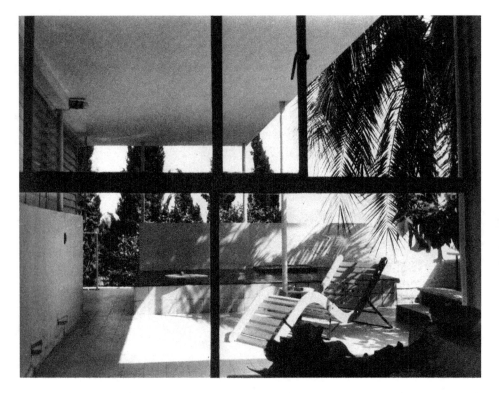

4.11 Tempe à Pailla, view from living room to terrace (Herbst, *25 années UAM*). Reproduced with the kind permission of the National Museum of Ireland.

as another separate living space, enclosed at left by the half walls, partial roof and drawn shutters and framed at right by the descending branches of the palm tree that crop the image where the footbridge to the adjoining property begins. While the other images in the interior architecture section of Herbst's publication reveal unambiguously *interior* designs in open, free-plan settings, Gray seemed resistant to expose or communicate the sensual interiors of Tempe à Pailla.

Gray published an obscured and partial image of the exterior and images of a closed interior that was not quite inside the house, defying modern architecture's convention of communicative clarity – neither a clear and direct expression of the exterior nor the interior, and limited communication between the two. At a time when modern architecture was aspiring to the clear communicability of an advertising image and to the physical clarity and openness carried by iron and reinforced concrete construction, replacing the "fortresslike incarceration" of closed interiorized dwellings with the promise of open exteriorized dwelling imbricated in the fabric of public life, or inhabitable systems of clear communication, Tempe à Pailla's resistance to

communications seems as carefully designed a critique of modern architecture as E.1027's resistance to visual clarity. According to Constant, "Gray conceived of her house at Castellar as a place of solitude and retreat ... [It is both] more compact and introverted, tailored not only to Gray's small frame but also her solitary way of life."[69] The house is a critique, but an introverted one, less expressive than E.1027, but no less grounded in Gray's critical attention to the private tastes, needs, desires and sensual intimacies of the individual. And while the architectural and design ideas could be adapted to others, in the case of Tempe à Pailla the private desires being attended to were specifically Gray's. As Adam explains, "[t]his house was built according to her own need. It corresponds entirely to her own character."[70] Gray's critique at Castellar consists of a demonstration of her privacy – an introverted, impenetrable expression of incommunicability. Both inside and out, the house seems designed as a series of disconnected experiences of this non-communicative sensuality. While Tempe à Pailla's sequence from foyer to dining room to living room/study to terrace is architecturally open, promising the sort of interpenetration and uninterrupted communication between spaces, both inside and out, that characterized modern architecture, Gray's design and photography worked as interjections to disturb continuity and "augment the experiential qualities of her spatial sequence"[71] – both enhancing and protecting the contained, non-communicative sensuality of each space. That is, the house both protects a sensually complex way of dwelling or living from the reductive tendencies of communication and enhances this complex sensuality through its various strategies of resisting communication. By turning to an analysis of *Nightwood*'s non-communicative narrative strategies, I believe we can better understand Tempe à Pailla's dual-function resistance to communication – for Barnes' book, like Gray's house, works similarly to both protect and provoke a complex sensuality that communicative clarity threatened to reduce (to a fixed modern architectural or lesbian look and identity). In the section that follows, I argue that Barnes' novel operates in much the same way as Gray's house as a demonstration of impenetrable, unrepresentable, non-communicative sensuality.

Nightwood and Tempe à Pailla: some conclusions

"Miscalculated longing": Nightwood's lesbians

While no less critically engaged with modernist architectural and design principles than E.1027, Tempe à Pailla was highly personal, built according to Gray's needs, inscribed with her body's presence and, perhaps like Barnes' *Nightwood*, born of a highly personal investment in guarding and protecting the incommunicability of private desires, intimacies and interiors. *Nightwood* is a

fictionalized account of Barnes' eight-year relationship with Thelma Wood, which she characterized in a letter to her friend and sometimes editor Emily Coleman as "that terrible past reality, over which any new life can only come, as a person marching up and over the high mound of a grave ... I have *had* my great love, there will never be another."[72] While Barnes was never private about her intense and long-lasting love for Wood, she was famously private about her lesbianism: "I was never a lesbian – I only loved Thelma Wood."[73] Despite this well-known relationship with Wood, and several women before and after, Barnes never identified as lesbian, and as her recent biographer puts it even more strikingly, "[s]he didn't want to create lesbians with *Nightwood*."[74] Barnes' resistance to claiming or creating a lesbian identity has been attributed, like Gray's, to her intensely private character: Mary Lynn Broe, for example, described Barnes as "[c]omplex in her privacy, refusing to be controlled by an audience or pinioned to a single representation."[75] Despite the complexity of her privacy and resistance to sexual identity, feminist scholars have for years hailed *Nightwood* as a "classi[c] of lesbian imagination."[76] Several feminist analyses contend that after the Hall trials and the looming threat of censorship, *Nightwood*'s dense and non-representative poetics, its resistance to stable meaning or clear communication, its "virtuosity of language," constitutes "a strategy of disguise" to obscure its story of "specifically lesbian love."[77] According to this reasoning, *Nightwood* managed to dodge the obscenity charges that seized *The Well of Loneliness* because, as Leigh Gilmour puts it, "Barnes' readers did not 'see' the lesbianism of Nora and Robin [*Nightwood*'s primary lovers] ... because it was presented neither through a medical discourse nor in terms of narrative realism."[78] *Nightwood*'s defamiliarizing avant-garde literariness is supposedly hiding the lesbianism that we, savvy readers, know is there. Such readings have prompted an alternate line of feminist enquiry which attempts to tackle the sorts of question that Dianne Chisholm puts to Gilmour:

if Barnes' lesbianism is not legible under available, pathologizing rubrics, if it bears no identifying signs of medical taxonomy or narrative realism, how then is it to be recognised as such? What is lesbianism if not a discursive category or operation? How does Gilmour "see" the lesbianism behind this strategic literary/legalizing obscurity? Why does she insist on reading the characters of *Nightwood* as lesbian (or as representing sexual identity) ... ? Why read erotic realism back into an avant-garde text to imply that the author ... intended to represent lesbianism surreptitiously? Is the function of avant-garde literariness limited ... to obscuring the art of representation, that is, of making visible and identifiable, hence real, the discursive categories of *scientia sexualis*?[79]

Rather than reading *Nightwood*'s non-representative, anti-realist poetics as an obscured representation of some real lesbianism, new historicist feminist scholarship has argued that the novel is, as Barnes herself was, dedicated to the complex privacy of those sexual desires and subjects which refuse to be "pinioned to a single representation."

Nightwood's dense and disorienting poetics, which T.S. Eliot praises as Barnes' "great achievement of a style,"[80] Boone explains as a thick exterior "surface [that] translates into a resistance to interiorization."[81] *Nightwood*'s experimental narrative, comprising a confounding mix of literary styles variously characterized as Elizabethan,[82] Byzantine, Renaissance,[83] neo-baroque,[84] surreal, expressionist, avant-garde modernist[85] and post-modernist,[86] has been described as opaque, obscure and impenetrable.[87] The complex opacity of the textual surface blocks the reader's access to the story's interiors, its meaning, plot, theme, subjects and characters. Is it a story about Felix Volkbein, "the wandering Jew" (7) masquerading in the title of a Viennese Baron, who marries and then loses Robin Vote, "a tall girl with the body of a boy" (46)? Is it a story about Nora Flood's loss of Robin, whom Nora loves like "death, come upon with passion ... as one condemned to it" (137)? Is it a story about

this love we have for the invert, boy or girl? It was they who were spoken
of in every romance that we ever read.... They go far back in our lost
distance where what we never had stands waiting; it was inevitable that we
should come upon them, for our miscalculated longing has created them.
They are our answer to what our grandmothers were told love was, and
what it never came to be; they, the living lie of our centuries (137).

Is it a story about Robin, "a woman who is beast turning human" (37), leaving both Felix and Nora for a drugged and drunken abandonment to the subconscious terrain of the urban nightscape? Is it about the night itself, "the night [that] does something to a person's identity ... [where] his 'identity' is no longer his own" (81) – "the Great Enigma [that] can't be thought of unless you turn the head the other way, and come upon thinking with the eye that you fear" (83). Or is it a story about "Dr. Matthew-Mighty-grain-of-salt-Dante-O'Connor" (80), alcoholic, narcissist, Catholic, transvestite, "sodomite" (93), maybe doctor, whose incoherent flights of monologue drive the novel's narrative? It seems to be about a combination of all these themes and characters, but its linguistic opacity and oblique narrative make it impossible to cohere any stable meaning around the text.

The story is notoriously and deliberately difficult to access, as Doctor O'Connor, the novel's great storyteller, the embodiment of language itself,[88] explains: "I have a narrative, but you will be put to it to find it ... there is no direct way" (97). It is tempting to read the self-conscious difficulty of *Nightwood* as typical of the highly criticized "modernist artist's response to the fragmentation and alienation associated with early twentieth-century life [which] was to valorize his (or perhaps her) unifying vision as the ultimate authority capable of bestowing meaning on the randomness, the flux, of an otherwise meaningless, decentered universe."[89] Eliot's praise of *Nightwood* in formalist terms, albeit tepid, encourages us to read the novel's indirect, obscure

experimental style as he had famously read James Joyce's modernist technique in *Ulysses*: "simply a way of controlling, of ordering, or giving a shape and a significance to the immense panorama of futility and anarchy which is contemporary history."[90] However, as Kaup explains, "experimental narration in *Nightwood* does not restore order through symbolic reference and mythic narration.... The verbal spectacle of *Nightwood*'s extravagant narration only affirms the failure of language and representation."[91] *Nightwood* emphatically rejects what Doctor O'Connor scorns as attempts to "dres[s] the unknowable in the garments of the known" (136). Because of its thorough resistance to any sort of coherence or knowability, "the novel can only with the greatest difficulty be assimilated into the canon of high modernist practice."[92] Instead, as Kaup argues, "*Nightwood* inverts the high modernist doctrine of mastery through technique and narrative design"[93] to explore the sensual intensity of interiors that defy visual or verbal communication. *Nightwood* is composed in "a style which is non-communicative and transgressive ... where [a]ny recognition of reference or content is embedded in a play of deception and truth that questions the very principle of representation,"[94] not simply in order to reward the learned, diligent reader with "the discovery of the underlying unity,"[95] thereby affirming both the text's and the reader's claim to elite, avant-garde and/or lesbian knowledges.[96]

Dianne Chisholm explains that Barnes' "narration does not voice the struggle of an emerging subculture ... Instead of speaking out on lesbianism in cryptic modernism, *Nightwood* seriously challenges the epistemological and ontological claims of sexual discourse in general and the category of 'inversion' in particular."[97] Echoing Chisholm, Dana Seitler adds that *Nightwood* consistently "frustrate[s] identitarian notions of sexuality, opening up the narrative to a range of erotic possibilities."[98] Importantly, these various erotic possibilities – incest, lesbianism, male homosexuality, transvestism, bestiality, even heterosexuality – are not represented in any recognizable way, but are instead obliquely suggested by the intricate contortions of an always evasive narrative. Instead, *Nightwood*'s non-communicative style is importantly linked to its reconceptualization of sexuality outside the logic of representation, visibility and identity through which it was coming increasingly to be known by the 1930s. By comparing *Nightwood*'s strategies of resistance to communication with Tempe à Pailla's, we can begin to recognize the ways in which Gray's house may have been designed to cultivate a similarly reconceived, non-identitarian sensuality which could not be accommodated by either the sexual or the architectural systems and logics of communication at the time.

INCOMMUNICABLE SUBJECTS

Barnes' obscure literary style and indirect narrative path work like Tempe à Pailla's obstructive façade and prolonged, circuitous entrance route to delay and distort our access to an interior. But as at Tempe à Pailla, once we

follow the circuitous path to finally enter the interior spaces of *Nightwood* we are denied the reward of an unobstructed and complete view. Just as Gray makes selective use of the free plan, Barnes makes strategic use of omniscient narration. Both of these structural styles promise the total view: the undifferentiated openness of the great rooms that we find in Le Corbusier's, Gropius', and Mies van der Rohe's architecture, for example, and in fiction not only the possibility of seeing the characters "clearly" from a detached and objective perspective, but also and particularly in modernist fiction the ability to dive into the interior thought processes of every character, the torrential stream of consciousness that characterizes modernist writing from James Joyce to Virginia Woolf. However, *Nightwood*, like Tempe à Pailla, disrupts the logic of the modernist technique that it uses. In *Nightwood*, this disruption takes place on two levels: first, at the level of character; and second, at the level of the text's visual logic. While an omniscient narrator is invested with the power to render characters entirely transparent, to bring us to their innermost thoughts and motivations, *Nightwood*'s characters are impenetrable. Rather than being taken into the minds of the character, swept into their stream of consciousness, we are perpetually kept outside. As Boone explains, the omniscient narrator

> does not represent the individual thought-processes or inner worlds of her characters.... Even those narrative moments that the reader may think provide glimpses into the inner depths of these characters ultimately reveal that what lies "beneath the surface" is ... a façade of surface upon surface that underscores the secondariness and estrangement inherent in all representation.[99]

When, for example, Nora pays a surprise late-night visit to the doctor in the most intimate of spaces, his *"chambre à coucher"* (79), to find him under the covers in a woman's nightgown, heavily made up in a long curly blond wig, Nora sees that she had "come upon the doctor at the hour when he had evacuated custom and gone back into his dress" (80). We would seem to be getting a rare glimpse at these inner depths of Matthew O'Connor, behind custom, his thin façade of "doctor" and his loquacious performance of authority, but as Boone notes, "this natural essence is itself dressed in full regalia: behind one covering ('custom') lies another ('dress').... [T]he performative play of surfaces [and representations] is *all* we ever get."[100] Rather than a stream of consciousness, the narrator gives us a stream of "images, tableaux, metaphors, and other renderings of the visual as verbal."[101] When we are introduced to Nora, we read,

> There is a gap in "world pain" through which the singular falls continually and forever; a body falling in observable space, deprived of the privacy of disappearance; as if privacy, moving relentlessly away, by the very sustaining power of its withdrawal kept the body eternally moving downward, but in one place, and perpetually before the eye. Such a singular was Nora. (51)

While Nora is "deprived of the privacy of disappearance" and kept "perpetually before the eye," Robin is private to the point of being "utterly unknown" (138), nearly invisible: "Thinking of her, visualising her, was an extreme act of the will; to recall her after she had gone, however, was as easy as the recollection of a sensation of beauty without the details" (41). The narrator describes Robin as "an image of a forgotten experience ... like a person who has come from some place that we have forgotten and would give our life to recall" (37, 118). As Felix later explains,

> If I should try to put it into words, I mean how I did see her, it would be incomprehensible, for the simple reason that I find that I never did have a really clear idea of her at any time. I had an image of her, but that is not the same thing. An image is a stop the mind makes between uncertainties. (111)

Rather than taking us inside the characters, the omniscient narrator guards their interiors, giving us surfaces and images which, Barnes reminds us, are only ever partial stops between uncertainties, at best a "thought, which [is] only the sensation of a thought" (79). The transparency promised by the all-seeing narrative voice is disrupted by the opacity of the characters in much the same way as the connectedness of the interior spaces promised by the free plan is disrupted by Gray's various screening devices at Tempe à Pailla – and in both the novel and the house, these obstructions produce a desire to know and see more whose satisfaction is continually deferred, a forgotten person or place that we "would give our life to recall."

On the basis of Barnes' highly visual language and the narrator's perpetually exterior perspective, several scholars have suggested that *Nightwood* is written as a series of these stopped images that Felix describes, with each scene as "essentially the verbal equivalent of the photographic image."[102] Jean Gallagher, however, argues that Barnes makes use of the conventions of the photographic still to stage a critique of the detached

> "peephole" model of seeing that plays such an important role in the visual culture of modernity, especially through the technologies of vision associated with the camera ... [*Nightwood*] attempts to model an "inverted" observer who is, as the etymology of the word suggests, "turned in" to the novel's visual field rather than occupying a privileged, transcendent, voyeuristic position outside of it.[103]

Gallagher argues that the novel works to invert the logic of the photographic vision by inscribing the viewer into the space of the visual scene. For example, when the novel introduces the unconscious Robin, who has apparently fainted on her bed, she is presented as the object of a detached and voyeuristic gaze within the conventions of a photograph:

> On a bed, surrounded by a confusion of potted plants, exotic palms and cut flowers, faintly over-sung by the notes of unseen birds, which seemed to have been forgotten – left without the usual silencing cover, which, like cloaks on funeral urns, are cast

over their cages at night by good housewives – half flung off the support of cushions from which, in a moment of threatened consciousness she had turned her head, lay the young woman, heavy and disheveled. Her legs, in white flannel trousers, were spread as in a dance, the thick-lacquered pumps looking too lively for the arrested step. Her hands, long and beautiful, lay on either side of her face. (34)

The narrative is transfixed by the picture for another two paragraphs, describing the smells of "perfume that her body exhaled," the texture of flesh, the "phosphorus glowing about" her head, and compared to a painting by Rousseau (34–35). But the sovereignty of this floating narrative gaze is compromised when "Felix, out of delicacy, stepped behind the palms" (35). Felix becomes suddenly conscious of his own physical presence in the scene, and in turn, we as readers are compelled to see viewing as a "delicate" act of embodied engagement.

Felix's recognition of this delicate viewing position, his physical presence inside the picture, prompts him to seek a hiding spot not outside but only partially shielded by the foliage on the margin of the picture, which leaves him "[e]xperiencing a double confusion" (35). Gallagher suggests that Barnes anticipates the insights of feminist post-structuralist film theorists like Kaja Silverman, narrativizing the double confusion of the voyeur, self-conscious of his being "at least potentially subject to observation."[104] *Nightwood* may present us with a series of photographs, but it inscribes the viewer within the visual field, and emphasizes the embodied sensual experience of their viewing. In this scene, Felix not only experiences a confused self-consciousness in the act of viewing, but also hears the sounds of "unseen birds," catches a whiff of the "perfume" of Robin's body, "the quality of that earth-flesh, fungi, which smells of captured dampness and yet is so dry, overcast with the odour of oil of amber" and beneath the vegetal texture of her flesh "*sensed* a frame, broad, porous and sleep-worn, as if sleep were a decay fishing her beneath the visible surface" (34, my emphasis). And again, to return to Nora's visit to the doctor described above, the scene is presented as a snapshot but one that Nora both takes, in "but a second's duration as she opened the door" (79), and physically enters: "The room was so small that it was just possible to walk sideways up to the bed.... Just above them was a very small barred window, the only ventilation ... and there is a metallic odour" (78–79). Nora's embodied engagement with this picture, her entrance into the room, the "conflation of the photographic and the haptic," constitutes *Nightwood*'s visual inversion.[105] As Gallagher explains,

The description of the room's smell and the sense of intense physical enclosure (emphasized by the small barred window which provides the only ventilation and the crowded space which allows Nora only "to walk sideways") suggest that the "inverted" visual field—which represents and contains the [doctor's] "inverted" body and which "turns in" the reader-viewer from a detached viewing position—also continually reinscribes the physical, embodied nature not just of the object of vision, but the subject as well.[106]

Nightwood's circumscribed images, particularly of interior living spaces (both Robin's and the doctor's), create "the sense of intense physical enclosure" through which the viewer-reader is brought into the visual space. As at Tempe à Pailla, access to the objects of vision, which Gray pictured as carefully circumscribed rooms, relies on embodied engagement, a conflation of the haptic and the visual that choreographs the same inversion as *Nightwood*.

Moreover, in both the book and the house, access to the object is perpetually postponed through these passages, which, as Constant notes, "enhanc[e] haptic awareness."[107] For example, in the scene where we meet Robin, arguably the novel's main character (it is around her that the other characters and the plot is organized), it is only after going through five pages of the sensual intensity of the room, the doctor's actions and Felix's physical self-consciousness that "the doctor inquired the girl's name" and the character being introduced is announced as "Mademoiselle Robin Vote" (38). This strategy of sensually charged delay is exercised down to the level of syntax, where even the subject of the sentence is reached at the end of extended descriptive passages: we pass through the potted plants, palms, cut flowers, bird songs (along with cloaked bird cages and good housewives) and flung bed cushions before we find the subject of the sentence and the object of the view, "the young woman" (34); and only after climbing "slowly" with Nora up "six flights" of stairs to "the top of the house, to the left," after "fumbling," "walk[ing] sideways" and "groping her way" though one and a half detailed pages of "incredible disorder" do we find that "[i]n the narrow iron bed, with its heavy and dirty linen sheets, lay the doctor in a woman's flannel nightgown" (78, 79). These syntactic delays work like Tempe à Pailla's long threshold passages. Take, for example, Gray's prescribed route of access to the living room/study (arguably the main room in the house, and the largest, most photographed one, around which the plan is organized): the prolonged entrance through the front gate, up two flights of stairs, under the half-covered terrace, but diverted to the left, away from the object of our passage, the interior of the house, presented like a photograph framed by the wall of windows, and led to the narrow passage around the back side of the house, through the sunken front door into the tightly constricted foyer, around the obstructive storage screen, and through the intense enclosure of the dropped-ceiling hall before finally physically entering the main room. In *Nightwood* and Tempe à Pailla, the representational techniques promising transparency and communicability (the free plan, omniscient narration, photography) are undermined by the opacity of exteriors and façades (the dense literary style, impenetrability of characters, obscured architectural faces) and long passages of sensual intensity through which the reader/viewer/occupant is inverted into the scene.

As new historicist feminist literary critics like Chisholm, Seitler, Kaup and Gallagher have argued, rather than representing gay and lesbian identities, Barnes inscribes sexual inversion or disorder into the literary and visual logic

of her text, managing to avoid contributing to the early twentieth century's proliferating discourses on sex by circumventing the reductive identitarian logic that had come to characterize practices of sexuality and modes of desire at the time. Such readings suggest that *Nightwood* is less concerned with defending the sexual identities and subcultures that *The Well of Loneliness* represents, and that the media spectacle around Hall's trials helped to render visible, identifiable and real, than with preserving the incommunicable privacy of sexually dissident subjects and desires. *Nightwood*'s indirect, evasive narrative and obscure style might be seen as a dense system of protection, not unlike Tempe à Pailla's "dense system of architectural layers,"[108] for subjects, bodies and desires that were threatened by systems of representation and communication at the time.

Gray's work has been read for too long in relation to the modern architectural figures and movements that her work seems to have been contesting. Her resistance to the means and theories of communication through which architecture came to count as modern has been either overlooked entirely, attributed to her lack of publicity skills or dismissed as another part of her unaccountably "shy and modest," "critical and fussy" personality.[109] However, when it is considered in a historical context where the machinations of communications media had effectively reduced the chic ambiguity of not-necessarily-heterosexual women to the fixed, clearly intelligible image of lesbian identity, we can see that Gray's increasing wariness to communications, and reductive communicative clarity, may have been common to "*all* women who lived with other women, or *all* women drawn to masculine styles of dress."[110] And indeed, this historical context helps us to understand why both Gray and Barnes may have been hyper-conscious, even fussy and critical, about the ways in which they and their works were represented, adamant and complex in their personal privacy, and dedicated to aesthetic projects that reflected this complexity and resisted the reductive tendencies of communication.

I hope to have shown in this chapter that Tempe à Pailla's extreme privacy, like Gray's, may be understood less as a personal retreat and more as the foundation of her critique, as complex a refusal of modernist modes and theories of communications as *Nightwood*'s and Barnes'. During the 1930s, at a time when both the new architecture and the New Woman were stripped of these complex ambiguities and reductively defined through their unprecedented engagement with communications, Gray and Barnes, in both their personal lives and their aesthetic works, endeavoured to protect the incommunicability of intimacies, interiorities and subjects. When read in relation to *Nightwood*, Tempe à Pailla's dense architectural protection, its "mute" and "impenetrable" façade, its obstructive designs for blocking detached views, circumscribing and enclosing spaces, "enhancing haptic awareness" and delaying access to interiors, can be seen as part of an alternate modernism whose aesthetic innovations were importantly linked to investments in reconceiving gender

and sexual subjectivity outside the increasingly familiar terms of representation and identity. I hope to have shown that the details of Gray's resistance to communications at Tempe à Pailla resonate with Barnes' in *Nightwood*, and so to suggest that Gray's work formed a critique of early twentieth-century constitutions of not only modern architecture but also sexual identity.

Notes

1. Laura Doan, *Fashioning Sapphism: The Origins of a Modern English Lesbian Culture* (New York: Columbia University Press, 2001), 193.
2. Peter Adam, reporting the recollections of Gray's mason at Tempe à Pailla, André-Joseph Roattino, in *Eileen Gray, Architect, Designer: A Biography* (New York: Harry N. Abrams, Inc., 2000), 267–268.
3. Caroline Constant, *Eileen Gray* (London: Phaidon Press Limited, 2000), 155.
4. Kester Rattenbury, *This is not Architecture: Media Constructions* (London and New York: Routledge, 2002), xxii.
5. Beatriz Colomina, *Privacy and Publicity: Modern Architecture as Mass Media* (Cambridge, MA: The MIT Press, 1998), 14.
6. Rem Koolhaas and Bruce Mau, *S, M, L, XL* (New York: Monacelli Press, 1995); Robert Venturi, *Complexity and Contradiction in Architecture* (New York: Museum of Modern Art, 1966); Robert Venturi, Denise Scott Brown and Steven Izenour, *Learning from Las Vegas* (Cambridge, MA: MIT Press, 1972).
7. Colomina, *Privacy and Publicity*, 15, my emphasis.
8. Mark Wigley, *White Walls, Designer Dresses: The Fashioning of Modern Architecture* (Cambridge, MA: The MIT Press, 1995), 303.
9. *Wendingen* (Amsterdam), vol. 6, no. 6 (1924), special issue on Eileen Gray with articles by Jan Wils and Jean Badovici; A.S., "An Artist in Lacquer," *Vogue* (August 1917), 19; Elisabeth de Clermont-Tonnerre, "Les lacques d'Eileen Gray," *Feuillets d'art*, no. 3 (March 1922); "Lacquer Walls and Furniture Displace Old Gods in Paris and London," *Harper's Bazaar* (September 1920), 130.
10. VII Salon de Artistes Décorateurs (1913); X Salon de Artistes Décorateurs (1919); Salon d'Automne (1922); French Furnishings in Amsterdam (1922); XIV Salon de Artistes Décorateurs (1923); Salon d'Automne (1923); XV Salon de Artistes Décorateurs (1924).
11. On the basis of a private holding of Jean Badovici's archives in Vézelay, Constant concludes that Gray anonymously collaborated on five publications with Badovici between 1924 and 1926: "Harmonies" : *intérieurs de Ruhlmann* (Paris: Albert Morancé, 1924); *Intérieurs de Süe et Mare* (Paris: Albert Morancé, 1924); *Intérieurs français* (Paris: Albert Morancé, 1925); *La maison d'aujourd'hui* (Paris: Albert Morancé, 1925); "L'architecture utilitaire," *L'architecture vivante* (Winter 1926), 17–24.
12. Eileen Gray and Jean Badovici, "Maison en bord de mer," *L'Architecture vivante* (Winter 1929).
13. Gray showed E.1027 at the first Union des Artistes Modernes (UAM) exhibition (1930), photos of her renovations and storage systems for Badovici's apartment at the second UAM exhibition (1931) and E.1027 and storage systems once again at the XXIV Salon de Artistes Décorateurs (1933), and her last significant exhibition was the Vacation and Leisure Center at Le Corbusier's Pavillon des Temps Nouveaux at the Universal Exposition in Paris in 1937. During the 1930s, she grew increasingly frustrated with the ways in which her work was represented: dissatisfied with the spot she was given at their first exhibition, she resigned from the UAM by 1934 (Adam, *Eileen Gray*, 249), and, unhappy with her stand in 1937, she refused to attend the opening of Le Corbusier's Pavillon (ibid., 301).
14. Ibid., 125.
15. Gray lived closely with her maid, Louise Dany, from 1927 until she died in 1976.
16. Barnes lived on the Left Bank in Paris from 1921 to 1929, and bought a house at 9, rue Saint-Romain, around the corner from Gray, in 1927. Adam writes that Gray knew Barnes, at least

"casually," and that "Seeing Janet Flanner, Solita Solano, and Djuna Barnes sitting at the Café Flore, wearing black tailored suits with white gloves and white silk scarves, and sipping martinis, always made her smile" (ibid., 109).

17. She named the house after a local agricultural saying, "with time and hay the figs will ripen" – suggesting the patience and cultivation that precede reaping the fruits of labour, which seems in retrospect an appropriate comment on Gray's professional career and long-delayed, late-life recognition.

18. Djuna Barnes, *Nightwood* (1936) (New York: New Directions Books, 1961). All further references to *Nightwood* will come from this edition.

19. Bridget Elliott and Jo-Ann Wallace, *Women Artists and Writers: Modernist (Im)positionings* (London and New York: Routledge, 1994), 128.

20. Ibid., 122, 123.

21. Ibid., 123.

22. Ibid., 127.

23. Barnes, letter to Natalie Barney (September 10, 1967), quoted in Phillip Herring, *Djuna: The Life and Works of Djuna Barnes* (New York: Viking Press, 1995), 348, n. 1.

24. Joseph Allen Boone, *Libidinal Currents: Sexuality and the Shaping of Modernism* (Chicago and London: University of Chicago Press, 1998), 233.

25. T.S. Eliot, Introduction to *Nightwood*, xvi.

26. A. Desmond Hawkins in *The New English Weekly* (April 29, 1937), quoted in Jane Marcus, "Mousemeat: Contemporary Reviews of *Nightwood*," in *Silence and Power: A Reevaluation of Djuna Barnes*, Mary Lynn Broe, ed. (Carbondale and Edwardsville: Southern Illinois University Press, 1991), 201.

27. Carolyn Allen, "Writing towards *Nightwood*: Djuna Barnes' Seduction Stories," in *Silence and Power*, Broe, ed., 54.

28. Marylin Reizbaum, "A 'Modernism of Marginality': The Link between James Joyce and Djuna Barnes," in *New Alliances in Joyce Studies*, Bonnie Kime Scott, ed. (Newark: University of Delaware Press, 1988), 185–186; and Boone, *Libidinal Currents*, 233.

29. Dylan Thomas in *Light and Dark* (March 1937), quoted in Marcus, "Mousemeat," 199.

30. Fadiman in *New Yorker* (March 13, 1937), quoted in Marcus, "Mousemeat," 203.

31. Carolyn Allen, "Djuna Barnes: Looking Like a Lesbian/Poet," in *The Modern Woman Revisited: Paris between the Wars*, Whitney Chadwick and Tirza True Latimer, eds (New Brunswick, NJ, and London: Rutgers University Press, 2003), 148; Monika Kaup, "The Neobaroque in Djuna Barnes," *Modernism/Modernity*, vol. 12, no. 1 (2005), 85.

32. Louis Vauxcelles, unidentified proof copy of manuscript on Eileen Gray, Eileen Gray archive, Victoria and Albert Museum, London, England.

33. Gray scholars are unsure about the origin of the name Jean Désert. Adam writes, "[r]emembering her first trip to the désert and assuming that the name of a man would give a more serious tone, she called the gallery Jean Désert" (Adam, *Eileen Gray*, 119). Constant reiterates that in naming her shop, Gray was "assuming a male guise and invoking a remote local," but goes on to speculate that Jean Désert "can be interpreted as 'Jean has gone, or déserted' [and] may allude to the elusive figure of Badovici" (Constant, *Eileen Gray*, 43) – who had not gone; he had, by 1924, just begun collaborating with Gray.

34. Gray, letter to Sheila de Bretteville (1973), quoted in Constant, *Eileen Gray*, 13.

35. Gray apparently turned down invitations to work with more established male architects, such as Robert Mallet-Stevens around 1923, and, as Peter Adam explains, despite the "formidable chance for her to work with other architects and designers [whom she joined in founding the UAM], Eileen seems to have kept apart, preferring for the most part to work alone" (Adam, *Eileen Gray,,* 249). For more on Charlotte Perriand, see Mary McLeod, ed., *Charlotte Perriand: An Art of Living* (New York: Harry N. Abrams, Inc., 2003) and Arthur Rüegg, ed., *Charlotte Perriand: livre de bord 1928–1933*, Steven Lindberg, trans. (Berlin: Birkhäuser-Publishers for Architecture, 2004). On Lilly Reich, see Matilda McQuaid, *Lilly Reich: Designer and Architect* (New York: Museum of Modern Art, 1996).

36. Le Corbusier, quoted in Esther da Costa Meyer, "Simulated Domesticities: Perriand before Le Corbusier," in *Charlotte Perriand: An Art of Living*, McLeod, ed., 31.

37. See Wigley, *White Walls*, 99; on women at the Bauhaus, see Magdalena Droste, *Bauhaus 1919–1933* (Berlin: Bauhaus-Archiv Museum für Gestaltung and Benedikt Taschen, 1990), 38–40.

38. Despina Stratigakos, "The Uncanny Architect: Fears of Lesbian Builders and Deviant Homes in Modern Germany," in *Negotiating Domesticity: Spatial Productions of Gender in Modern Architecture*, Hilde Heynen and Gülsüm Baydar, eds (London and New York: Routledge, 2005), 148.

39. See McQuaid, *Lilly Reich*, 28–34.

40. Adam, *Eileen Gray*, 131; on Gray's 1937 exhibition, Adam writes, "As usual, she was fussing about and angry" (ibid., 301).

41. Bridget Elliott, "Housing the Work: Women Artists, Modernism and the *maison d'artiste*: Eileen Gray, Romaine Brooks and Gluck" in *Women Artists and the Decorative Arts, 1880–1935: The Gender of Ornament*, Bridget Elliott and Janice Helland, eds (Aldershot, England, and Burlington, VT: Ashgate, 2002), 178.

42. Walter Gropius, "The Theory and Organization of the Bauhaus," in *Bauhaus: Weimar/Dessau, 1919–1928*, Walter Gropius, Herbert Bayer and Ise Gropius, eds (New York: Museum of Modern Art, 1938), 29.

43. Le Corbusier, *The Decorative Art of Today* (1925) (Cambridge, MA: The MIT Press, 1987), 170.

44. Le Corbusier, *The New World of Space* (New York: Reynal & Hitchcock, 1948), 37.

45. Theo van Doesburg, *Theo van Doesburg*, Joost Baljieu, ed. (London: Cassell and Collier Macmillan Publishers Limited, 1974), 1.

46. Henry-Russell Hitchcock and Philip Johnson, *The International Style* (New York: Norton, 1932), 59.

47. Walter Gropius, "Appraisal of the Development of Modern Architecture," in *Scope of Total Architecture* (London: East Midland Allied Press, 1956), 69.

48. Le Corbusier in *Urbanisme* (1925), quoted in Colomina, *Privacy and Publicity*, 306.

49. Le Corbusier in *Précisions sur un état présent de l'architecture et de l'urbanisme* (1930), quoted in Colomina, *Privacy and Publicity*, 332.

50. Sigfried Giedion, *Building in France, Building in Iron, Building in Ferroconcrete*, J. Duncan Berry, trans. (Santa Monica: The Getty Center for the History of Art and the Humanities, 1995), 91.

51. Ibid., 147.

52. Ibid., 90–91.

53. Giedion's first examples of the iron construction that has revolutionized modern architecture are, not incidentally, also technologies of communication: "[i]n the air-flooded stairs of the Eiffel Tower, [or] better yet, in the steel limbs of a *pont transbordeur* … through the delicate iron net suspended in midair stream things, ships, sea, houses, masts, landscape, and harbour. They lose their delimited form: as one descends, they circle into each other and intermingle simultaneously" (ibid., 91). The *pont transbordeur* was located in a busy port of Marseilles and was used to ferry foot and car traffic across the harbour; and by the time of Giedion's writing, the Eiffel Tower had been used for nearly 30 years as a radio transmitter.

54. Constant, *Eileen Gray*, 146.

55. Le Corbusier writes, "l'auto s'engage sous les pilotis," so that the car doesn't simply "go" under the house, but engages with this underside of the house. The house is conceived in relationship with but *after* the car. See Le Corbusier, *Oeuvre complète de 1929–1934* (Zürich: H. Girsberger, 1935), 24, my translation.

56. Stanislaus von Moos, *Le Corbusier: Elements of a Synthesis* (Cambridge, MA: MIT Press, 1979), 84.

57. Adam, *Eileen Gray*, 267–268.

58. Constant, *Eileen Gray*, 148.

59. Adam, *Eileen Gray*, 259.

60. Constant, *Eileen Gray*, 148.

61. "the deflector/divider without giving the impression of resistance brings the desire to penetrate. gives the transition. keeps the mystery. the objects to be seen keep pleasure in suspense." Notes in the Eileen Gray archive, Collins Barracks, National Museum of Ireland, Dublin, my translation.

62. Giedion, *Building in France*, 147.

63. Constant, *Eileen Gray*, 146.

64. Hitchcock and Johnson, *International Style*, 97.

65. Constant, *Eileen Gray*, 146.

66. Ibid., 149–152.

67. Radclyffe Hall, *The Well of Loneliness* (1928) (London: Virago Press Limited, 1982), 246.

68. René Herbst, *25 années UAM* (Paris: Éditions du Salon des Arts Ménagers, 1956).

69. Constant, *Eileen Gray*, 146, 155.

70. Adam, *Eileen Gray*, 286.

71. Constant, *Eileen Gray*, 149.

72. Barnes, letter to Emily Coleman, 10 January, 1936, quoted in Herring, *Djuna*, 166.

73. Barnes, quoted in Herring, *Djuna*, 167.

74. Ibid., 302.

75. Mary Lynn Broe, Introduction to *Silence and Power*, Broe, ed., 5.

76. Allen, "Writing towards *Nightwood*," 54.

77. Judith Lee, "*Nightwood*: 'The Sweetest Lie,'" in *Silence and Power*, Broe, ed., 207.

78. Leigh Gilmour, "Obscenity, Modernity, Identity: Legalising *The Well of Loneliness* and *Nightwood*," *Journal of the History of Sexuality*, vol. 4, no. 4 (April 1994), 614.

79. Dianne Chisholm, "Obscene Modernism: Eros Noir and the Profane Illumination of Djuna Barnes," *American Literature*, vol. 69, no. 1(March 1997), 175–176.

80. Eliot, Introduction to *Nightwood*, xvi.

81. Boone, *Libidinal Currents*, 248.

82. Eliot, Introduction to *Nightwood*, xvi.

83. Victoria L. Smith, "A Story beside(s) Itself: The Language of Loss in Djuna Barnes' *Nightwood*," *PMLA*, vol. 114, no. 2 (March 1999), 196.

84. Kaup, "Neo-Baroque," 85.

85. Boone, *Libidinal Currents*, 233.

86. Ann Kennedy, "Inappropriate and Dazzling Sideshows: Interpellating Narratives in Djuna Barnes' *Nightwood*," in *Post Identity*, vol. 1, no. 1 (Fall 1997), 94.

87. Smith, "Story beside(s) Itself," 195; Boone, *Libidinal Currents*, 233.

88. See Carolyn Allen, "Dressing the Unknowable in the Garments of the Known," in *Women's Language and Style*, Douglas Butturf and Edmund Epstein, eds (Akron, OH: University of Akron Press, 1978), 106–118; Monika Kaup, "Neobaroque," 102–104.

89. Boone, *Libidinal Currents*, 6.

90. T.S. Eliot, "*Ulysses*, Order and Myth," quoted in Kaup, "Neobaroque," 102–103.

91. Kaup, "Neobaroque," 103, 102.

92. Boone, *Libidinal Currents*, 233.

93. Kaup, "Neobaroque," 102.

94. Ibid., 85.

95. Boone, *Libidinal Currents*, 23.

96. For more on this problematic of "modernist fiction, whose difficulty, impenetrability and obliqueness has raised serious questions about the aesthetic politics of a literary elitism that necessarily excludes large populations of would-be readers – even some of Sedgwick's ardently queer readers – and whose exclusivity becomes a self-justifying reason for its canonical enshrinement as 'high art'," but particularly for his argument on textual "difficulty" and "close reading" as part of a sexual "politics of resistance," see ibid., 23–25.
97. Chisholm, "Obscene Modernism," 172.
98. Dana Seitler, "Down on All Fours: Atavistic Perversions and the Science of Desire from Frank Norris to Djuna Barnes," *American Literature*, vol. 73, no. 3 (2001), 525–562.
99. Boone, *Libidinal Currents*, 248
100. Ibid., 249.
101. Allen, "Looking Like a Lesbian/Poet," 148.
102. Louis Kannenstine, *The Art of Djuna Barnes: Duality and Damnation* (New York: New York University Press, 1977), 90; see also Allen, "Dressing the Unknowable," 110, and Boone, *Libidinal Currents*, 239.
103. Jean Gallagher, "Vision and Inversion in *Nightwood*," *Modern Fiction Studies*, vol. 47, no. 2 (Summer 2001), 279, 280.
104. Ibid., 286.
105. Ibid., 291.
106. Ibid.
107. Constant, *Eileen Gray*, 149.
108. Ibid., 148.
109. Adam, *Eileen Gray*, 249, 131.
110. Doan, *Fashioning Sapphism*, 193.

Conclusion: staying in

The construction of queer existence as an "impossible object" of historical inquiry suggests an analogy between the epistemological disadvantage of queer studies in the academy today and the epistemological disadvantage of individual queers, those "impossible people" who, over the course of the last century, have been marginalized not only through moral censure but also through silence and disregard…. [T]he demand for the recognition of queer history as a viable practice is charged with a long history of similar claims for the viability of certain "hard to believe" modes of existence and desire.

Heather Love[1]

What led us to show, ostentatiously, that sex is something we hide, to say it is something we silence?

Michel Foucault[2]

This book might be characterized as a study of the "impossible objects" that Heather Love describes. Insofar as I have attempted here to account for the significance of Gray's sexuality, which has been dismissed or disregarded in much of the critical literature on Gray and modern architectural and design history generally, this book makes the double claim for the viability of queers in history and for queer history as a viable practice. However, the impossibility of objects in a study of Gray's work and sexuality is exacerbated by the actual lack of objects of study – few surviving and accessible works; no recorded declarations of sexual identity; no unequivocal archival "evidence" of sexual desires, practices or relationships[3] – and the related sense that Gray would have resisted the objects upon which this research is based. That is, like many of the artists, writers and designers associated with the cultural field of sapphic modernity, Gray seems to have rejected the logic that would make of sexuality an object of study. The challenge, then, has been to show how sexuality matters to understanding the architectural and design work of someone for whom sexuality did not seem to matter.

One of the ways I have taken on this challenge is to attend to the difference between dissident sexuality and sexual identity that studies in sapphic

modernity have helped us recognize as particularly important for women like Gray, Brooks, Hall and Barnes during the interwar years. As Tirza True Latimer explains, "[f]or many women artists of the last century, opting out of the heterosexual contract – and, with it, received ideas about what it meant to be a woman – was a fundamental condition of artistic identity and professional achievement."[4] Non-heterosexuality was critical to but not exhaustive of these women's modern artistic and professional identities. As Joanne Winning argues, what constituted the *modern* of any modern identity at the time was the tension of a non-identitarian sexually dissident becoming, "a mixture of possibility and closure, dissolution and formation, excitement and terror.... [T]o be sapphist is *indelibly* to be modern."[5] That is, the unhinged sapphic sexual dynamism and tension constitutes the modern's promise of becoming and futurity. It does this, however, through a strange sort of temporal discontinuity, gesturing to the past to generate a sense of future. As Love points out, sapphism "yokes a modern form of desire to the name of a poet dead for centuries who may or may not have had erotic relations with women.... While modernity reaches forward to an ever brighter future, sapphism pulls backward toward the past, toward a legacy of female same-sex desire that is at best uncertain."[6] While the uncertainty of this past, the undetermined and indeterminate status of early twentieth-century sexual dissidence, generates and seems to have generated much of modernity's promise of possibility and excitement for scholars and subjects of the period, Love reminds us that it also amplifies a history of queer longing and isolation that contemporary scholars are compelled to overlook.

Love focuses on the affective valences of this queer temporality in early twentieth-century literary texts as "an account of the corporeal and psychic costs of homophobia" and the "painful negotiation of the coming of modern homosexuality."[7] This is a history of "feeling backward" that characterizes a particularly "queer modernist melancholy"[8] – comprising experiences and representations of feelings like nostalgia, shame, despair, self-hatred and loneliness which are expected to be expunged from the twenty-first-century queer subject's affective repertoire. As Love explains,

The embarrassment [and shame] of owning such feelings, out of place as they are in a movement that takes pride as its watchword, is acute.... These texts do have a lot to tell us, though: they describe what it is like to bear a "disqualified" identity, which at times can simply mean living with injury – not fixing it.[9]

Attending to this affective history allows us to recognize that the "corporeal and psychic costs of homophobia" are not only historical, and interrupts the narrative of progress, from sexual repression to post-Stonewall liberation, which we are encouraged to reiterate and with which we are compelled to identify.

I want to suggest that attending to Gray's resistance to "the coming of modern homosexuality," or the emergence of a modern lesbian identity,

is another means by which to interrupt this progress narrative of western sexual liberation. Gray's rejection of the technologies and theories of clear communication, which were coming to reduce the exciting possibilities of female sexual dissidence and designs for alternate forms of dwelling into the fixed formation of modern sexual identity and modern architecture, might be seen as a disturbance of the "regime of power-knowledge-pleasure" driving the proliferation of modern discourses of sex.[10] My epigraph from Foucault is meant to remind us that sexuality and its liberation are products of a regulatory repressive hypothesis. Gray, like many of the women associated with sapphic modernity, was not interested in making sexuality the secret to her identity. The ostentatious showing of sex as something that we hide and the loquaciousness with which we say that sex is something we silence are the discursive channels that power takes "to reach the most tenuous and individual modes of behaviour, the paths that give it access to the rare or scarcely perceivable forms of desire, how it penetrates and controls everyday pleasures."[11] Because "lesbian" was just then being solidified as a subject, as a category of being, "a personage, a past, a case history ... a type of life, a life form, and a morphology ... a species,"[12] women like Gray were in the rare position of being able to reject the regulatory discourse to and through which female sexual dissidents would thereafter be subjected (rendered subjects, but also subjected to this regime of power-knowledge-pleasure). Indeed, I think that Gray and her contemporaries interrupt the familiar story that sexuality is the secret key to knowing the self, the repressed reality of being, a loud and proud proclamation of which is the performance of true liberation. Instead, I hope to suggest that Gray contributed to the design of a sapphic modernity which cultivated the dynamism of "impossible objects," uncertain bodies and unfixed pleasures.

As many critics have argued, the progress narrative of sexual liberation reiterated in the politics of gay pride has had some dangerous effects. Love points out that such an approach can contribute to the marginalization "of queers who experience the stigma of poverty, racism, AIDS, gender dysphoria, disability, immigration, and sexism."[13] The trajectory of this narrative has led to the generation of a western homonormativity which dangerously celebrates specifically raced, classed, cultural and citizenship privileges as "liberation."[14] Within this framework, very few, very specifically disciplined bodies come to count as viable, healthy, happy and good queer subjects. These proud homonormative subjects have been constructed and used, particularly by overdeveloped countries like the United States, to support the "liberation" of variously racialized, classed, ethnicized, and especially recently Muslim, bodies, cultures and countries.[15] I am wary of such a narrative of progress, which can work to obscure ongoing violences against queered bodies, subjects and privacies both in the few overdeveloped countries which advertise their (sexual) freedoms and elsewhere.

Attending to early twentieth-century strategies to resist the liberation of sexuality, to disturb its communicability and publicity, strikes me as a particularly important project in such a climate. The cultivation of forms of privacy can be understood as such a strategy, and the sheer number of sexually dissident women who engaged in the practice or profession of reconceptualizing or redesigning domestic and interior spaces at the time suggests that it was a significant one. Along with Gray, we can think of Evelyn Wyld and her designing partner Elizabeth Eyre de Lanux, Phyllis Barron and Dorothy Larcher, Enid Marx, Norah Braden, Ada (Peter) Mason, Katharine Pleydell-Bouverie, Constance Spry, Elsie de Wolfe, Marie Laurencin, Marion Dorn, Betty Joel, Syrie Maugham the design historian and advisor Margaret Jourdain and Ann Macbeth from the Glasgow School of Art.[16] Moreover, if we extend our scope, as I hope this book has encouraged us to do, to include women who dedicated significant creative and critical energy to reconfigurations and reconsiderations of domestic space and design, we can count visual artists such as Romaine Brooks and Gluck, and writers such as Virginia Woolf, Radclyffe Hall, Djuna Barnes, Natalie Barney and Gertrude Stein. Works by these women constitute a major cultural history of re-imagining and designing private and semi-private spaces in the service of sexually dissident, not necessarily lesbian, possibility.

This cultural history may go some way to redressing the tendency in contemporary gay, lesbian and queer studies to privilege the politics of public space (and sex) and cast investments in private space as backward, regressive or inherently normative. As Lee Wallace explains, "thinking about homosexuality and space tends to concentrate on public sex culture and advances, even in its lesbian iterations, gay male sexual practice as the paradigmatic model for the homosexual occupancy of social space."[17] Since the 1970s, studies of gay male uses, occupations and transformations of mostly public spaces (streets, bars, bath houses, cinemas) have allowed for crucial critical interrogations of the unequal power relations sustained in the separation between public and private. That is, punitive violence against embodiments and enactments of homosexuality in public space starkly reveals the sexual normativity demanded and enforced in access to the "public." Moreover, only those normative sexual acts and relations are granted the legal protection of privacy. The rejection of sexual privacy is, then, a rejection of the very public regulation of sexuality – bestowing and denying rights and privileges according to one's allegiance to certain sexual acts and relations. Within recent literature, this has led to linking "politically radical sexuality with claims on public space" and the concomitant assumption that sexual politics and cultures associated to private and domestic spaces "are, and always have been, more socially and sexually conservative."[18]

Such a tendency seems not only to follow the libratory logic of pride politics – demanding that we "come out" with "public sex" – but also to repeat the

sort of dismissals and suppressions of domesticity which characterized and constituted early twentieth-century modern art and architecture. It also works now, much as it worked then, to demarcate performances and spaces of avant-garde, radical "freedom" which exclude women (linked, of course, to the feminization of domestic space) and all those gendered, racialized, classed, alternately abled bodies whose survival strategies involve the avoidance of public space and its routinized, sanctioned violences. As Wallace points out,

> [a]lthough the public-sex model serves well the project of gay male history, it critically distorts the lesbian historical project ... since lesbian communities frequently manifest on a social network model and lack the economic infrastructure associated with gay enterprise that is needed to sustain a territorial model of spatial occupancy.[19]

Taking seriously the designs and uses of private and/or domestic spaces can, I think, introduce us to the history and cultural politics of not only lesbians, but all sexual dissidents who "lack the economic infrastructure" and access to public space "associated with gay enterprise." Indeed, the politics of "coming out" seem to overlook the bodies and subjects for whom such a public performance of queerness is neither possible nor desirable – casting as oppressed, backward, pre-modern or normative those whose survival depends on staying in.

donne la transition. garde le mystère. les objets à voir tiens en haleine le plaisir.
Eileen Gray[20]

I hope with this book to have done some justice to Gray's work, its contributions to the design of sapphic modernity and the implications of this design for historical and contemporary research on the regulation and contestation of sexuality. Recognizing that early twentieth-century architecture and design were committed to building not just new places, but new people for those places, allows us to shift our understandings of Gray's work, as well as the work of so many other sexually dissident female designers, visual artists and writers at the time. That is, the decision to work on defining or designing domestic space brought these women into a field of discourse that was importantly involved in the definition and design of modern bodies and subjects. In this context, a pronounced hint of decadent aesthetics was not simply a sign of bad or old-fashioned taste but a force of perversion and degeneration that "ARE CAPABLE OF AFFECTING OUR SENSES,"[21] transforming minds and bodies, creating perverse and degenerate subjects. Hidden corners, dark alcoves or private spaces were not simply contraventions of the modernist "free plan" but dishonest visual obstructions that produced deceptively ambiguous bodies and desires. Indeed, breaking up the clarity of communication, designing sensually rich spaces for visual and physical privacy, generated possibilities for bodies and pleasure whose incommunicability or refusal to public intelligibility seemed designed to evade the discursive reach of power-knowledge-pleasure.

This shift to recognizing the intersections between architecture, design, communication and the production of modern sexual subjects lets us tell a different story. That is, we can see in Gray's work, and in the design of sapphic modernity, the story of resistance to discourses of sexual liberation, to narratives of coming out proud for freedom. The design of sapphic modernity suggests an attention to those excluded by such a narrative and may tell a story not of progress but of the sort of transition that Gray's work cultivated. In the story of progress from sexual opacity to clarity, privacy to publicity, repression to liberation, the design of sapphic modernity cultivates the space of transition where sexuality is a deliberately obscured, impossible object of knowledge and pleasures are sustained in its suspense. *Eileen Gray and the Design of Sapphic Modernity* introduces this transition as a space of possibility which might redirect research to those strategies for negotiating and complicating the regulative libratory discourses that still dominate our approaches to sexuality and subjectivity.

Notes

1. Heather Love, *Feeling Backward: Loss and the Politics of Queer History* (Cambridge, MA: Harvard University Press, 2007), 129.
2. Michel Foucault, *The History of Sexuality*, vol. I: *An Introduction* (1978) (New York: Vintage Books, 1990), 9.
3. Much of her design work has disappeared, or is scattered in private collections and museums around the world, and so removed from the contexts and uses for which they were intended; her architecture is either in ruins or renovated beyond recognition by subsequent owners; she published only the one short article; her archival materials, most of which she seems to have destroyed before she died, contain little personal information (beyond a long correspondence with her niece, Prunella Clough) and nothing that would serve as "proof" of her sexuality.
4. Tirza True Latimer, *Looking Like a Lesbian: The Sexual Politics of Portraiture in Paris between the Wars*, Ph.D. dissertation, Stanford University (Ann Arbor: UMI Dissertation Publishing, 2002), iv.
5. Joanne Winning, "The Sapphist in the City: Lesbian Modernist Paris and Sapphic Modernity," in *Sapphic Modernities: Sexuality, Women and National Culture*, Laura Doan and Jane Garrity, eds (New York: Palgrave Macmillan, 2006), 19.
6. Heather Love, "Impossible Objects: Waiting for the Revolution in *Summer will Show*," in *Sapphic Modernities*, Doan and Garrity, eds, 134.
7. Love, *Feeling Backward*, 4.
8. Ibid., 4–5.
9. Ibid., 4.
10. Foucault, *History of Sexuality*, 11.
11. Ibid.
12. Ibid., 43.
13. Love, *Feeling Backward*, 147.
14. See Lisa Duggan, "The New Homonormativity: The Sexual Politics of Neoliberalism," in *Materializing Democracy: Toward a Revitalised Cultural Politics*, Russ Castronovo and Dana D. Nelson, eds (Durham, NC, and London: Duke University Press, 2002), 175–194.

15. For an excellent account of gay and lesbian liberation in contemporary constitutions of US exceptionalism, the war on Iraq and violence against Muslim men and women, see Jasbir Puar, *Terrorist Assemblages: Homonationalism in Queer Times* (Durham, NC, and London: Duke University Press, 2007).

16. While it is difficult to be certain whether all of these women engaged in same-sex sexual relationships, I would argue that each of these women challenged the conventions of hetero-femininity – by either remaining unmarried or being married to gay men, living alone or with other women, working as artists and designers alone or in partnerships with other women and perhaps most significantly, as Bridget Elliott argues, having "largely directed their energies toward redesigning the home for the modern woman" (Elliott, "Art Deco Hybridity, Interior Design and Sexuality between the Wars: Two Double Acts: Phyllis Barron and Dorothy Larcher / Eyre de Lanux and Evelyn Wyld," in *Sapphic Modernities*, Doan and Garrity, eds, 118–119). I want to follow Elliott's lead here by using these challenges as criteria for "[p]lacing their work within the rubric of sapphic modernity" (ibid., 119), and so tracing a broad modern design movement, comparable to the much more celebrated modern architectural movement, but with the significant difference of having the interests of modern women as its focus.

17. Lee Wallace, *Lesbianism, Cinema, Space: The Sexual Life of Apartments* (New York: Routledge, 2009), 14.

18. Ibid., 124, 14. For more on the politics of public sex, see Lauren Berlant, *The Queen of America Goes to Washington: Essays on Sex and Citizenship* (Durham, NC: Duke University Press, 1997); Lauren Berlant and Michael Warner, "Sex in Public," in *Intimacy*, Lauren Berlant, ed. (Chicago: Chicago University Press, 2000), 547–566; and Michael Warner, *The Trouble with Normal: Sex, Politics, and the Ethics of Queer Life* (New York: The Free Press, 1999).

19. Wallace, *Lesbianism*, 122, 128.

20. "gives the transition. keeps the mystery. the objects to be seen keep pleasure in suspense." Notes in the Gray archive, Collins Barracks, National Museum of Ireland, Dublin, my translation.

21. Le Corbusier, *Towards a New Architecture* (1923), F. Etchells, trans. (New York: Dover Publications, 1986), 16.

Bibliography

Adam, Peter (1989). Eileen Gray and Le Corbusier. *9H*, no. 8: 150–153.
Adam, Peter (2000). *Eileen Gray, Architect, Designer: A Biography*. New York: Harry N. Abrams, Inc.
Adams, Janet (1982). *Decorative Folding Screens: 400 Years in the Western World*. New York: Viking Press.
Agrest, Diana (1996). The Return of the Repressed: Nature. In *The Sex of Architecture*, Diana Agrest, Patricia Conway and Leslie Kanes Weisman, eds New York: Harry N. Abrams, Inc.
Agrest, Diana, Conway, Patricia and Weisman, Leslie Kanes, eds (1996). *The Sex of Architecture*. New York: Harry N. Abrams, Inc.
Allen, Carolyn (1978). Dressing the Unknowable in the Garments of the Known. In *Women's Language and Style*, Douglas Butturf and Edmund Epstein, ed. Akron, OH: University of Akron Press.
Allen, Carolyn (1991). Writing towards *Nightwood*: Djuna Barnes' Seduction Stories. In *Silence and Power: A Reevaluation of Djuna Barnes*, Mary Lynn Broe, ed. Carbondale and Edwardsville: Southern Illinois University Press.
Allen, Carolyn (2003). Djuna Barnes: Looking Like a Lesbian/Poet. In *The Modern Woman Revisited: Paris between the Wars*, Whitney Chadwick and Tirza True Latimer, eds New Brunswick, NJ, and London: Rutgers University Press.
Anscombe, Isabelle (1982). Expatriates in Paris: Eileen Gray, Evelyn Wyld and Eyre de Lanux. *Apollo*, vol. 115, no. 240, February: 117–118.
Anscombe, Isabelle (1984). *A Woman's Touch: Women in Design from 1860 to the Present Day*. New York: Viking Penguin.
Badovici, Jean (1924). L'art d'Eileen Gray. *Wendingen* (Amsterdam), vol. 6, no. 6. Special issue on Eileen Gray.
Badovici, Jean (1924). Eileen Gray. *L'architecture vivante*, Winter: 27–28.
Bailey, Colin B., ed. (2001). *Gustav Klimt: Modernism in the Making*. New York: Harry N. Abrams, Inc.
Banham, Reyner (1962). *Guide to Modern Architecture*. London: Architectural Press.
Banham, Reyner (1973). Nostalgia for Style. *New Society*, February: 248–249.
Barnes, David S. (1995). *The Making of a Social Disease: Tuberculosis in Nineteenth-Century France*. Berkeley: University of California Press.
Barnes, Djuna (1961). *Nightwood* (1936). New York: New Directions Books.
Barnes, Djuna (1992). *Ladies Almanack* (1928). Normal, IL: Dalkey Archive Press
Barney, Natalie (1929). *Aventures de l'esprit*. Paris: Éditions Émile-Paul Frères.

Barrès, Renaud (2002). Eileen Gray: le modernisme en bord de mer. *L'oeil*, no. 537, June: 36–43.
Baudelaire, Charles (1954). L'invitation au voyage (1857). In *The Flowers of Evil*, William Aggeler, trans. Fresno, CA: Academic Library Guild.
Baudelaire, Charles (1986). L'invitation au voyage (1869). In *Baudelaire: The Complete Verse*, Francis Scarfe, trans. London: Anvil Poetry.
Baudot, François (1998). *Eileen Gray*. Paris: Éditions Assouline.
Behrens, Peter (1984). Introductory Comments, Exhibition Catalogue, Darmstadt, May 1901. In *Industriekultur: Peter Behrens and the AEG, 1907–1914*. London, England: MIT Press.
Bei, Neda (2000). The Two-Fold Woman (Water-Snakes). In *Klimt's Women*, Tobias G. Natter and Gerbert Frodl, eds New Haven and London: Yale University Press.
Benstock, Shari (1986). *Women of the Left Bank: Paris, 1900–1940*. Austin: University of Texas Press.
Benstock, Shari (1990). Expatriate Sapphic Modernism: Entering Literary History. In *Lesbian Texts and Contexts: Radical Revisions*, Karla Jay and Joanne Glasgow, eds New York: New York University Press.
Berlant, Lauren (1997). *The Queen of America Goes to Washington: Essays on Sex and Citizenship*. Durham, NC: Duke University Press.
Berlant, Lauren and Warner, Michael (2000). Sex in Public. In *Intimacy*, Lauren Berlant, ed. Chicago: Chicago University Press.
Berman, Avis (1987). Eileen Gray: In the Vanguard of Twentieth Century Design. *Architectural Digest*, vol. 45, no. 5, May: 62, 66, 70.
Birnbaum, Paula (2003). Painting the Perverse: Tamara de Lempicka and the Modern Woman Artist. In *The Modern Woman Revisited: Paris between the Wars*, Whitney Chadwick and Tirza True Latimer, eds New Brunswick, NJ, and London: Rutgers University Press.
Bloomer, Jennifer (1996). The Matter of Matter: A Longing for Gravity. In *The Sex of Architecture*, Diana Agrest, Patricia Conway and Leslie Kanes Weisman, eds New York: Harry N. Abrams, Inc.
Boeken, Albert (1923). *Bouwkundig Weekblad* (Amsterdam), July 14.
Bonnevier, Katarina (2005). A Queer Analysis of Eileen Gray's E.1027. In *Negotiating Domesticity: Spatial Productions of Gender in Modern Architecture*, Hilde Heynen and Gülsüm Baydar, eds London and New York: Routledge.
Boone, Joseph Allen (1998). *Libidinal Currents: Sexuality and the Shaping of Modernism*. Chicago and London: University of Chicago Press.
Bruce, Kathleen (Lady Scott) (1949). *Self-Portrait of an Artist* (London: Hazell Watson & Viney.
Butera, Virginia Fabbri (2002). *The Folding Screen as Sexual Metaphor in Twentieth Century Western Art: An Analysis of Screens by Eileen Gray, Man Ray, and Bruce Conner*. Ph.D. dissertation, City University of New York. Ann Arbor: UMI Dissertation Publishing.
Caplan, Jane (1989). "Educating the Eye": The Tattooed Prostitute. In *Sexology in Culture: Labelling Bodies and Desires*, Lucy Bland and Laura Doan, eds Chicago: University of Chicago Press.
Carey, Allison Elise (2003). *Domesticity and the Modernist Aesthetic: F.T. Marinetti, Djuna Barnes, and Gertrude Stein*. Ph.D. dissertation, University of Tennessee, Knoxville. Ann Arbor: UMI Dissertation Publishing.
Chadwick, Whitney (1985). *Women Artists and the Surrealist Movement*. London: Thames and Hudson.
Chadwick, Whitney and Latimer, Tirza True (2003). Becoming Modern: Gender and Sexual Identity after World War I. In *The Modern Woman Revisited: Paris between the*

Wars, Whitney Chadwick and Tirza True Latimer, eds New Brunswick, NJ, and London: Rutgers University Press.
Chadwick, Whitney and Latimer, Tirza True (2003). Introduction to *The Modern Woman Revisited: Paris between the Wars*, Whitney Chadwick and Tirza True Latimer, eds New Brunswick, NJ, and London: Rutgers University Press.
Chadwick, Whitney and Latimer, Tirza True, eds (2003). *The Modern Woman Revisited: Paris between the Wars*, Whitney Chadwick and Tirza Latimer, eds New Brunswick, NJ, and London: Rutgers University Press.
Chisholm, Dianne (1997). Obscene Modernism: Eros Noir and the Profane Illumination of Djuna Barnes. *American Literature*, vol. 69, no. 1, March: 167–206.
Clark, T.J. (1985). Olympia's Choice. In *The Painting of Modern Life: Paris in the Art of Manet and his Followers*. New York: Alfred A. Knopf.
Clermont-Tonnerre, Elisabeth de (1922). Les laques d'Eileen Gray. *Feuillets d'art*, no. 3, March. Republished in English as The Laquer [sic] Work of Miss Eileen Gray. *The Living Arts*, no. 3, March: 147–148.
Cogdell, Christina (2004). *Eugenic Design: Streamlining America in the 1930s*. Philadelphia: University of Pennsylvania Press.
Colomina, Beatriz (1992). The Split Wall: Domestic Voyeurism. In *Sexuality & Space*, Beatriz Colomina and Jennifer Bloomer, eds New York: Princeton Architectural Press.
Colomina, Beatriz (1993). War on Architecture. *Assemblage*, no. 20: 28–29.
Colomina, Beatriz (1995). Battle Lines: E.1027. *Center*, no. 9: 22–31.
Colomina, B. (1996). Battle Lines: E.1027. In *The Architect: Reconstructing her Practice*, F. Hughes, ed. Cambridge, MA: The MIT Press.
Colomina, Beatriz (1996). Battle Lines: E.1027. In *The Sex of Architecture*, Diana Agrest, Patricia Conway and Leslie Kanes Weisman, eds New York: Harry N. Abrams, Inc.
Colomina, Beatriz (1997). The Medical Body in Modern Architecture. *Daidalos: Architektur, Kunst, Kultur*, vol. 64: 60–71.
Colomina, Beatriz (1998). *Privacy and Publicity: Modern Architecture as Mass Media*. Cambridge, MA: The MIT Press.
Constant, Caroline (1994). E.1027: The Nonheroic Modernism of Eileen Gray. *The Journal of the Society of Architectural Historians*, vol. 53, no. 3, September: 265–279.
Constant, Caroline (2000). *Eileen Gray*. London: Phaidon Press Limited.
Constant, Caroline, ed. (1996). *Eileen Gray: An Architecture for All Senses*. Wasmuth: Harvard University Graduate School of Design.
Conway, Kelly (1999). *The Chanteuse at the City Limits: Femininity, Paris and the Cinema*. Ph.D. dissertation, University of California, Los Angeles. Ann Arbor: UMI Dissertation Publishing.
Cottingham, Laura (1996). Notes on Lesbian. *Art Journal*, vol. 55, no. 4, Winter: 72–77.
Deepwell, Katy, ed. (1998). *Women Artists and Modernism*. Manchester and New York: Manchester University Press.
DeKoven, Marianne (1991). *Rich and Strange: Gender, History, Modernism*. Princeton, NJ: Princeton University Press.
Dijkstra, Bram (1986). *Idols of Perversity: Fantasies of Feminine Evil in Fin-de-Siècle Culture*. New York: Oxford University Press.
Doan, Laura (2001). *Fashioning Sapphism: The Origins of a Modern English Lesbian Culture*. New York: Columbia University Press.
Doan, Laura and Garrity, Jane, eds *Sapphic Modernities: Sexuality, Women and National Culture* (New York: Palgrave Macmillan, 2006).
Doan, Laura and Waters, Chris (1998). Homosexualities: Introduction. In *Sexology Uncensored: The Documents of Sexual Science*, Lucy Bland and Laura Doan, eds Chicago: University of Chicago Press.

Doesburg, Theo van (1990). Persisting Life-Style and Architectural Innovation (1924). In *On European Architecture: Complete Essays from Het Bouwbedrijf 1924–1931*, Charlotte I. Loeb and Arthur L. Loeb, trans. Basel, Switzerland: Birkhäuser Verlag.

Doesburg, Theo van (1974). *Theo van Doesburg*, Joost Baljieu, ed. London: Cassell and Collier Macmillan Publishers Limited.

Doyle, Laura Anne (1994). *Bordering on the Body: The Racial Matrix of Modern Fiction and Culture*. New York: Oxford University Press.

Droste, Magdalena (1990). *Bauhaus 1919–1933*. Berlin: Bauhaus-Archiv Museum für Gestaltung and Benedikt Taschen.

Duggan, Lisa (2002). The New Homonormativity: The Sexual Politics of Neoliberalism. In *Materializing Democracy: Toward a Revitalised Cultural Politics*, Russ Castronovo and Dana D. Nelson, eds Durham, NC, and London: Duke University Press.

Duncan, Nancy (1996). *Body Space: Destabilizing Geographies of Gender and Sexuality*. New York: Routledge.

Edwards, Jason (2000). "The Generation of the Green Carnation": Sexual Degeneration, the Representation of Male Homosexuality, and the Limits of Yeats's Sympathy. In *Modernist Sexualities*, Hugh Stevens and Caroline Howlett, eds Manchester and New York: Manchester University Press.

Eliot, T.S. (1961). Introduction to Djuna Barnes, *Nightwood* (1936). New York: New Directions Books.

Elliott, Bridget (1986). Covent Garden Follies: Beardsley's Masquerade Images of Posers and Voyeurs. *Oxford Art Journal*: 38–48.

Elliott, Bridget (1998). Performing the Picture or Painting the Other: Romaine Brooks, Gluck and the Question of Decadence in 1923. In *Women Artists and Modernism*, Katy Deepwell, ed. Manchester and New York: Manchester University Press.

Elliott, Bridget (2000). Arabesque: Marie Laurencin, Decadence and Decorative Excess. In *Modernist Sexualities*, Hugh Stevens and Caroline Howlett, eds Manchester and New York: Manchester University Press.

Elliott, Bridget (2002). Housing the Work: Women Artists, Modernism and the *maison d'artiste*: Eileen Gray, Romaine Brooks and Gluck. In *Women Artists and the Decorative Arts, 1880–1935: The Gender of Ornament*, Bridget Elliott and Janice Helland, eds Aldershot, and Burlington, VT: Ashgate.

Elliott, Bridget (2003). Deconsecrating Modernism: Allegories of Regeneration in Brooks and Picasso. In *The Modern Woman Revisited: Paris between the Wars*. New Brunswick, NJ, and London: Rutgers University Press.

Elliott, Bridget (2006). Art Deco Hybridity, Interior Design and Sexuality between the Wars: Two Double Acts: Phyllis Barron and Dorothy Larcher / Eyre de Lanux and Evelyn Wyld. In *Sapphic Modernities: Sexuality, Women and National Culture*, Laura Doan and Jane Garrity, eds New York: Palgrave Macmillan.

Elliott, Bridget and Wallace, Jo-Ann (1994). *Women Artists and Writers: Modernist (Im)positionings*. London and New York: Routledge.

Favro, Diane (1996). The Pen is Mightier than the Building: Writing on Architecture, 1850–1940. In *The Sex of Architecture*, Diana Agrest, Patricia Conway and Leslie Kanes Weisman, eds New York: Harry N. Abrams, Inc.

Fillin-Yeh, Susan, ed. (2001). *Dandies: Fashion and Finesse in Art and Culture*. New York and London: New York University Press.

Fischer, Lucy (2000). Designing Women. In *Music and Cinema*, James Buhler, Caryl Flinn and David Neumeyer, eds Hanover, NH: University Press of New England.

Foucault, Michel (1990). *The History of Sexuality*, vol. I: *An Introduction* (1978). New York: Vintage Books.

Frampton, Kenneth (1985). *Modern Architecture: A Critical History*. London: Thames and Hudson.
Friedman, Alice T. (1998). *Women and the Making of the Modern House: A Social and Architectural History*. New York: Harry N. Abrams, Inc.
Gallagher, Jean (2001). Vision and Inversion in *Nightwood*. *Modern Fiction Studies*, vol. 47, no. 2, Summer: 279–305.
Garber, Marjory (1992). *Vested Interests: Cross-Dressing and Cultural Anxiety*. New York: Routledge.
Gardiner, Stephen (1974). *Le Corbusier*. New York: Viking Press.
Giedion, Sigfried (1995). *Building in France, Building in Iron, Building in Ferroconcrete*, J. Duncan Berry, trans. Santa Monica: The Getty Center for the History of Art and the Humanities.
Gillian, Perry (1995). *Women Artists and the Parisian Avant-Garde: Modernism and "Feminine" Art, 1900 to the Late 1920s*. Manchester and New York: Manchester University Press.
Gilmour, Leigh (1994). Obscenity, Modernity, Identity: Legalising *The Well of Loneliness* and *Nightwood*. *Journal of the History of Sexuality*, vol. 4, no. 4, April: 603–624.
Golan, Romy (1995). *Modernity and Nostalgia: Art and Politics in France between the Wars*. New Haven and London: Yale University Press.
Gray, Eileen and Badovici, Jean (1929). Maison en bord de mer. *L'architecture vivante*, Winter. Special issue on E.1027.
Gray, Eileen. Galérie Jean Désert client list, address book, receipts; press clippings, reviews, design sketches. Eileen Gray archive, Victoria and Albert Museum, London, England.
Gray, Eileen. Miscellaneous notes, correspondence, books, photographs. Eileen Gray archive, Collins Barracks, National Museum of Ireland, Dublin.
Gropius, Walter (1935). *New Architecture and the Bauhaus*. London: Faber and Faber Limited.
Gropius, Walter (1938). The Theory and Organization of the Bauhaus. In *Bauhaus: Weimar/Dessau, 1919–1928*, Walter Gropius, Herbert Bayer and Ise Gropius, eds New York: Museum of Modern Art.
Gropius, Walter (1956). *Scope of Total Architecture*. Londonn: East Midland Allied Press.
Hall, Radclyffe (1994). *The Well of Loneliness* (1928). London: Virago Press Limited.
Herbert, Robert L., ed. (1964). *Modern Artists on Art: Ten Unabridged Essays*. Englewood Cliffs, NJ: Prentice-Hall, Inc.
Herbst, René (1956). *25 années UAM*. Paris: Éditions du Salon des Arts Ménagers.
Herring, Phillip (1995). *Djuna: The Life and Works of Djuna Barnes*. New York: Viking Press.
Hitchcock, Henry-Russell and Johnson, Philip (1932). *The International Style*. New York: Norton.
Howlett, Caroline and Stevens, Hugh, eds (2000). *Modernist Sexualities*. Manchester and New York: Manchester University Press.
Huysmans, J.K. (1969). *Against the Grain (À rebours)*. New York: Dover Publications.
Ingraham, Catherine (1996). Missing Objects. In *The Sex of Architecture*, Diana Agrest, Patricia Conway and Leslie Kanes Weisman, eds New York: Harry N. Abrams, Inc.
Irigaray, Luce (1993). *An Ethics of Sexual Difference*, C. Burke and G.C. Gill, trans. Ithaca and New York: Cornell University Press.
Jagose, Annamarie (2002). *Inconsequence: Lesbian Representation and the Logic of Sequence*. Ithaca: Cornell University Press.
Jardine, Alice (1985). *Gynesis: Configurations of Woman and Modernity*. Ithaca, NY: Cornell University Press.

Johnson, J. Stewart (1972). Pioneer Lady. *Architectural Review*, vol. 152, no. 186, August: 125.
Johnson, J. Stewart (1980). *Eileen Gray, Designer*. London: Debrett's Peerage for the Museum of Modern Art, New York.
Kannenstine, Louis (1977). *The Art of Djuna Barnes: Duality and Damnation*. New York: New York University Press.
Kaup, Monika (2005). The Neobaroque in Djuna Barnes. *Modernism/Modernity*, vol. 12, no. 1: 85–110.
Kennedy, Ann (1997). Inappropriate and Dazzling Sideshows: Interpellating Narratives in Djuna Barnes' *Nightwood*. *Post Identity*, vol. 1, no. 1, Fall: 94–112.
Koolhaas, Rem and Mau, Bruce (1995). *S, M, L, XL*. New York: Monacelli Press.
Krafft-Ebing, Richard von (1998). *Psychopathia sexualis* (1886, 12th edition, 1903). In *Sexology Uncensored: The Documents of Sexual Science*, Lucy Bland and Laura Doan, eds Chicago: University of Chicago Press.
Laity, Cassandra (1990). H.D. and A.C. Swinburne: Decadence and Sapphic Modernism. In *Lesbian Texts and Contexts: Radical Revisions*, Karla Jay and Joanne Glasgow, eds New York: New York University Press.
Latimer, Tirza True (2002). *Looking Like a Lesbian: The Sexual Politics of Portraiture in Paris between the Wars*. Ph.D. dissertation, Stanford University. Ann Arbor: UMI Dissertation Publishing.
Latimer, Tirza True (2005). *Women Together/Women Apart*. New Brunswick, NJ: Rutgers University Press.
Lauretis, Teresa de (1990). Eccentric Subjects: Feminist Theory and Historical Consciousness. *Feminist Studies*, vol.16, no.1, spring: 115–150.
Lavin, Sylvia (1996). Colomina's Web: Reply to Beatriz Colomina. In *The Sex of Architecture*, Diana Agrest, Patricia Conway and Leslie Kanes Weisman, eds New York: Harry N. Abrams, Inc.
Lavin, Sylvia (1999). Open the Box: Richard Neutra and the Psychology of the Domestic Environment. *Assemblage*, no. 40: 6–25.
Lavin, Sylvia (2000). New Mood or Affective Disorder. *Assemblage*, no. 41: 40.
Le Corbusier (1927). Où en est l'architecture? *L'architecture vivante*, Fall, 7–11.
Le Corbusier (1935). *Oeuvre complète de 1929–1934*. Zürich: H. Girsberger.
Le Corbusier (1948). *L'architecture d'aujourd'hui*, April. Special issue on Le Corbusier.
Le Corbusier (1948). Le Corbusier, muraliste. *Interiors*, June.
Le Corbusier (1948). *The New World of Space*. New York: Reynal & Hitchcock.
Le Corbusier (1960). *Creation is a Patient Search*, James Palmes, trans. New York: Praeger.
Le Corbusier (1960). Graffiti at Cap Martin. In *My Work*, James Palmes, trans. London: The Architectural Press.
Le Corbusier (1964). *Oeuvre complète 1910–1929*. Zürich: Éditions d'Architecture.
Le Corbusier (1986). *Towards a New Architecture* (1923), F. Etchells, trans. New York: Dover Publications.
Le Corbusier (1987). *The Decorative Art of Today* (1925). Cambridge, MA: The MIT Press.
Le Corbusier and Ozenfant, Amadée (1964). Purism (1920). *In Modern Artists on Art: Ten Unabridged Essays*, Herbert, Robert L. ed. Englewood Cliffs, NJ: Prentice-Hall, Inc.
Lee, Judith (1991). Nightwood: "The Sweetest Lie." In *Silence and Power: A Reevaluation of Djuna Barnes*, Mary Lynn Broe, ed. Carbondale and Edwardsville: Southern Illinois University Press.
Lesbian History Group (1993), *Not a Passing Phase: Reclaiming Lesbians in History, 1840–1985*. London: Women's Press.

Lilley, Ed (1994). The Name of the Boudoir. *The Journal of the Society of Architectural Historians*, vol. 53, no. 2, June: 193–198.
Long, Richard A. and Jones, Iva G. (1961). Towards a Definition of the "Decadent Novel." *College English*, vol. 1: 245–249.
Loos, Adolf (1982). Ladies' Fashion (1898). In *Spoken into the Void: Collected Essays 1897–1900*, Jane O. Newman and John Smith, trans. Cambridge, MA: The MIT Press.
Loos, Adolf (2002). Ornament and Crime (1908). In *Crime and Ornament: The Arts and Popular Culture in the Shadow of Adolf Loos*, Melony Ward and Bernie Miller, eds Toronto, Ontario: YYZ Books.
Love, Heather (2006). Impossible Objects: Waiting for the Revolution in *Summer will Show*. In *Sapphic Modernities: Sexuality, Women and National Culture*, Laura Doan and Jane Garrity, eds New York: Palgrave Macmillan.
Love, Heather (2007). *Feeling Backward: Loss and the Politics of Queer History*. Cambridge, MA: Harvard University Press.
Loye, Brigitte (1984). *Eileen Gray: 1879–1976: Architecture, Design*. Paris: Analeph, J.P. Viguier.
Lucchesi, Joe (2000). "An Apparition in a Black Flowing Cloak": Romaine Brooks' Portraits of Ida Rubinstein. In *Amazons in the Drawing Room: The Art of Romaine Brooks*, Whitney Chadwick, ed. Berkeley: University of California Press, Chameleon Books, Inc.
Lucchesi, Joe (2000). *Romaine Brooks' Portraits and the Performance of Lesbian Identity*. PhD dissertation, Chapel Hill University. Ann Arbor: UMI Dissertation Publishing.
Lucchesi, Joe (2001). "The Dandy in Me": Romaine Brooks's 1923 Portraits. In *Dandies: Fashion and Finesse in Art and Culture*, Susan Fillin-Yeh, ed. New York and London: New York University Press.
Lucchesi, Joe (2003). "Something Hidden, Secret and Eternal": Romaine Brooks, Radclyffe Hall, and the Lesbian Image in *The Forge*. In *The Modern Woman Revisited: Paris between the Wars*, Whitney Chadwick and Tirza True Latimer, eds New Brunswick, NJ, and London: Rutgers University Press.
Mansbach, Steven (1989). *Visions of Totality: Laszlo Moholy-Nagy, Theo van Doesburg, and El Lissitzky*. Ann Arbor, MI: UMI Research Press.
Marcus, Jane (1991). Mousemeat: Contemporary Reviews of *Nightwood*. In *Silence and Power: A Reevaluation of Djuna Barnes*, Mary Lynn Broe, ed. Carbondale and Edwardsville: Southern Illinois University Press.
McGrath, Mary Beth (1991). Beardsley's Relationship with Oscar Wilde. *The Victorian Web*. http://www.victorianweb.org, accessed 2007.
McGrath, Mary Beth and Lasner, Mark Samuels (1991). The Life of Aubrey Beardsley. *The Victorian Web*. http://www.victorianweb.org, accessed 2007.
McLeod, Mary (1983). "Architecture or Revolution": Taylorism, Technocracy, and Social Change. *Art Journal*, vol. 43, no. 2: 132–147.
McLeod, Mary (1996). "Other" Spaces and "Others." In *The Sex of Architecture*, Diana Agrest, Patricia Conway and Leslie Kanes Weisman, eds New York: Harry N. Abrams, Inc.
McLeod, Mary, ed. (2003). *Charlotte Perriand: An Art of Living*. New York: Harry N. Abrams, Inc.
McNeil, Peter (1994). Designing Women: Gender, Sexuality and the Interior Decorator, c.1890–1940. *Art History*, vol. 17, no. 4: 631–657.
McQuaid, Matilda (1996). *Lilly Reich: Designer and Architect*. New York: Museum of Modern Art.
Meyer, Esther da Costa (2003). Simulated Domesticities: Perriand before Le Corbusier. In *Charlotte Perriand: An Art of Living*, Mary McLeod, ed. New York: Harry N. Abrams, Inc.

Micale, Mark S., ed. (2004). *The Mind of Modernism: Medicine, Psychology, and the Cultural Arts in Europe and America, 1880–1940*. Stanford, CA: Stanford University Press.

Mondrian, Piet (1995). *Natural Reality and Abstract Reality: An Essay in Trialogue Form 1919–1920*. New York: George Braziller, Inc.

Moon, Michael (1989). Flaming Closets. *October*, vol. 51, Winter: 19–54.

Moos, Stanislaus von (1979). *Le Corbusier: Elements of a Synthesis*. Cambridge, MA: MIT Press.

Mourey, Gabriel (1900). Round the Exhibition: The House of the "Art Nouveau Bing." *Studio*, vol. 20: 164–180.

Nava, Mica (1996). *Modernity's Disavowal: Women, the City, and the Department Store*. In *Modern Times: Reflections on a Century of English Modernity*, Mica Nava and Alan O'Shea, eds London and New York: Routledge.

O'Grady, Lorraine (2003). Olympia's Maid: Reclaiming Black Female Subjectivity. In *The Feminism and Visual Culture Reader*, Amelia Jones, ed. London: Routledge.

Oud, J.P.P. (1976) International Architecture: Werkbund Exhibition, "The Dwelling," July–September 1927, Stuttgart. *i*, vol. 10, no. 6 (1927). Trans. Suzanne Frank, *Oppositions*, vol. 7, Winter: 78–79.

Partsch, Susanna (1994). *Gustav Klimt: Painter of Women*. Munich and New York: Prestel Press.

Peach, Mark (1995). "Der Architekt denkt, die Hausfrau lenkt": German Modern Architecture and the Modern Woman. *German Studies Review*, vol. 18, no. 3, October: 441–463.

Pollock, Griselda (1999). *Differencing the Canon: Feminist Desire and the Writing of Art's Histories*. London: Routledge.

Prosser, Jay (1998). *Second Skins: The Body Narratives of Transsexuality*. New York: Colombia University Press.

Puar, Jasbir (2007). *Terrorist Assemblages: Homonationalism in Queer Times*. Durham, NC, and London: Duke University Press.

Rasch, Wolfdietrich (1982). Literary Decadence in Artistic Representations of Decay. *Journal of Contemporary History*, vol. 17, no. 1, January: 201–218.

Rattenbury, Kester (2002). *This is not Architecture: Media Constructions*. London and New York: Routledge.

Ray, Chelsea (2005). Decadent Heroines or Modernist Lovers: Natalie Clifford Barney's Unpublished *Feminine Lovers or the Third Woman*. *South Central Review*, vol. 22, no. 3, Fall: 32–61.

Rayon, Jean Paul (1989). Eileen Gray: The North Star and the South Star. *9H*, no. 8: 164–182.

Reed, Christopher, ed. (1996). *Not at Home: The Suppression of Domesticity in Modern Art and Architecture*. London: Thames and Hudson Ltd.

Reizbaum, Marylin (1988). A "Modernism of Marginality": The Link between James Joyce and Djuna Barnes. In *New Alliances in Joyce Studies*, Bonnie Kime Scott, ed. Newark, DE: University of Delaware Press.

Rendell, Jane (2002). *The Pursuit of Pleasure: Gender, Space & Architecture in Regency London*. New Brunswick, NJ: Rutgers University Press.

Rieszler, Walter (1927). Die Wohnung. *Die Form*, vol. 2, no. 9, September: 258–266.

Roberts, Mary Louise (1994). *Civilization without Sexes: Reconstructing Gender in Postwar France, 1917–1927*. Chicago and London: University of Chicago Press.

Roberts, Mary Louise (2003). Samson and Delilah Revisited: The Politics of Fashion in 1920s France. In *The Modern Woman Revisited: Paris between the Wars*, Whitney Chadwick and Tirza True Latimer, eds New Brunswick, NJ, and London: Rutgers University Press.

Rosner, Victoria (2001). Once More unto the Breach: The Well of Loneliness and the Spaces of Inversion. In *Palatable Poison: Critical Perspectives on The Well of Loneliness*, Laura Doan and Jay Prosser, eds New York: Colombia University Press.
Rosner, Victoria Page (1999). *Housing Modernism: Architecture, Gender and the Culture of Space in Modern British Literature*. Ph.D. dissertation, Columbia University. Ann Arbor: UMI Dissertation Publishing.
Rosner, Victoria Page (2005). *Modernism and the Architecture of Private Life*. New York: Columbia University Press.
Rothschild, Joan ed. (1999). *Design and Feminism: Re-Visioning Spaces, Places, and Everyday Things*. Brunswick, NJ, and London: Rutgers University Press.
Rüegg, Arthur ed. (2004). *Charlotte Perriand: livre de bord 1928–1933*, Steven Lindberg, trans. Berlin: Birkhäuser-Publishers for Architecture.
Rykwert, Joseph (1968). Un omaggio a Eileen Gray: pioniera del design. *Domus* (Milan), no. 469, December: 33.
Rykwert, Joseph (1972). Eileen Gray: Pioneer of Design. *Architectural Review*, 152, no. 910, December: 357–361.
Rykwert, Joseph (1972). Eileen Gray: Two Houses and an Interior, 1926–1933. *Perspecta*, vol. 13, no. 14: 66–73.
Safran, Y. (1989). La pelle. *9H*, no. 8: 155–159.
Schor, Naomi (1987). *Reading in Detail: Aesthetics and the Feminine*. New York and London: Methuen, Inc.
Schultz, Gretchen (2000). Baudelaire's Lesbian Connections. In *Approaches to Teaching Baudelaire's "Les fleurs du mal,"* Laurence Porter, ed. New York: The Modern Languages Association of America.
Schulze, Franz (1985). *Mies van der Rohe: A Critical Biography*. Chicago: University of Chicago Press.
Secrest, Meryle (1974). *Between Me and Life: A Biography of Romaine Brooks*. New York: Doubleday & Company, Inc.
Seitler, Dana (2001). Down on All Fours: Atavistic Perversions and the Science of Desire from Frank Norris to Djuna Barnes. *American Literature*, vol. 73, no. 3: 525–562.
Shaw, Jennifer (2003). Singular Plural: Collaborative Self-Images in Claude Cahun's *Aveux non avenues*. In *The Modern Woman Revisited: Paris between the Wars*, Whitney Chadwick and Tirza True Latimer, eds New Brunswick, NJ, and London: Rutgers University Press.
Showalter, Elaine (1990). *Sexual Anarchy: Gender and Culture at the Fin de Siècle*. New York: Viking.
Silver, Kenneth (1989). *Esprit de Corps: The Art of the Parisian Avant-Garde and the First World War, 1914–1925*. Princeton: Princeton University Press.
Silverman, Debora L. (1989). *Art Nouveau in Fin-de-Siècle France: Politics, Psychology and Style*. Berkeley: University of California Press.
Somerville, Siobhan (1994). Scientific Racism and the Emergence of the Homosexual Body. *Journal of the History of Sexuality*, vol. 5, no. 2, October, 243–266.
Somerville, Siobhan B. (2000). *Queering the Color Line: Race and the Invention of Homosexuality in American Culture*. Durham, NC: Duke University Press.
Smith, Victoria L. (1999). A Story beside(s) Itself: The Language of Loss in Djuna Barnes' *Nightwood*. *PMLA*, vol. 114, no. 2, March: 194–206.
Soulillou, Jacques (2002). Ornament and Order, trans. Mark Heffernan, in *Crime and Ornament: The Arts and Popular Culture in the Shadow of Adolf Loos*, Melony Ward and Bernie Miller, eds Toronto, Ontario: YYZ Books.
Steele, Valerie (1998). *Paris Fashion: A Cultural History*. Oxford and New York: Berg Press.
Stewart, Mary Lynn (2001). *For Health and Beauty: Physical Culture for Frenchwomen, 1880s–1930s*. Baltimore and London: Johns Hopkins University Press.

Stratigakos, Despina (2005). The Uncanny Architect: Fears of Lesbian Builders and Deviant Homes in Modern Germany. In *Negotiating Domesticity: Spatial Productions of Gender in Modern Architecture*, Hilde Heynen and Gülsüm Baydar, eds London and New York: Routledge.

Topp, Leslie (1997). An Architecture for Modern Nerves: Josef Hoffman's Purkersdorf Sanatorium. *The Journal of the Society of Architectural Historians*, vol. 56, no. 4, December: 414–437.

Tournikiotis, Panayotis (1999). *The Historiography of Modern Architecture*, Cambridge, MA: MIT Press.

Troy, Nancy J. (1991). *Modernism and the Decorative Arts in France: Art Nouveau to Le Corbusier*. New Haven and London: Yale University Press.

Troy, Nancy J. (2003). *Couture Culture: A Study in Modern Art and Fashion*. Cambridge, MA: MIT Press.

Vauxcelles, Louis. Unidentified, undated proof copy of manuscript on Eileen Gray. Eileen Gray archive, Victoria and Albert Museum, London, England.

Venturi, Robert (1966). *Complexity and Contradiction in Architecture*. New York: Museum of Modern Art.

Venturi, Robert, Brown, Denise Scott and Izenour, Steven (1972). *Learning from Las Vegas*. Cambridge, MA: MIT Press.

Walker, Lynne (2003). Architecture and Reputation: Eileen Gray, Gender, and Modernism. In *Women's Places: Architecture and Design 1860–1960*, Brenda Martin and Penny Sparke, eds London and New York: Routledge, Taylor & Francis Group.

Wallace, Lee (2009). *Lesbianism, Cinema, Space: The Sexual Life of Apartments*. New York: Routledge.

Ward, Melony (2000). Cleaning House: Purity, Presence and the New Spirit in Le Corbusier. In *Practice Practise Praxis: Serial Repetition, Organizational Behaviour, and Strategic Action in Architecture*, S. Sorli, ed. Toronto: YYZ Books.

Warner, Michael (1999). *The Trouble with Normal: Sex, Politics, and the Ethics of Queer Life*. New York: The Free Press.

Weeks, Jeffery (1981). *Sex, Politics, and Society: The Regulation of Sexuality since 1800*. New York and London: Longman Press.

Weisburg, Gabriel (1986). *Art Nouveau Bing: Paris Style 1900*. New York: Harry N. Abrams, Inc.

Weiss, Jeffrey (1994). *The Popular Culture of Modern Art: Picasso, Duchamp, and Avant-Gardism*. New Haven and London: Yale University Press.

Whiting, S. (1996). Voices between the Lines: Talking in the Gray Zone. In *Eileen Gray: An Architecture for All Senses*, Caroline Constant, ed. Wasmuth: Harvard University Graduate School of Design.

Wigley, Mark (1992). Untitled: Housing Gender. In *Sexuality & Space*, Beatriz Colomina and Jennifer Bloomer, eds New York: Princeton Architectural Press.

Wigley, Mark (1995). *White Walls, Designer Dresses: The Fashioning of Modern Architecture*. Cambridge, MA: The MIT Press.

Wilde, Oscar (1894). *Salomé*. London; Boston: Elkin Mathews & John Lane; University of Virginia Library Electronic Text Center, http://etext.lib.virginia.edu/modeng/modengW.browse.html, accessed 2007.

Winning, Joanne (2006). The Sapphist in the City: Lesbian Modernist Paris and Sapphic Modernity. In *Sapphic Modernities: Sexuality, Women and National Culture*, Laura Doan and Jane Garrity, eds New York: Palgrave Macmillan.

Woolf, Virginia (1994). *A Room of One's Own* (1928). London: HarperCollins Publishers.

Young, Iris (2000). House and Home: Feminist Variations on a Theme. In *Resistance, Flight, Creation: Feminist Enactments of French Philosophy*, Dorothea Olkowski, ed. Ithaca: Cornell University Press.

Index

Abbott, Bernice vii–viii, 11–12, 112–13, 122
Adam, Peter x, 7, 9–10, 13–16, 21–5, 55, 59, 70, 78, 83, 88–91, 93–4, 96, 112, 119–23, 125, 127, 132, 137, 147, 156–60, 169
androgyny 64, 82, 84
L'architecture vivante 6, 22–3, 45, 58, 88, 94, 97–8, 104, 118–20, 127, 132, 156, 169, 173–4
art nouveau 39, 55–7, 76–7, 83, 88, 90, 123, 176–8
avant-garde 6, 11, 19–20, 31, 43, 45, 48, 54, 59, 68, 70, 94, 96, 101, 104–5, 112, 120, 126–7, 129, 131, 148–9, 173, 177

Badovici, Jean 6, 8, 16, 22–4, 31–2, 56, 93–5, 103, 110, 121, 127, 156–7, 169, 173
Bakst, Leon 84–5
Banham, Reyner 13, 16, 24–5, 31, 52, 56, 60, 83, 91, 93–4, 119, 169
Barnes, Djuna, vi, viii, 1, 4, 13, 15, 20–21, 50, 52, 88, 112, 125, 127–30, 132–3, 147–57, 159–60, 162, 164, 169–77; *see also Nightwood*
Barney, Natalie 11, 13–15, 20, 25, 50–52, 59, 68, 70, 84, 88–9, 107, 127, 157, 164, 169–70, 176
Barron, Phyllis 5, 22, 164, 167, 172

Baudelaire, Charles 17, 27, 37, 45–50, 57, 59, 170, 177
Bauhaus 10, 24, 27, 30, 45, 55, 61, 84, 131, 133, 158, 172–3
Beardsley, Aubrey vii, 17, 24–5, 52, 79–83, 90, 93, 172, 175
Behrens, Peter 24, 27–8, 55, 170
Benstock, Shari 4, 22, 24, 52, 60, 170
bisexual 5, 8, 15, 95
Bloch, Gabrielle (Gaby) 11, 14–16, 25, 68, 88
Boeken, Albert 32–3, 56, 170
Bonnard, Pierre 75–8
Bonnevier, Katarina 10, 23, 170
Boone, Joseph Allen 129, 149, 151, 157, 159–60, 170
de Bretteville, Sheila 8, 23, 131, 157
Brooks, Romaine v, vii, 1, 4, 9, 11, 13, 15–16, 20–21, 23, 49–54, 59–75, 77–9, 85–9, 91, 107, 119–20, 132–3, 158, 162, 164, 172, 175, 177; *see also The Screen; White Azaleas*
Bruce, Kathleen 13–14, 24, 170
Butera, Virginia Fabbri 74–6, 89–90, 170

Castellar 125, 134–5, 137, 147
Chadwick, Whitney 9, 22–4, 70–72, 83, 87, 89, 91, 95, 119, 122, 157, 169–71, 175–7

Charcot, Jean-Martin 35–6, 38, 54, 57
Chisholm, Dianne 148, 150, 154, 159–60, 171
Clermont-Tonnerre, Duchesse de 15, 25, 51, 59, 171
Colomina, Beatriz x, 2–4, 6, 8–9, 18, 21–3, 25, 28, 34, 40–41, 44, 55–8, 67, 83, 88, 95, 108–10, 117–19, 121, 123, 125–6, 156, 158, 171, 174, 178
communication technologies 1, 5, 21, 125–6, 133–6, 138, 158
Constant, Caroline x, 3, 6, 9, 11, 19, 22–3, 25–6, 33, 46–9, 55–6, 58–9, 61, 68, 83–5, 88, 91, 101, 103, 109–10, 117–21, 125, 134, 136–7, 140, 142, 147, 154, 156–60, 171, 178
Le Corbusier vii, 2–4, 6, 8–10, 18–20, 22–7, 30–31, 34, 40–46, 49, 55–9, 61, 83–4, 90, 93–6, 101, 103–5, 107–12, 115–21, 123, 131–3, 135–7, 145, 151, 156, 158, 167, 169, 173–6, 178
Cottingham, Laura 112, 122, 171

Damia 6, 11, 13, 15–16, 25, 50, 88; see also Damien, Marie-Louise
Damien, Marie-Louise 6, 15, 88; see also Damia
De Stijl 10, 17, 27, 32, 61, 83–4
Des Esseintes 36–7, 40, 53
Le destin vii, 64–7, 80, 82
Diaghilev, Sergei 84–5
Doan, Laura 5, 8, 21–4, 51, 57, 59–60, 95, 112, 114–16, 119–23, 125, 128, 156, 160, 166–7, 170–72, 174–5, 177–8
van Doesburg, Theo 27, 55, 94, 133, 158, 172, 175
domestic space 1, 4, 5, 20–21, 29, 31, 44–5, 54, 64–9, 73–6, 78, 86–7, 94, 101–3, 107, 110, 116–7, 132–3, 142, 164–5

E. 1027 v, vii, x, 2–4, 6, 8–10, 18, 20–24, 45–6, 49, 59, 68, 83, 87–8, 93–105, 108–11, 117–19, 127–8, 131–2, 134–5, 137–8, 140–42, 147, 156, 170–71, 173
Elliott, Bridget 5, 9–10, 17, 22–5, 48–54, 59–60, 66, 69, 75, 80, 82, 88–90, 95, 119–20, 129–30, 132, 157–8, 167, 172
Ellis, Havelock 114, 122

female masculinities 3, 5, 21
feminist 2–3, 8–12, 17, 20, 22, 49, 52, 60, 62, 70, 74, 79–80, 83, 88, 148, 153–4, 174, 176, 179
Foucault, Michel 28, 44–5, 55, 58, 60, 88, 161, 163, 166, 172
France, South of 2, 6, 68, 120
Fuller, Loie 11, 13–15, 88
functionalism 10, 30, 45, 61

Gallagher, Jean 152–4, 160, 173
Gavin, Jesse 11, 13–14
Giedion, Sigfried 133, 158–9, 173
Gilmore, Leigh 148, 159, 173
Gluck [Gluckstein], Hannah 9, 13, 23, 50–51, 53–4, 60, 66, 88–9, 119–20, 132–3, 158, 164, 172
Gray, Eileen v–viii, x, 1–33, 45–56, 58–62, 64–72, 78–80, 82–4, 86–91, 93–8, 100–113, 115–23, 125–8, 130–38, 140–48, 150–52, 154–60, 161–7, 169–78; see also *Le destin*; E. 1027; *Le magicien de la nuit*; Tempe à Pailla; *La voie lactée*
Gropius, Walter 10, 24, 27, 55, 61, 94, 131, 133, 151, 158, 173

Hall, Radclyffe v, vii, 1, 4, 13, 20–21, 23, 50, 52, 87, 93, 96, 102, 106–8, 115–18, 120, 122, 127, 142, 148, 155, 159, 162, 164, 173, 175; see also *The Well of Loneliness*
Herbst, René viii, 123, 145–6, 159, 173
heteronormative 7–8, 10, 94–5, 117–18, 130

Hitchcock, Henry-Russell 133, 140, 158–9, 173–4
House-Machine 31, 34; *see also machine à habiter*
house-tool 18, 42, 44
Huysmans, Joris Karl 36–7, 48, 52–3, 57, 173

International style 16, 54, 133, 158–9, 173
L'invitation au voyage vii, 45–7, 49, 59, 170; *see also* Baudelaire, Charles

Jagose, Annamarie 95, 115, 119, 122, 173
Jean Désert 6, 15–16, 24–5, 32, 88, 127, 131, 157, 173

Kaup, Monika 150, 154, 157, 159, 174
Klimt, Gustav 78–9, 90, 169–70, 176
Krafft-Ebing, Richard von 38, 57, 103, 108, 121–2, 174

Laity, Cassandra 52, 60, 174
de Lanux, Elizabeth Eyre 5, 15, 22, 25, 50, 88–9, 164, 167, 169, 172
Larcher, Dorothy 5, 22, 164, 167, 172
Latimer, Tirza True 9, 22–4, 70–72, 83, 87, 89, 91, 95, 112, 115, 119, 122, 157, 162, 166, 169–77
Laurencin, Marie 50, 52–3, 60, 164, 172
Lavin, Sylvia 6–7, 9, 22, 28, 34–5, 55–6, 174
Left Bank 4, 11, 20, 22, 24, 52, 60, 71, 106, 112, 127, 129, 156, 170
lesbian v, 1, 3–5, 7–8, 10–11, 13–17, 21–4, 47, 49–53, 59–60, 66, 70, 72–5, 78–80, 83–7, 89–91, 95–6, 102, 107, 112, 114–20, 122, 125, 127–9, 132, 147–8, 150, 154–8, 160, 162–7, 169–71, 173–5, 177–8; *see also* non-heterosexual; sexual dissidence
liberation 162–4, 166–7
Loos, Adolf 23, 27, 31, 39–41, 45, 56–7, 94, 120, 175, 177

Lucchesi, Joe 23, 72–3, 78, 85–6, 89–91, 95, 119, 123, 175
luxe 19, 47–8

machine aesthetic 10, 31, 55
machine à habiter 18, 34; *see also* House-Machine
McNeil, Peter 11, 13, 23–4, 69, 75, 88–9, 175
Le magicien de la nuit vii, 67, 80, 82
maison d'artiste 22, 53, 60, 88, 120, 158, 172
Manet, Édouard 53, 73–8, 86, 89, 171
mannish lesbian 1, 11, 24, 112, 114–16
Mathieu-Lévy, Madame 17, 86
Mies van der Rohe, Ludwig 24, 131–2, 141, 151, 177
modernist movement 6–7, 4, 11, 16, 31–2, 49, 53, 61, 83–4, 103, 105, 126, 131
Mondrian, Piet 27, 55, 176
Monte Carlo room vii, 17–18, 30–31, 96
Moon, Michael 84–6, 91, 176
Mourey, Gabriel 76–7, 90, 176

National Museum of Ireland vii–viii, x, 2, 7, 12, 18, 23, 25, 55, 88, 97, 99, 100, 113, 120–22, 128, 136, 138–40, 143, 145–6, 159, 167, 173
non-heterosexual 1, 3–4, 7–8, 10, 12, 16, 21, 49, 55, 72, 95–6, 117–18, 120, 127, 142, 162; *see also* lesbian; sexual dissidence
Nightwood vi, 1, 20, 128–9, 142, 147–55, 157, 159, 169, 172–5, 177; *see also* Barnes, Djuna

Olympia 53, 73–5, 77–8, 86, 89, 171, 176
ornamentation 39–40, 42, 44, 52, 105
Oud, J.J.P. 10, 24, 27, 61, 176

Perriand, Charlotte 24, 131–2, 157–8, 175, 177
pioneer lady v, 11, 24, 174

Pollock, Griselda 7, 22, 62, 88, 176
purism 10, 31, 33, 55–6, 61, 174

queer 10, 14, 23, 58, 84, 160–67, 170, 175–8

Reed, Christopher 44, 58, 67, 70, 88–9, 176
Reich, Lilly 131–2, 157–8, 175
Roberts, Mary Louise 28–9, 55–6, 59, 114, 122–3, 176
A Room of One's Own 71, 88, 101, 120, 178; see also Woolf, Virginia
Rosner, Victoria Page 101, 103, 106–7, 119–21, 177
Rubinstein Ida 13, 50, 53, 79, 84–6, 89, 175
Rykwert, Joseph 11, 13, 16–17, 24–5, 52, 59–60, 80, 83, 90–91, 93–4, 118–19, 123, 177

Salomé 79–80, 82, 85, 90, 178
Salon des Artistes Décorateurs vii, 17–18
sapphic modernity v–vi, viii, 1, 3–5, 21–2, 52, 60, 161, 163, 165–7, 172, 174–5, 178
Schehérazade 84–6
The Screen vii, 62–4, 72–3, 77–8
Seitler, Dana 150, 154, 160, 177
sexual dissidence 3, 5, 8, 21, 52, 102, 163; see also lesbian; non-heterosexual
sexual inversion 103, 106, 114–17, 122, 154
Showalter, Elaine 17, 25, 33, 56, 90, 177

Silverman, Debora L. 35–9, 41–2, 56–7, 67, 77, 88–90, 153, 177
Spry, Constance 53, 89, 164

Tempe à Pailla vi–viii, 6, 20–21, 123, 128, 134–41, 143–7, 150–52, 154–6
Topp, Leslie 33, 56, 178
Troubridge, Lady Una 50, 115–16
Tuberculosis 41–2, 58, 67, 169

Union des Artistes Modernes (UAM) viii, 117, 123, 132, 145–6, 156–7, 159, 173

Vauxcelles, Louis 32, 56, 130, 157, 178
violence 2–4, 8, 95, 118, 163–5, 167
Vivien, Renee 13, 50
La voie lactée 64, 67, 78

Walker, Lynne 3, 7–10, 22–3, 62, 88, 95, 119, 178
The Well of Loneliness v, 1, 20–21, 87, 96, 102–3, 105, 118, 120–21, 125, 127–8, 142, 148, 155, 159, 173, 177
White Azaleas 62, 64, 72–4, 78, 85–6
Wigley, Mark 21–2, 43, 57–8, 88, 105, 108, 110–11, 121–2, 126, 156, 158, 178
Wilde, Oscar 33, 37–8, 40, 48, 50, 57, 79–80, 85, 90, 175, 178
Wils, Jan 32, 51, 56, 156
de Wolfe, Elsie 89, 164
Woolf, Virginia 52, 61, 71–2, 78, 88–9, 101–2, 120, 151, 164, 178; see also *A Room of One's Own*
Wyld, Evelyn 5–6, 15–16, 22, 25, 50, 68, 88–9, 164, 167, 169, 172